Wanderings of a Wayward Woodcarver

Wanderings of a Wayward Woodcarver

Stories from a Life in Wood

Gerry Holzman

LINDEN PUBLISHING

Fresno, California

Published by Linden Publishing®
2006 South Mary Street, Fresno, California 93721
(559) 233-6633 / (800) 345-4447
www.lindenpub.com

Linden Publishing and colophon are trademarks of
Linden Publishing, Inc.

Linden Publishing titles may be purchased in quantity at special
discounts for educational, business, or promotional use. To inquire
about discount pricing, please refer to the contact information below. For
permission to use any portion of this book for academic purposes, please
contact the Copyright Clearance Center at www.copyright.com.

ISBN: 978-161-035384-7
1 3 5 7 9 8 6 4 2

Printed in the United States of America
Library of Congress Cataloging-in-Publication data on file

*To my fellow artists in wood who have brought joy and
beauty to a world that is too often sad:*

*"Bless thee in all the work of thy hands
which though doest."*

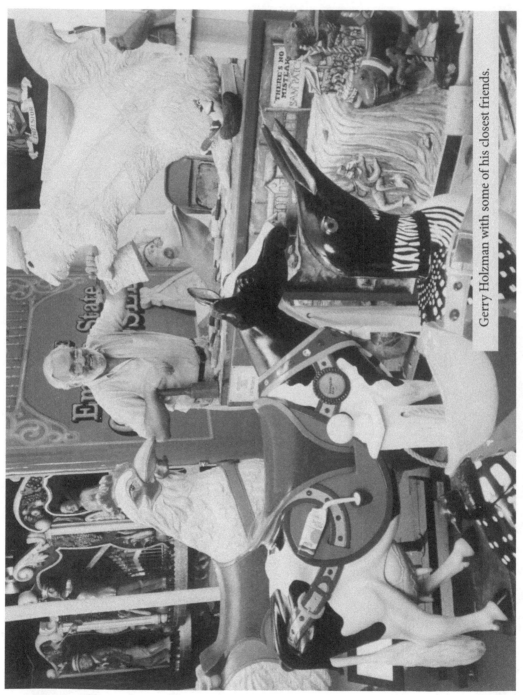

Gerry Holzman with some of his closest friends.

Contents

Foreword

By Liam Stegman

Over the course of his many years, Gerry Holzman has been many things: A first-born son, then an older brother; a husband, then a father to three daughters; a grandfather to six grandchildren. He's been a teacher, an artist, a writer, a union activist, and a rabble-rouser. Throughout all of these transformations, however, one title has endured: Gerry is, above all else, a *seeker*. An eternal student. One whose appetite for enlightenment has remained insatiable. His entire adult life has been one lived in the vise grip of Carl Sandburg's immortal verse: "Where to? What next?"

That sacred restlessness, that dogged desire to decipher so many of life's great mysteries, has ferried him from rural New York to some of the world's most distant places. Still, whether he found himself in the foothills of Haiti, the dusty boulevards of Mumbai, or the smoky comfort of a London pub, he could not escape the relentless call of Walt Whitman's captivating lyric: "I hear America singing, the varied carols I hear." This book is one man's synthesis of that siren song.

Of all the merry carolers that color the contents of this wry chronicle, none are as merry as its composer. Gerry's indefatigable zest for life and his unrivaled passion for people fly off the page like so many wood chips from a chisel. Like the tools that have built the bulk of his life's work, his prose is sharp and cutting. Like his carvings, the finished product is one of arresting depth—a reminiscence made of

that mercurial union of reverence and irreverence—a meditation on humanity honed by a practiced hand. And while this book will not provide the elusive answer once and for all to Sandberg's question about the soul of America, Gerry Holzman, even after nine decades in hot pursuit, shows no sign of letting up.

If, however, he were to grow weary of so much listening, so much learning, when he does one day finish his self-assigned search, he'll have left his quest in capable hands—the hands of his grandson. My hands.

Of all the redeeming and irredeemable qualities that I've inherited from my *meschuggenah* grandfather, none has proved more absorbing than this singular search for the people concealed behind their public facades. He has a compulsion for chronicling the complexities of lived experiences in an attempt to answer the unanswerable. Without him I never would have been able to realize that the soul of America is not crafted in the corridors of power. It is born on the artisan's workbench and spanked into life with a quilter's hoop. It's nurtured in the class-rooms and the barrooms, in the barbershops and beauty parlors, and in the neighborhood diners. It's cultivated in the garages, basements, and attics of those driven folks who must give tangible being to their visions. And while many of those precious packages may have not yet arrived on our collective doorsteps, this book certainly brings us a little bit closer to that delightful delivery day.

When my grandfather asked me to write this foreword, he requested that I include a couple of sentences describing who I am. For folks that are not as capable as he is, this can be a daunting challenge. In the end, I found that I kept coming back to the same simple sentence: I'm a young man following in the footsteps of an old one.

So, come meet the old geezer and some of his eccentric buddies. It could be the beginning of a beautiful friendship.

Liam Stegman, a thirty-one-year-old graduate student completing his MFA in creative writing, has sold Christmas trees out of a trailer in Queens, flogged exotic pizzas in the Hamptons, tended bar in Vermont, and taught school in Uganda. His most recent journey was through America's Rust Belt, where he, like his grandfather, sought the soul of America.

Preface

I have been a woodcarver for more than forty years. I began as a hobbyist and then, after being properly trained in the UK by an English master carver, made a mid-life career change from teacher of history to carver of wood.

During this time, I have reworked thousands of lifeless and shapeless pieces of wood into all sorts of attractive and useful creations. And as I formed the wood into something other than it was, the very act of working with that wood has transformed me into a person I never imagined I could be.

It all began as a reaction to the challenging words of Zorba the Greek: "A man needs a little madness—or else he never dares cut the rope and be free."

I accepted Zorba's challenge, reached inside myself, found my madness, and embarked upon the journey from teacher's desk to woodcarver's workbench. During this time, just as Zorba had promised, I became free (well, as free as a guy with all my hang-ups could be). For me, the experience has been both magical and mystical. But—equally important to my wife and to my children—I made a living.

The unexpected triumphs, unwanted disasters, and unanticipated joys during those same years cause me to believe—somewhat immodestly—that these experiences of mine might well be of some interest to others.

Henry David Thoreau once claimed, "I have traveled a good deal in Concord." More recently, Robert Fulghum contended, "All I really need to know I learned in kindergarten." I believe that the practice

of woodcarving has been my Walden, and the people and places it has introduced me to have been my kindergarten. More important, I believe that we woodcarvers have many fascinating tales to tell that are about much more than woodcarving. By describing some of my own adventures, I hope to suggest a few useful ideas for living in this increasingly perplexing world.

Introduction
The Sounds of Carving

During the years between 1983 and 2006, a great deal of my carving activity revolved around the Empire State Carousel—a statewide volunteer project entirely based on the theme of New York State's history and culture. As its originator and head carver, I was primarily responsible for creating this full-size merry-go-round and organizing the fundraising and educational programs that would bring it to fruition.

To help publicize the carousel and recruit volunteers, our carving workshop was open to the public, and we regularly hosted visits from a wide variety of schools, clubs, and service organizations. Once, one of our volunteer guides was conducting a private tour for a small group of teenage students from a school for the blind. The guide stopped the group in front of me while I was shaping a large piece of decorative molding. I was alternating between vigorously roughing out major areas with the aid of a mallet and gently smoothing them with a very sharp gouge.

When I paused to talk with the blind students about the work I was doing, one of them—before I had a chance to say many words—turned toward me and offered an extraordinary observation: "I like the sounds of carving." I don't think I'd ever thought of carving in quite that way. Up to that moment, for me, carving was physical, through all of the sawing and chiseling; it was visual, full of symmetry and flowing

curves; and it was tactile, involving smooth and rough. But from that moment on, from the moment I heard those perceptive words, wood-carving became audible. I began listening to the sounds it produced. I learned to recognize its distinctive music—the solid click when a mallet strikes the gouge handle dead center, the sudden snap as a piece of waste wood pops off the side of a board, and best of all, the sweet silvery sound that the edge of a sharp tool makes as it cleanly slices off just the right amount of wood. I like the sounds of carving.

And, if you turn the page and come along with me, I think you'll like them too.

But First—a Caution to Potential Critics

Although I did occasionally run afoul of the law in my precarving days—I've received my share of traffic tickets, and I was arrested at three in the morning for being drunk and disorderly while singing and carrying a park bench to my girlfriend's sorority house—I did not commit any truly dreadful crimes nor did I consort with criminals until I became a professional woodcarver.

As I wallow in the octogenarian ranks of white-bearded woodcarvers, my merciless conscience tell me that it's time to fess up and warn the world about the hidden hazards of our profession. Where do I begin? It's not easy. My crimes are many, and my criminal associations are manifold. So, for no reason other than the fact that it is my most recent involvement in the criminal world, I present the story of a most unusual offer.

A while back, I received a phone call requesting information about a carousel horse. The caller was about to buy a very expensive antique horse and wanted reassurance before he made the purchase. Would I provide an opinion before he bought it? He had taken an elaborate set of photographs of the horse and would bring them over to my workshop if I would be willing to look at them. When I readily agreed to help out, he said he would stop by within the hour.

Shortly thereafter, a luxurious black SUV pulled up in front of my workshop. The driver, a well-built guy in his late thirties wearing a fitted polo shirt, was accompanied by an attractive woman, a young

child, and a black Lab, all of whom he left behind in the car. He introduced himself—we'll call him Joe—with a very firm handshake and thanked me for taking the time to help him out.

The $25,000 price, had the horse been authentic, would have been fair, and he seemed to have no worries about spending that much money. But as his visit indicated, he wanted to be sure he was not being cheated. The pictures and the background information that he provided strongly suggested that the horse was a fake—one of those many imports that flooded the carousel market in the 1980s and 1990s when values were skyrocketing. I told him that it was difficult to be absolutely certain from a picture, but I felt it was not a genuine antique horse and, if it were offered to me, I definitely would not buy it.

Joe's face took on a hard look. "It's not the money so much, I do deals all the time. It's the disrespect that gets me. This guy is supposed to be a friend, and he's trying to take me. But—that's my problem, not yours. You saved me from being made a fool of, and I really, really appreciate it." With that, he vigorously shook my hand. "What do I owe you?"

"Nothing," I said. "I carve new horses and I restore old ones for a living. To me, carousel horses are beautiful works of art, and I do all I can to prevent fakers from screwing around with them. I'm glad I could help you."

Joe shook my hand again. "Hey, you did me a big favor. So I still owe you. Tell you what, you won't take any money but maybe I can do something for you like you did something for me—another kinda payback." Here his face took on that hard look again. "If someday, somebody bothers you, gives you a hard time, you know, that sort of thing, call me. I'll take care of it." He solemnly handed me a business card. "It's the way the world works—a favor for a favor."

Joe picked up his pictures, got back into his big black SUV, and drove out of my life.

But, critics, beware, I still have his card.

In the Beginning

I took up the trade of woodcarving because I became dissatisfied with a world increasingly dominated by people who manipulate oral and written symbols; a world filled with brazen blowhards, talking heads, and snake oil salesmen; a world where what one says or writes is much more important than what one does.

Although I certainly realize that verbal communication is a major element in the continuity of human society (this very book is proof of that belief), I had come to sense and resent an imbalance in contemporary America, where that particular skill had been elevated to a position of paramount importance. Having grown up respecting farmers, carpenters, and mechanics, whose worth was measured in terms of visible products or tangible manual skills, I found myself wanting to become part of their world—a world where a person is judged by his ability to cut a clean line or plow a straight furrow, not by his ability to distort an issue or misrepresent an idea.

Fortunately, at that crucial point in my life, I had been around long enough to realize that total immersion in the world of manual skills could produce an imbalance as damaging as the one from which I was fleeing. So I sought an occupation that would permit me to do tangible things without isolating me from the world of abstract ideas. After exploring and dismissing a whole array of manual trades as being inappropriate to either my nature or my circumstances, I settled. It seemed to offer a proper mix of tradition, creativity, independence, and discipline, qualities that I had long admired.

"I settled on woodcarving." It sounds so natural and so predictable. And perhaps it was. In Yiddish there is a word—*bashert.* (It seems, in Yiddish, there is always a word.) Like so many Yiddish words, it loses something in translation, but if you combine *destiny* and *fate* with the phrase *It is written*, you come close. If you want to be completely accurate, you'll have to add an element of free will to the mix. *What is written* are the actions of others and the varied responses that you, the principal actor, can make to them. *What remains unwritten* is the response you choose, a choice that must be guided by that soft, small voice that you hear inside your head. For a guy with a slight mystical bent who lived on Cedar Avenue and whose name in German means *woodman*, it was not too great a stretch to believe, that for me, wood-carving was bashert.

It began with four completely distinct and unsought acquisitions. During my college days, I succumbed to the temptation of joining a book club, convinced that I had the discipline to return those pesky monthly refusal cards and not receive unwanted books. I was wrong. Before I was able to end my membership and turn off the shipping department's conveyor belt, I had received a half dozen unordered books. Although I did enjoy *The Works of Rudyard Kipling* and read it in its entirety, *Early American Woodcarving* was relegated to the bottom of my trunk with disgust. It remained there, unread, for over twenty years. The second acquisition was a miniature musical trio—a drummer, an accordionist and a trumpeter—that had been hand-carved for our Swiss babysitter by an Austrian doctor in gratitude for the food packages that she sent him during the turbulent years immediately following World War II. For some unknown reason, she sensed that I would appreciate them and gave them to me in 1961 as a housewarming gift for our newly acquired home. Nine years later, at an autumn yard sale, I came across a book with a delightfully optimistic title—*You Can Whittle and Carve*. In leafing through it, I found a photograph of a carved Appalachian mountaineer that bore a vague resemblance to the Austrian trumpeter, both in style and in coloring. So, I plunked down

my quarter, brought the book home, and shoved it in the bookcase, where it remained unappreciated until the following spring.

A few months later, in the course of my regular Sunday phone call to my mother (now that I've admitted to knowing some Yiddish, it is obvious that I belong to that exclusive group of fully grown, gutless men who are required to report to their mothers once a week), I was asked what I would like for the holiday season. Since I had just seen one of those business-card-size ads in the Sunday *New York Times Magazine* for an X-ACTO woodcarving kit priced at an affordable $7.95, I suggested that as the ideal gift for my mother's thirty-seven-year-old son.

The basic kit arrived in the mail a few weeks later—a couple of handles with replaceable blades, all neatly arrayed in a small wooden box. I carefully ran my finger along the edges of the blades and marveled at their sharpness. However, after a few minutes of experimenting with the various gouge-shaped blades on a scrap piece of pine, I lost interest and put the kit away. Another Christmas was over.

Boredom. Boredom and bashert. One evening during the early spring as I sat quietly in my small library, brooding about being caught in the soft, comfortable web of teaching and musing about seeking stimulating alternatives, the whittling book—*You Can Whittle and Carve* by Amanda Hellum—caught my eye:

> Many people have an instinctive desire to carve and never lose their desire to shape something from a piece of wood . . . Nor is the desire to carve dimmed by the passing years, for many devotees of the craft have long since passed three score and ten.
>
> Carving is an enjoyable pastime. It can become an absorbing hobby, and in many instances has developed into a profitable occupation. The boy who carves his initials on the school desk can, with the proper directions and encouragement, be changed from a despoiler of public property into an enthusiastic young sculptor. The more

mature idler, under tactful compulsion, might turn his pastime into more useful channels which could lead to a profitable occupation.

"The more mature idler . . ." That's me, I thought. "More useful channels which could lead to a profitable occupation." A tempting prophecy. I opened my $7.95 X-ACTO carving kit and got a scrap piece of pine from the wood pile. One week later, I proudly displayed a small hand-carved wooden deer, just as Amanda Hellum had promised. Next out of the box was a pig, which was quickly followed by the mountain man who had first attracted me to the book. And then came a mountain woman to play Eve to the Adam I had created. It was heady stuff this woodcarving thing. I found it to be somewhat like a Zen exercise—it was all-absorbing and all-connecting; my dark musings and somber broodings were put aside because I had to give the little figures the complete concentration that they demanded.

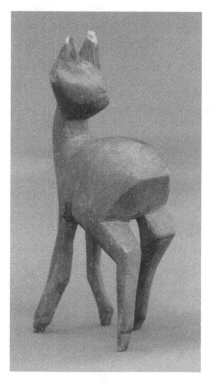

By summer's end, I had gone through Hellum's entire book and had a shelf filled with an impressive array of simple figures. That winter, tiring of copying, I experimented with original caricatures by carving a complete chess set, trying to give each of the thirty-two figures a distinctly different facial expression. The results were serendipitous, fascinating, and revealing. One light pawn looked exactly like Richard Nixon, and the dark queen bore more than a passing resemblance to my high school English teacher.

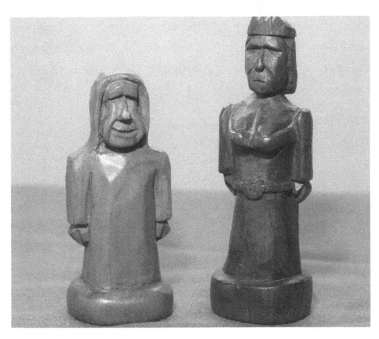

Over the next four years, I became increasingly confident and experimented with all sorts of carvings. I reclaimed *Early American Woodcarving* from its ignominious burial spot and found inspiration in its illustrations and kinship with its artisans. I even took the audacious step of transforming my Austrian musical trio into a quintet by adding a cymbal player and a bugler. And, best of all, I began selling some carvings. There is nothing more gratifying than discovering that people so appreciate your work that they will actually pay to possess it. Of course, as most artists can understand, there was some separation anxiety at first, which was engendered by the fear that the carving I was about to sell was the product of a fortunate accident that I would never again be able to replicate. It is a fear that I hold to this very day: the fear that my best work is behind me and that the next self-assigned challenge is beyond me. (In an unintentional and somewhat paradoxical way, my wife has encouraged this emotion by periodically claiming one of my carvings for her own. Such an act, which is obviously intended as a compliment, could easily be construed by a neurotic artist as an implication that the chosen piece must be preserved because

9

there will be no more like it.) As the sales became more frequent and the quality of my work continued to improve, I worked through my neurosis and began to think the unthinkable: the moment for a little madness had arrived.

A Face in the Woods

I created my first woodcarving—that three-inch-long sugar pine deer—nearly fifty years ago when I was thirty-nine years old. But I knew a little bit about woodcarvings much earlier. When I was just fourteen years old I heard a story about a strange man who carved faces into the sides of white birch trees.

The Cunasek family lived in a simple rustic house by a dirt road on the side of a small mountain just outside of Amenia, the tiny village in upstate New York where I grew up. Today, we might be politically correct and say they were locavores who were living off the grid, but back then we simply thought they were poor people who couldn't afford to live in town.

The father, Milos, was an artist who painted on canvas, sculpted with metal—and sometimes carved faces on trees. I never saw any of his work; in fact I never even saw Milos or his house on the mountainside but I knew about him because I went to high school with his son. Harry, although understandably unwilling to talk about his home situation, would sometimes cater to our insatiable teen-age curiosity by reluctantly responding to embarrassingly direct questions about his unusual life style. Consequently, over the four years of high school, we were able to piece together a patchwork story of their lives. As I recall the little we knew, it was not a happy story. Apparently, Milos Cunasek had some sort of job and sold a piece of art in New York City and other art centers often enough to sustain their meager lifestyle but not often enough to improve it.

Harry never asked any of us to visit his home. And it was hard to be friendly with him because he protected himself with a fence made of silence and sarcasm. But, one afternoon in the lunchroom when I asked him whether his father really carved faces in the woods, he sensed that I was genuinely interested in his father's unusual artwork. That's when Harry opened up a bit and talked about them. And the more interested I became, the more details he provided: they were life-size, shallow-relief caricatures of people his father knew or knew about—friends, relatives, politicians, and historical figures. He said there were about a dozen faces around their house, all carved shoulder high on live white birch trees.

The next day, unasked, he brought in a small Kodak Brownie print that showed him standing next to a portrait of Abraham Lincoln that Milos had carved into the side of a white birch tree. As I remember the photo, the carving looked very much like the president—beard, long face, stovepipe hat and all. So I said something about his father being a pretty good artist.

That lunchroom incident was the closest I ever came to direct contact with Harry's father or with his artwork. Most of us—there were only fifteen seniors left by graduation day—simply dismissed his family as poor people who lived in the woods and Milos as a strange artist-guy who did strange artist-guy stuff, like carving faces in trees.

And that was it with the faces—until some twenty-odd years later when my brother and I bought a 35-acre hilltop farm in the Schoharie Valley. The farm contained a small pond, a six-room Civil War era farmhouse, a falling-down chicken coop, a fallen-down barn, and a mile or two of stone walls. Although there was a large hillside meadow alongside the house, most of the farm had reverted to new growth forest consisting of oak, maple, pine, hickory, and—white birch. Lots and lots of mature white birch, eight to ten inches in diameter. White birch, just like those that Milos had carved in Amenia.

Yeah, you guessed it. I carve faces in trees. My faces are not quite as good as that one he did of Lincoln but, hey, they aren't half bad either.

Each October, for sixteen years, I have carved a life-sized face, shoulder-high, on one of the white birch trees. I usually leave the house just after breakfast, when the dew has dried on the meadow, carrying a roll of carving tools and a mallet, a thermos, a sandwich, and a couple of our crisp Schoharie Valley apples. I walk about 300 yards into the woods and pick my tree. (The dog usually comes along but she gets bored after an hour or so and returns home.) Following an old West African custom, I pour a small libation from the thermos and I ask forgiveness from the tree before I make my opening cut.

My subjects vary. The first was George Washington, copied from a dollar bill portrait that I tacked to the tree. But others have been more whimsical—a sea captain, a Russian Cossack, a Keystone cop. In 1977, I even carved a smiling Jimmy Carter.

The whole process takes about five to six hours—including a long lunch break when I just lie quiet on the forest floor and soak in the sounds, the smells, and the scenery. However, the experience itself is timeless. I love the quiet and the solitude. Just me, the woods, the falling and fallen leaves, the tree and a face where there had earlier been only some grayish-white bark.

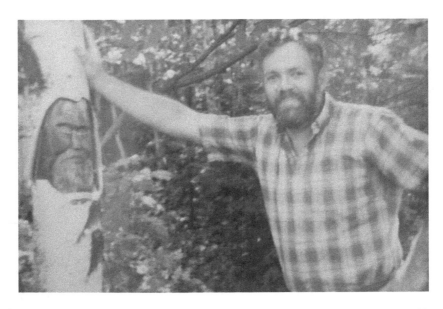

As I lie there, all sorts of strange thoughts run through my mind. Sometimes I even wonder what that strange artist-guy was thinking on the day he carved Abraham Lincoln.

Epilogue: When we sold the farm some twenty years later, I ignored Arlene's heartfelt protests about leaving the faces for the new owner and took a chain saw up to my white birch pantheon. After walking around a while, breathing in the forest air and admiring my remarkable artistic accomplishments, I made my selection, set my saw on Jimmy Carter's tree and cut out his two-foot long portrait. So today, the President from Plains continues to smile down at me from his tree-trunk home on my workshop wall, appropriately framed by the natural protective curl that the bark creates to heal its wounds. And, like so many of Holzman's Holzmans that I've kept for myself, that old peanut farmer brings back a lovely memory of a special moment in life's grand adventure.

"Are You an Artist?"

It wasn't a robo call, nor was it a phone solicitation. It was a direct—and very sincere—question put to me by a college student who had been given an art-class assignment to interview an artist.

I replied by saying that I was a woodcarver who created a wide variety of pieces: utilitarian carvings like signs and walking sticks, decorative stuff like moldings and plaques, and animal and human figures that were simply pleasant to look at. I told her that I honestly wasn't sure what I was (my wife claims that she knows exactly what I am), but she certainly was welcome to visit me and decide if I was a good fit for her assignment. She came to my workshop a few days later—an attractive girl who had a no-nonsense air about her. She was tightly clutching a notebook in one hand and cradling a small tape recorder in the other. Some interviews take the form of conversations; this was more of an interrogation—not a hostile one, mind you, but a brusque, business-like barrage of questions. She kept the tape recorder running the whole hour and took extensive notes. The questions, provided by the teacher, were incisive, wide-ranging and, quite personal.

"Did you go to art school? Or are you self-taught? Name some artists who have influenced you. Are there any artists in your family? Do you make your entire living from your art or is it just part-time job or is it just a hobby? Do you like your work, love your work, or just do it because you have to make a living somehow? How do you feel inside when you finish a complicated piece of art?"

There had been no small talk during the interview, no attempt on her part to establish a social relationship. I had tried to relax her

with some humorous responses and by telling her the backstories on a couple of my pieces. But she was largely unresponsive and seemingly uninterested in any of the carvings on display. Nor did she seem interested in the substance of my responses. I got the distinct feeling that all she wanted was to get this damn thing over with and get out.

I was determined not to let her off that easily. "Now that you've asked me more than a dozen questions and tape-recorded and written down all my answers, it's only fair that I ask you one: Am I an artist?"

A perplexed and troubled look came over her face. She hesitated for fully half a minute and then uncomfortably admitted, "I don't know. I'll have to ask my teacher."

I asked her to contact me to let me know the answer and to send me a copy of her paper. She did neither.

It was to be two years before I got the answer to my question, and it came from a completely unanticipated source. I told the story of the art student on one of my cruise-ship carving gigs during a lecture on American folk art. It got a big laugh, and a couple of passengers even asked me to elaborate on the concept during the Q&A. Later that afternoon, as I walked onto the rear deck to begin my daily informal carving demonstration, a chorus from some of the regulars greeted me: "Good afternoon, Mr. Artist."

But the actual anointment didn't take place until a month after we returned from that cruise. A large packet arrived in the mail, containing an impressive-looking framed certificate sent by some passengers from California with whom we had become quite friendly. Decorated with an illustration of a jointed wooden model and signed in a bold calligraphic hand, it unequivocally stated:

<div align="center">

GERRY HOLZMAN

IS

AN ARTIST

</div>

You, dear readers, might kindly ask me what this certificate means. Well, it means that this wayward wanderer is one of the few

woodcarvers in the English-speaking world who has compelling and irrefutable documentary evidence to prove that he is an artist. And that simple fact, aside from its obvious ceremonial significance, has a very practical hidden value: a certified artist can charge more than a mere woodcarver.

The Past Is Present

I first encountered Sol Stein, a Russian immigrant woodworker who died in 1937, at Canadarago Lake in the early fall of 1981. But I didn't really get to know him until the spring of 1982, when I—the descendant of a Russian horse trader and a Hungarian woodcutter—painstakingly restored some of his well-worn wooden carousel horses in my Islip, Long Island, workshop. He had skillfully—and painstakingly—carved the horses in 1909 while working in the vicinity of Brooklyn's Coney Island.

If the chronology, the demography, and the geography above are a bit confusing, bear with me, trust me, and read on.

It all began in 1981 when I took a trip to Hamilton College in upstate New York to visit my daughter. At that time, I was suffering from a serious addiction problem that afflicts many middle-aged men: I had an irresistible compulsion to browse in rural antique shops and buy useless things. My wife, fearful of the dangers of making me quit cold turkey, allowed me one stop on our northward journey. That stop was at a small shop in Richfield Springs, where I learned that an entire carousel was for sale just a few miles down the road. So, I bought it.

Of course, it really wasn't anywhere near that simple. In fact, the process was quite complicated, and it all took about three months to work out. But it did end well. A fellow carver and I acquired and restored all of the thirty-six horses, twenty-four of which had been

carved by Sol Stein and Harry Goldstein in their Brooklyn workshop during the very early years of their partnership. They had created lively and tension-filled horses straining to run, prance, and jump as their nature demanded. Stein and Goldstein went on to carve nineteen of the most splendid merry-go-rounds ever created, chief among them Manhattan's Central Park Carousel.

Of course, Sol and Harry were many years dead when I encountered them in that derelict carousel building on Canadarago Lake, but we woodcarvers have a way of communicating that transcends mere mortality. All I had to do was take a few rides on Long Island's Nunley's Carousel, another of their magnificent works of art, and restore some of the horses that they carved, and I knew who they were.

I was particularly drawn to Sol Stein, who began life in America as an eighteen-year-old carver of decorative ladies' combs, an optimistic immigrant who had the determination and skill to transform himself into one of our great American folk artists, whose work is now on display in the Smithsonian. This trained craftsman and highly imaginative artist came to America around 1900, exactly the same moment in time as did my Russian grandmother. Following that vein, I sometimes fantasized that Sol may have come from her shtetl or traveled here on the same ship that she did. I even went so far as to imagine that she might have bought one of his hand-carved combs from a pushcart on Hester Street.

As I worked recreating the worn, blurred lines that he had carved and felt my gouge moving along the same path that his had once moved, I experienced a sense of communion with him. It's a strange feeling, one I suspect only a fellow craftsman can fully understand. To be completely candid, I should also admit that every once in a while, after I had finished the day's restoration work, I would place his photo on my workbench, pour myself a glass of wine, and talk to Sol Stein about what I had done to his horse that day. For those who might fear for my sanity, I am happy to report that these were one-sided conversations.

I went on to read everything I could find on his life, which was tragically brief (he died at age fifty-five). I discovered that Sol Stein was, like most immigrants "a dreamer of great dreams." I suspect my attraction to him came in no small measure from that attitude and, even more so, from the closing words of the eulogy that Stein's son presented at his father's funeral: "My father was a man who was industrious, intellectually curious, generous in friendship, artistically inventive, loyal and most important, a man who loved people."

Except for the shortness of his span, not a bad ending at all. I suspect most of us would warmly welcome words like this when we finish our time on earth.

The Last Woodcarver

The obituary wasted no words and contained no poetry.

> North Tonawanda—Joseph D. Weber, 85, died unexpectedly in his home on Monday, March 13, 1967. He was born in Buffalo and lived here for the last 45 years. Mr. Weber was a woodcarver until the 1930s and he was the last member of the Woodcarver's Association. He was a member of the Ascension Church and Knights of Columbus Council No.2535.

And that was it. Eighty-five years of a man's life summed up in under eighty-five words.

It is from one of Weber's survivors—his daughter—that I bought the shabby black leather Gladstone bag that held the obituary and 150 of Joseph Weber's woodcarving tools. They were finely made carving gouges, most of them forged around the turn of the-century. His daughter said she'd sought me out because I was a professional woodcarver and she felt that her father "would have wanted them to be put to some good use." She murmured, with genuine sadness in her voice, "They were just lying in the attic. No one in the family knew how to use them or wanted them."

There are those who say that you can judge the quality of a craftsman by the manner in which he cares for his tools. If they are to be

believed, then Joseph Weber must have been a competent and conscientious carver. His carving gouges were carefully wrapped in bulky tool rolls made of a coarse gray cloth with thin blue stripes, probably hand-sewn by his wife. These rolls, which were divided into individual pouches for each tool, had become smudged and discolored through years of being opened and closed by the hands of a man who earned his bread by carving wood.

I spread the opened rolls on my workbench. Closed tightly for over twenty years, they quickly filled the air with the aroma of oil, musty attics, and yesterdays. I tried to visualize Joseph's hand hovering over one of those rolls, ready to make a selection. I guessed it was the sort of hand that would have given a memorable handshake, a strong and compact hand, with fingers thickened through constant use. A rough, sturdy hand, framed on its outside edge by the characteristic callus that comes from constant contact with raw wood. A carver's hand.

I stared at the tool roll that was bristling with gouges. The carving gouges seemed to radiate an energy of their own. They reminded me of foxhounds, straining at the leash, eager to do they work that they were created to do. I couldn't help but wonder if there was some sense, some essence, of Joseph Weber still present in those tools.

I took one of the gouges out of its pouch and let my hand experience it. The worn, stubby handle was a warm shade of dark brown. It had the feel and look—that unique glow—that wood takes on only when it is in constant contact with a human hand. I placed my fingertip on the shallow hallmark stamped into the shaft of the steel and felt the inscription—"S.J. Addis London," one of those grand tool-making foundries that were among the casualties of the Great Depression. I carefully ran the cutting edge of the tool along the face of my fingernail; it was still sharp despite twenty years of idleness.

Casually setting a piece of white pine in my vise, I put the tool to work. I had no particular design or shape in mind. I simply wanted to become acquainted with that gouge and perhaps, if such things be possible, with Joseph Weber. Long, curly shavings fell to the floor. The

smell of fresh-cut pine filled my nostrils. The sensual sound of a sharp edge cutting across the grain was in my ears. I particularly liked the way the wide wooden handle felt in my hand. It snuggled into my palm much like my infant grandson used to snuggle into my neck. It felt good because it seemed to belong there.

My mentor, the late Gino Masero, told me that the Association of Master Carvers in England once had a tradition for distributing the carving gouges of a deceased member. His gouges would be brought to the annual meeting, laid out on a table, and each member would be invited to take one. If the widow was in need of funds, a payment would be made, but otherwise, the tools were to be taken at no cost.

I wish they had been able to follow that practice in the North Tonawanda Woodcarver's Association. It would have been a fitting thing to do. I suspect that the assurance of such continuity would have pleased Joseph Weber. Just knowing that the carving tools that were so much a part of his being—those tools which had helped him raise his family, those skillfully shaped fingers of steel with which he had shared many a private moment and which had so often been his partners in creating beauty—just knowing these old friends were going to literally be in good hands would have been a comforting thought.

But I'd like to think that Joseph Weber would be more than satisfied to know that there is a well-weathered woodcarver in Mid-Coast Maine who is still putting those well-worn tools of his "to some good use."

Friendly Hands

Bless thee in all the work of thy hand which thou doest
—Deuteronomy 14:29

The first thing you noticed about Gino was his hands. They were massive and broad, strong and competent, with fingers so thick that his son can recall a time when, as a young child, he was unable to encompass any one of them with his entire fist. They were hands that knew what they were about and showed not the slightest hesitation as they approached their appointed task. I sometimes imagined them coming to the shop by themselves, fully capable of meeting the day's challenges without Gino being there.

Gino Masero, one of the thirty-two members of the English Association of Master Carvers, was my teacher, my mentor, and my friend. In addition to teaching me ordinary, everyday skills like carving hair and sharpening tools, he bestowed a much more important gift—he generously opened a window into his soul. And what I saw there, combined with what I learned at his workbench, made it possible for me to become a professional woodcarver.

On the morning that he began my lessons, Gino had me place my short, stubby hands on the workbench, the left palm up, the right palm down. He studied them for a moment and then solemnly told me that I had "carver's hands." He pronounced them large enough to comfortably grasp a carving gouge and strong enough to control it. That

was one of the reasons he took me on as a student, he said. "But you won't become a woodcarver," he continued in his serious tone, "until the gouges become extensions of your hands. When that moment comes—and you'll probably not even be aware that it has come—when the carving tool becomes a part of your hand and you forget that you are holding a tool, then you'll be a woodcarver."

Gino was right: that moment did eventually come for me—and yet I don't remember it happening as an event. There was certainly no drum roll or flashing lightbulb. It just seemed part of a natural progression. One day I was guiding the tool through the wood, and the next day the tool seemed to know the way by itself. I belonged to the gouge as much as the gouge belonged to me. In a near-mystical transference, which perhaps only a fellow craftsman can understand, the tool had become me.

After I had crossed that extraordinary threshold and Gino was satisfied that he had properly trained my hands, he then concentrated on a far more difficult task—he went to work on my head.

He set standards, confident now that I had the physical skills to meet them. "And it has to look right no matter where you stand. Don't be careless with one spot just because it's on the bottom or in the back. It doesn't matter if other people won't notice it; you'll know it's not right, and so will your god."

He wanted me to see what he saw when he looked at a piece of wood. He wanted me to see what Michelangelo, Tilman Riemenschneider, and Grinling Gibbons had seen. Books, museums, and cathedrals became as important a part of my life as the gouges and the sharpening stones. One afternoon, as we were finishing up the day's work, he gently chided me. "You're soon going to become a member of a very old family. That means you have a responsibility to learn from those chaps who were here before us. I think it's time you got to know some of them."

The next morning, we caught a train to London and visited the Victoria and Albert Museum, where he stood me in front of Gibbons's relief masterpiece, *The Stoning of St. Stephen*.

"See how subtly Gibbons guides the viewer's eye by carving those diagonal lines. And see how he adds interest to the lines by gently beveling them. He bloody well commands us to look at St. Stephen. The master is dead some three hundred years, but he's still communicating. Never forget that, Gerry—communicating, that's what we're about."

Gino loved to carve, and he communicated that love to all those who worked with him and even to some who simply watched him. I still remember the day he explained how he felt about his profession and how he graciously used that explanation to welcome me into the carving brotherhood.

"It's a grand job, isn't it? You get to do something you love to do and . . ." Here he paused with a look that somehow combined bemusement and bewilderment. "And, they pay you lots of brass to do it." Then, with a characteristic twinkle in his eye, he looked me full in the face and said, "Gerry, we're lucky fellows, us carvers, aren't we?"

The Elevenses Were Brilliant

The time has come, the Walrus said,
To talk of many things:
Of shoes—and ships—and sealing-wax—
Of cabbages—and kings
—Lewis Carroll

So, what is it like to spend an entire day "apprenticed" to a highly disciplined and uncommonly demanding English master carver? And, what is more, to spend it in the small confines of his home workshop under the ever-watchful eye of his welcoming—but always protective—wife? Well, just add to this curious mixture one "truly diabolical" carving project, sprinkle it generously with engaging conversation, and you have all the ingredients of what my limey friends would call an absolutely smashing day.

As a rule, we would begin work about eight thirty. That is, *I* would arrive at Gino's house around that time. *He* would have already been in the workshop for at least an hour, tending to his own chores and preparing my daily lesson. We would work until twelve thirty, take about an hour for lunch, and be back at the bench by one thirty. I never left earlier than five and often stayed until nearly six. In retrospect, I guess it might be termed a long day, but for me, it was made short by the

challenging tasks and the stimulating talk. (I always hoped that the same was true for Gino but—I was never quite sure.)

Let's take an actual day out of my journal and call it typical. The journal entry is for a Tuesday in April of 1979. Arlene and I had come over during my spring break and were staying just down the road at Nick and Judy's B & B. Gino and I were in the second day of my week's lesson, which was structured around the carving of a small (18" × 30") oak hope chest lid that I had brought with me from America. The main goals of the remaining four days were three-fold: to review and apply the basics of decorative composition and pattern use, to learn a simple technique for carving words on an undulating banner, and to practice two different styles of relief carving.

The workshop was in a small (12' × 15') wooden shed in the garden just behind the house. There was a large window located along the full length of the workbench. In addition to the obvious benefit of light, the window looked out on Gino's well-tended garden. On this particular morning, the daffodils were already in bloom, and there were definite signs of burgeoning color from their nearby comrades.

When I arrived that morning, Gino had placed my oak lid on the bench and had drawn some possible patterns alongside it. His proposals were very British—each centered around the heraldic design of a lion, a unicorn, or a stag. So British were they that my nationalistic hackles rose, and I countered by suggesting one of our own elegantly flowing Bellamy eagles. After an animated discussion of the mythological and symbolic implications of the four candidates, we agreed that the unicorn, the protector of maidens—and a creature that could only be tamed by a virgin—would be the most appropriate for a hope chest.

Then Gino, with a twinkle in his eyes, said there was one more very critical design decision to be made. "Would we carve the unicorn with a penis or without a penis?" He explained the "with" was more traditional than the "without" but, realizing that the hope chest was a wedding present for my brother and his bride, he wanted me to be the one to make that delicate decision. Since my brother and his

bride-to-be had already been living together for a couple of years and had drunk deeply—and frequently—from the overflowing cup of life, it was a no-brainer.

"With a penis," I replied and, employing my newly acquired heraldic vocabulary, gleefully added, "and both the unicorn and the penis should be fully rampant."

Always the historian, Gino couldn't resist adding a historic footnote to our discussion. In keeping with the very proper Victorian concept of morality, the heraldic beasts of nineteenth-century Britain were generally depicted as unsexed. But when randy old Bertie replaced his staid and dour mother at the dawn of the twentieth century, heraldic artists took it as license to restore the male organ to its proper place and posture. And rampant it has remained ever since—in the heraldic halls of the UK, in Bertie's bedroom at Buckingham Palace, and even in the Oval Office of our very own White House across the big pond.

Once Gino and I straightened out the penis problem, we moved on to more conventional topics. Ever since I had seen the heraldic crest that he had carved to mark Harold Wilson's elevation to the Knights of the Bath, I had been intrigued by the mystique of medieval heraldry. Quickly sensing my interest, Gino used this carving of the dower-chest lid as a teachable moment. So, to our drawing of a unicorn rampant he added quick sketches of a lion *passant* (walking) and a lion *couchant* (resting on his chest) all the while explaining the symbolism of these varied stances and the French and Norman origins of the heraldic lexicon. As we added other elements to our heraldic lid design we inevitably got into such things as *dexter* and *sinister* (right and left) and, finally, even touched on colors—*gules* (red) and *argent* (silver)—when he suggested I paint the shield in traditional bright colors so it would stand out sharply against its oak background. I rejected his suggestion, and, every time I visit my brother's house and look at the chest, I'm glad I did. Gino was wrong; paint would have diminished the carving.

Good stuff, you the reader might say, this business about left and right, but it isn't really relevant to the story or to a description of a typical day at the workbench. Why waste time on esoteric meanderings and historical asides? In defense of these meanderings, it must be noted that, by the sheerest of coincidences, two weeks after returning home, I received an unsought, and completely unanticipated commission from a Long Island Catholic church to do a series of carvings based on the heraldic devices of the Pope and the regional bishop. While we were discussing the details involved in changing their two-dimensional drawings into three-dimensional shields, a wee bit of chutzpah led me, confidently—and a bit mischievously—to ask the local priest whether he wanted the dexter and the sinister sides of their shields to be of equal value.

But, as usual, I digress. Back to the workbench and to some of those promised carving tips. Once we had completed a drawing that satisfied us both, Gino showed me how to pierce the pencil lines with a carving tool and thereby transform it into a pattern which was then

carefully positioned and taped on the chest lid. He took a small cloth bag filled with dark powder, pounced the perforated lines, and pulled off the pattern. And there on the chest lid was a very clear working drawing. (When I later explained this process to Arlene, she showed me how to do the same thing by placing dressmaker's colored wax paper between the unperforated drawing and the wood and simply tracing over the lines; it was so much easier that I'm surprised Kate, who was a seamstress, didn't suggest this process to Gino. Perhaps it was because Gino's method produced a pattern that could be easily reused while the tracing process could only be repeated a couple of times.)

Just as we finished the pattern transfer, almost as if on cue, the workshop door opened and Kate walked in carrying a small tray containing a pot of steaming hot tea and a plate full of those dry, mealy English biscuits that I love so much. It was only with her cheerful arrival that I realized that we had just gone through more than two hours of intense—very intense—design activity and I had not once thought to look at the clock. This stood in enormous contrast to the time I'd spent at school, where the minutes always seemed to drag and the hours rarely passed without psychic pain. But today, I was in battle. It was eleven o'clock, and it was time for our elevenses work break.

After about ten minutes of tea and talk—none of it about carving—Kate loaded up the tray, again as if on cue, and left us chaps to continue with the important business of the day. To me, an incurably romantic Anglophile, this diverting, almost stereotypical interlude of elevenses was doubly welcome because it seemed so terribly British. As she closed the door behind her and we turned back to the workbench, I had the momentary feeling that it was 1957 and I was a player in one of those bleak but nearly always compelling J. Arthur Rank black-and-white movies. Here it was only my second day on the job and I had already completed a major rite of passage. No longer just a plodding American pedagogue, Gerry Holzman—having drunk his cuppa, munched his bickie, and engaged in his chin wag—was now, as any fool could plainly see, a fully-fledged and absolutely proper English

workingman. (Sadly, I recently heard that this appealing tradition of elevenses is rapidly disappearing from the workplace because of the relentless demands of "productivity.")

My reverie ended with the sound of Gino's clamp tightening on the dower-chest lid. Once the lid was firmly attached to the workbench, we were ready to begin the actual carving. Gino explained that the relief would be done flat because that was the position in which its audience would view it. Working flat would enable us to create the shadows and highlights necessary to accentuate the full illusion of three dimensions. He hastened to caution me that other things like faces, which would usually be viewed upright, could be roughed out on the flat but ideally should be fine-carved in an upright position so the carver could clearly see where to create the appropriate shadows.

When Gino picked up a V-tool and said, "We're going to work Egyptian today," I hadn't a clue as to his meaning. But after he showed me some photos of relief carvings from ancient Egyptian tombs and demonstrated the basic outline cuts typical of this style, I quickly realized how appropriate it would be to my dower-chest lid.

The essence of the style was quite simple. The Egyptian stone carvers cut a narrow trench around the outline of the figure and left the background intact. That way, the figure remained on the same plane as the background but could still be easily shaped and given depth because it was separated from the background by the trench. Western carvers usually outline the figure and cut away the entire background so that the final carving emerges at a higher level than the background. Since this lid was going to be frequently opened and closed, the Western-style figures would have protruded from the lid and would be more likely to be damaged. And as further proof of the wisdom of his choice of style, Gino pointed out that it would be more comfortable to sit on a flat lid than on one with an uneven surface.

After Gino demonstrated the technique with an initial trench cut around the back of the unicorn, he handed the V-tool to me, and I went to work under his watchful eye.

"Turn the tool to the right a wee bit. If you do that, one side of the trench is square with the background and the figure side has a slight bevel to it. It is more efficient, and easier, to create the desired shadow now rather than go back and make a second unnecessary cut. In short, you are doing two things with one cut—isolating the figure and doing some rough preliminary shaping of it."

Gino always emphasized efficiency. He was, after all, an independent tradesman whose working time was measured in money. That is why he constantly chided me to keep all my tools facing the same way— handles toward me and cutting edges lined up. "If you train yourself to do that, your eye only has to move along a single line to find the proper tool instead of searching through a bloody jumbled mess." Reinforcing this view of efficiency, he further suggested: "When you have finished cutting with a tool, take a quick look around the work to see if you can use that same tool to make additional cuts somewhere else. It will save you putting it down and having to pick it up again five minutes later." He also urged that I always bear in mind the importance of "economy of cut." By that term, he meant the process of removing the waste wood with a gouge shape that also left behind a desirable concave surface in the carved wood—a bonus detail that would advance the carving's progress. Thus, a single cut could do double duty much like the V-tool did in the Egyptian outline procedure.

Lunchtime. Kate set a lovely table and usually tried to make it authentically English. On this Tuesday, she placed in front of me a plate containing an amorphous something about the size of a hamburger bun that was reassuringly surrounded by an array of familiar vegetables. "Toad in the hole." She smiled mischievously. "Try it; I think you'll like it." Try it I did; and like it I did. Despite the exceedingly odd name, it was nothing more than sausage wrapped in some sort of tasty batter, not unlike what we Yanks much more sensibly call a "pig in the blanket."

We drank a bit of wine every afternoon. Today, it was a bottle of Bully Hill white. I always brought along a couple of bottles of the

Finger Lakes' finest, accompanied by a generous assortment of our regional goodies: cheeses, jams, etc. One year, I even risked a suitcase disaster by packing a jar of upstate maple syrup. Kate and I had an undeclared competition in which we tried to show each other the best of our culinary traditions.

Good conversation, good food, and good wine. And then, Gino and I went out back where we had a quiet, introspective, ten-minute sit-down on the edge of the garden. Gino said this was his time to think about the day—how it had gone and how he hoped it would go.

Back to work. After making sure that I fully understood how important it was to "direct the viewer's eye" and that I was modeling the unicorn so that "the highlights and the shadows properly play off each other," Gino decided it was time to let me solo. Not one to waste his time, he took down a piece of molding that he had been working on the previous week and set about finishing it. I couldn't help but watch him out of the corner of my eye; his hands raced across the work, never hesitating as to which tool to select and never hesitating as where to cut. He would instinctively switch hands so as to meet the grain at the best possible angle. (Early on, Gino had impressed upon me the need to become ambidextrous. Back in the classroom, I used to practice writing on the blackboard with my left hand. At first the kids snickered a bit, but after a few days, they got used to it and, somewhat immodestly, I am pleased to report that I eventually became almost as good with my left hand as with my right.)

After about fifteen minutes of intense, silent work on both ends of the workbench, he put down his gouge and walked over to my area of the bench. "Smashing bit of work, that. I should leave you alone more often. Now, just see this line, here on the leg—let's give it a little more interest." And with that, he took the gouge from my hand and cut a narrow, rounded bevel between the knee and the hoof. With that one cut, he solved a problem that I had been struggling with since lunch—a problem of three-dimensional visualization that I was trying to solve by making a series of nibbling, uncertain cuts, each one

canceling out the other. With that one cut, the leg lost its flatness and became fully dimensional. Gino had cut my Gordian knot and taught me a carving lesson. And by extension, he had provided a guide for living that I carry with me to this very day: a single action, if appropriate, informed, and decisive, can accomplish far more than a multitude of tentative, ignorant, and impulsive acts.

Having satisfied himself that I could continue on my own, he returned to his molding, and we both went on with our respective tasks. And that's the pattern that we followed for the balance of the day. Though he seemed fully engaged in his own work, Gino immediately sensed when I was in trouble and would intervene with a very appropriate suggestion or a quick demonstration. (Although I paid for the lessons—in an amount in retrospect that seems far too small— he obviously felt a need to work on his simple commissioned piece of molding so that all of his bench time would be economically and professionally productive.)

And talk. Did we ever talk. Although both of us were, by nature, creatures of solitude—I often wonder whether carving attracts people of that inclination or whether the process makes us into that—we carried on an almost endless stream of conversation. It was during days like this that we discovered how similar our interests were and how we were equally confused by those endlessly perplexing conundrums that have troubled mankind since we first became sentient creatures. Gino was particularly intrigued by the closing questions raised by Carl Sandburg in his epic poem, *The People, Yes*—"Where to? What next?" Needless to say, we engaged in a considerable amount of stimulating speculation about our different responses.

I don't recall what we chatted about on that April Tuesday. But I do know that it had to be, as it almost always was, something out of the ordinary. As our comfort level grew over the years, we exchanged confidences: Gino spoke of catering to Kate's Irish temper and of his great respect for her business acumen, of his pride in son Tony's ability as an illustrator—"The book covers of his paperbacks bloody well glisten

35

with gore"—and of his own feelings of occasional discomfort about being an Italian Catholic "tradesman" doing commission work for the English Anglican aristocracy. In turn, I described, in what might have been painful detail for Gino, the sources of my evolving frustration with the teaching profession and the difficulty of reconciling my growing need for self-expression with the obligations of contemporary suburban Long Island life. I remember trying to sum it all up for him with a quotation from one of my favorite movies, *Zorba the Greek*: "Am I not a man. Is not a man stupid? I am a man. So I'm married—a wife, children, a house—the full catastrophe!" (In the interest of truthiness and a tranquil old age, I hasten to assure my lovingly tolerant family that for me, unlike Zorba, such feelings were only transitory.)

At four o'clock on the dot, Kate entered, stage right, with a tray containing the ubiquitous hot tea and more of those delicious biscuits. Work stopped, and the conversation became less confidential and more conventional. (Incidentally, I never reached the level of closeness with Kate that I did with Gino. I don't know whether it was a "man thing" or whether it was a matter of personality. Don't misunderstand me; Kate and I liked each other quite a lot but we never exchanged confidences or shared personal feelings in the way that Gino and I did.)

And then, back to work. An hour or two later, having finished our appointed tasks, we put down our tools in separate rows—all the handles facing the same way of course—and called it a day.

A couple of interesting asides: At the end of our first full-day session in 1976, Gino shook my hand as we parted at the door of the workshop; he continued that practice throughout all the days of my "apprenticeship." I suspect it was a show of comradeship and also his way of reassuring me that I had done a proper job. Further, he always stayed behind to clean up the day's debris. Although I repeatedly tried to sweep the floor, he steadfastly refused my attempts and made it clear that it was his workshop and, therefore, his responsibility to keep it clean. I wonder if he simply wanted to be alone—in his own place and, more important, reclaim his own personal space. But I leave it

up to you, dear reader, to make whatever you will of these concluding quirks—and to ponder well the ways of us walruses.

Baseball Bats and Carving Mallets

In 2009, when Rickey Henderson and Jim Rice were inducted into the Baseball Hall of Fame in Cooperstown, this wayward woodcarver was there.

The organizing committee had invited me to participate in the ceremonies, not because of my baseball abilities—I played left bench during two spectacular seasons in high school—but because of my carving activities. They asked me to talk to the wives of the Hall of Famers about the Empire State Carousel and how it came to be. But as I started to write down my recollections, I found myself straying onto a slightly different path. The more I thought about the dynamics of the day and what I might say, the more my mind was captivated by the discovery of an unanticipated relationship between baseball and carousels—and by the surprising similarity between woodcarvers and ballplayers.

Here is a condensed version of the speech I gave to those thirty-one women whose husbands are forever enshrined in Cooperstown as baseball's immortals.

While trying to explain the fascination and love we Americans have for this game of baseball, Ken Burns hit it right on the sweet spot when he asked us to remember the first organized baseball game we attended—and, more significantly, who brought us there.

Almost always, it was a father, an older brother, or a favorite uncle. And now years later, whenever we watch a baseball game, that delightful subconscious family memory is hard at work, enhancing our enjoyment of the moment. Best of all, it gives us another chance to be young again and to imagine ourselves as carefree kids.

I would suggest that it's exactly the same way for carousels. Do you remember your first ride? Where was it? Who brought you? Think about it for a moment. It was probably your father or your mother, a brother or a sister or a favorite uncle or aunt. Riding a carousel, like watching a baseball game, gives us all a chance to be young again.

But let's put the ballgame and the carousel aside for a moment and turn to the guys who bring both of them to life—the carvers and the players. And to me, no carver is more important than my mentor, Gino Masero, who wisely observed, "It's a grand job, isn't it? You get to do something you love, and they pay you lots of brass to do it. Gerry, we're lucky fellows, us carvers, aren't we?"

Hey, did you ever hear a better description of the game of baseball? Let me read those words again—with just a couple of changes. "It's a grand job, isn't it? You get to do something you love, and they pay you lots of bucks to do it. We're lucky fellows, us ballplayers, aren't we?"

And, by the way, I'm sure every one of your husbands can tell a similar story about some guy who inspired them, as Gino did me, and helped them to become a major league ballplayer. Maybe it's not as obvious as the Ripkins and the Griffeys, junior and senior, or the Berras, Yogi and Dale, but it's there—you bet it's there. We all are what we are because someone, real or imagined, gave us a model to build our lives upon. Perhaps Jackie Robinson, the Empire State's representative on the carousel, put it best when he said, "A life is not important except for the impact it has on other lives."

While I'm talking about carvers and players, what better connection is there than Armand LaMontagne, an ordinary baseball player but a very great woodcarver—arguably the best in America? He's the guy who used his extraordinary carving skills to bring Babe Ruth and

Ted Williams back to life so they could be forever enshrined in the entrance to the Hall of Fame.

As I look around, I see enough gray hair to assure me that many of you will remember Fiorello La Guardia. During a 1945 citywide newspaper strike, New York's irrepressible mayor presented a Sunday radio series on WNYC where, buoyed by his customary exuberance, he read the Sunday comics to the children of New York. On one of those Sunday mornings, upon reaching the end of the Dick Tracy detective strip, he posed a weighty philosophical question to his young audience: "Well kids, what does it all mean?" Once more, the question seems appropriate this morning.

My answer would be that Hall of Famers and the woodcarvers of the Empire State Carousel, even though we play an entirely different game, still have the same goal. We both have struggled to be our best at what we do and, not incidentally, to leave something of ourselves behind—a piece of our immortal soul, if you will. It is an attempt to say to future generations: "I was on the earth for a brief moment and this is what I did. I hope my presence here brought a little joy into the world and made it a tiny bit better for those who came after me."

And that, Mr. Mayor, is what I think it all means.

After the speech ended, we all got to be kids again and took a long ride on the carousel. Then we went to lunch (I sat with the lovely wife of the best-fielding third baseman in baseball history, Brooks Robinson). As a way of expressing their thanks, all of the wives autographed a baseball for me, which I plan to give to my only granddaughter—someday. (Julie will be here this week, and you can bet the damn kid will see it on display and ask, as she does every Thanksgiving, "Grandfather, when are you going to give me my baseball?")

Full Circle

There are many roads to immortality. An ancient Chinese philosopher once suggested three: have a child, plant a tree, write a book. I would like to offer a fourth possibility, one that I unexpectedly discovered on a Sunday morning when I walked through the northeast gate to London's Hyde Park.

We had arranged to meet the Maseros at the entrance to the park at about noon. Since this was our first meeting, we had to rely on a couple of small, indistinct internet photos to recognize each other.

As I stood by the gate peering expectantly at every entering face, a pleasant-looking young man carrying a little boy on his shoulders approached me.

"Are you Gerry?"

"Ah ha, then you must be Sonny?"

It took but a minute for Sonny and me to gather in our outlying families and go through the formality of attaching already-known names to unfamiliar faces. They were all there—Gino's three grandchildren—Sonny, Ricci, and Gina; Sonny's wife, Allison; and their two little boys, Sebastian and Luke Gino. I was accompanied by my daughter Susan; her fifteen-year-old son, Jonny; and my other daughter's sixteen-year-old son, Devan.

We were meeting in Hyde Park that lovely June morning because Ricci had discovered my book *Us Carvers* on the internet and wanted to buy three copies for his family. When I learned that he was Gino's grandson, I refused payment, insisting that he and his siblings accept the books as partial settlement of a long-overdue debt to his grandfather. Their response was immediate—a long phone call from Sonny, followed by a year's supply of my favorite English tea from Ricci (a lucky guess, he later suggested), and then a series of email exchanges—even a couple of old-fashioned letters—over the spring.

All three grandchildren made it clear that their childhood contact with their grandfather had been very limited. Teenagers when he died, they had heard that he was a highly respected member of the Master Carvers' Association but knew little of the scope of his sculptural work and nothing of the depth of his personal longings. They expressed appreciation for bringing those aspects of his life to their attention and, not surprisingly, even seemed to feel that they had inherited some of his character traits.

As Ricci wrote early on, "Reading about Gino . . . has opened up a door to my past that I thought had been closed forever. It has helped me understand so much more about myself, realizing that so many of what seemed to be my own intuitive feelings and thoughts—have come from my grandfather."

And then, a few months later, this amazing declaration from thirty-five-year-old Ricci:

"I've read the book again for the third time . . . Every time I read it I get more from it . . . it has changed my life . . . When I read your description of woodcarving as a craft that encourages 'tradition, creativity, independence and discipline' it seemed to ring true, an unambiguous message from across the pond . . . I feel I have so much passion inside of me, waiting to get out . . . So, I hope you'll be happy to hear that I've taken up carving, as you once did . . . first as a hobby and then one day when I'm ready, as a career."

My response was both cautionary and congratulatory. As grandfather Masero had once counseled me, I now found myself counseling grandson Masero: "The best gift of all is to hear that you may be following in your grandfather's footsteps—and that my book may have been the motivating factor. It is a hard road for those who enter it in later life as I did and as you propose. But the journey is well worth the effort and it is the journey as much as the destination that provides all those unanticipated rewards. My best wishes, of course, go with you and I will help in any way I can."

These exchanges, and all that they implied, encouraged me to put together an often-postponed trip with my own grandchildren. I did not want to be a vague, distant memory for them; I wanted them to know from personal experience that, while I sometimes appear to be a rip-snorting, fire-breathing curmudgeon, I am actually very much like they are, a complex creature occasionally restrained by regrets and fears but more often driven by hopes and dreams.

And that is why we all happened to be in Hyde Park on that early summer day. The Maseros took the Holzmans to lunch in a nearby hotel, where we spent a relaxed and delightful afternoon. The animated discussions—and cross conversations—flowed easily and ranged widely. In the course of the day's talk, I discovered that, except for a small carving of a horse that Gino had once made for Gina, nothing tangible remained to remind them of their grandfather.

That's when the spirit of Harry Willis became involved. Harry Willis had been Gino Masero's mentor and close friend, an old master carver who had guided Gino during the early stages of his career. Shortly after Harry died, his widow brought all his carving tools—each one inscribed with his initials—to Gino. She explained, "Harry's tools, in your hands, can continue to make beautiful things."

Years later, when I was training with Gino and having some difficulty cutting the bevels in a human figure's hair, he dug a tiny spoon chisel from the depths of his tool chest and told me to try using it. It worked perfectly. "Keep it," he said with an enigmatic smile. "It's a

gift from an old friend of mine." As I turned the worn, sweat-stained handle, I noticed the incised initials: HW. Since that memorable day in the Sussex workshop, I have used Harry Willis's tool many times to "add a little interest" (Gino's favorite instructional advice) to my carving work. It has proved to be an exceedingly practical gift.

Shortly after I returned home to America, I dug into the depths of my tool chest, found Harry's tiny spoon chisel, and mailed it off to Ricci Masero.

Because it is his time now.

But, all too soon, it will be my time—my time to sit back and wait for Ricci "to continue to make beautiful things." And, while I'm waiting, I'll be hearing an old, familiar voice reminding me that "we're lucky fellows, us carvers, aren't we?"

An Eight-Year-Old Kibitzer

Although the Empire State Carousel's Freddie is a bit of a dandy, he certainly is a well-educated dandy, as the presence of all his books attest. Featured behind the saddle is his major work, A Gourmet's Guide Entomology, *which is rumored to have inspired both Martha Stewart and Gordon Ramsay to embark on their culinary careers. Here, I present a brief encounter during which Freddie taught a couple of Long Islanders a valuable lesson about priorities.*

O n a sunny Saturday morning in April, my neighbor Carlo Lanza came to visit me at my home workshop. Carlo is a married man now and the father of two fine boys, but, at the time of this visit, he was only eight. And like most eight-year-olds, he was very, very curious.

My home workshop at that time had a large window that faced the street, and I did most of my carving by it, because of the excellent light that it provided. That morning, I was putting the finishing touches on a five-foot-long carousel figure of Freddie de Frogge and was completely engrossed in the task of carving the title on a book that formed his saddle. However, as I reached the *m* in *entomology*, I sensed a human presence.

Looking up, I saw Carlo on the other side of the low window. He was as absorbed in watching me carve as I was absorbed in doing the

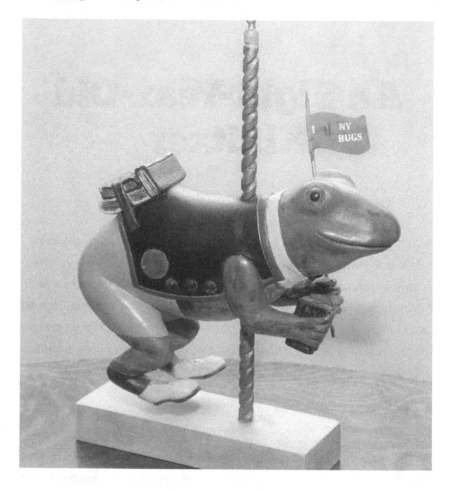

actual carving. Carlo smiled his innocent eight-year-old smile. "Hi, Mr. Holzman. What'cha doin'?"

It was a Dennis the Menace moment, and I was Mr. Wilson. But, like any good neighbor should do on a warm spring morning, I stopped work and chatted a bit about carving, about Freddie, and about life in the neighborhood. After a few minutes of this, it became apparent that Carlo had nothing else scheduled and that he intended to spend the rest of the morning watching me carve and asking me questions.

He tried to read the book title but couldn't quite get his tongue around it, so he asked me if that was a real word or just a made-up one.

I sensed an opportunity to do a little teaching and, more important, a way to get rid of my Dennis so I could get back to work. I printed the word—*entomology*—on a piece of scrap paper and told him to go home and look it up in a dictionary. He eagerly grabbed the paper and ran down the street toward his house half a block away. As I resumed my carving, I smiled and complimented myself on how quickly and cleverly I had gotten rid of him.

"Insects and bugs, that's what en-to-mol-ogy means, Mr. Holzman. Why did you carve a book about bugs? Huh, Mr. Holzman?"

That little son-of-a-bitch was back. It had only taken him ten minutes—and that probably included time for a quick pee and a couple of Oreos. I had been had by an eight-year-old.

So, like good neighbors always must, I spent the better part of that sunny spring morning chatting about frogs and bugs and making up silly jokes about woodcarving with Carlo. To commemorate our new-found comradeship, I had him carve some small slivers off the cover of one of Freddie's books and promised him a free ride on Freddie when the carousel was finished.

As another Freddie liked to say, "It was a beautiful day in the neighborhood."

The Boundaries of Bargaining

Because of the give-and-take that is so much a part of the professional artisan's world in modern America, negotiating over proposals and commissions is frequently necessary. However, I have long felt that this bargaining process should take place in an arena governed by mutual trust and a shared sense of fairness.

I learned a valuable lesson about the boundaries of bargaining from a proud woodcarver in India.

The year was 1968, when I was still working as a full-time teacher and was traveling on a US State Department summer grant designed to improve the teaching of Asian cultures in our public schools. I encountered the Indian woodcarver on a mist-shrouded street corner in Dehra Dun, a hill station near the base of the Himalayas. He had set up an informal stand where he displayed about a dozen well-crafted walking sticks. I pointed to one of the best and asked the price. He told me that the stick would cost fifteen rupees (about $2.10). Having been forewarned by an old India hand about the folly of paying any initial asking price no matter how small, I quickly countered with an offer of twelve rupees. The carver, after a moment of silent appraisal, without any sign of rancor or antagonism, offered this simple statement of fact: "I am an artist, sahib; I do not bargain."

I looked him full in the face and, impressed by what I saw there and embarrassed by my own pettiness, picked up the stick, placed fifteen rupees in the artist's hand, and wordlessly walked away.

Forty-five years later, I still treasure his carved walking stick, both for its beauty and for its message—a message that I shall never forget. But it is a message that, over the years, I have had to constantly reaffirm to myself—and to others.

I once was asked to restore an antique carousel horse for a prominent neurologist who prided himself on his extensive collection of valuable art and antiques. He had given me the work because of my reputation and because one of my close relatives was a friend of his. In short, although we were on a first name basis, we were not what might be called "good buddies." As I was examining the horse and taking extensive notes on its condition, the doctor walked over and, with a smile that wasn't really a smile, said: "Gerry, you know we want a good job— that's why we asked you to come over—but we don't want you to go crazy. So, before you come up with a final figure, sharpen your pencil and try to be reasonable."

I sharpened my pencil—and mentally raised my estimate by 20 percent. That seemed reasonable to me, because my initial reaction to his not-so-subtle bargaining was to double the price. Since I was one of the few competent restorers in the region, he had little choice and, rather reluctantly, gave me the job.

I wonder what would happen if one of the good doctor's patients who was in need of brain surgery were to say, "Doctor T., you know we want a good job—that's why we asked you to examine me—but we don't want you to go crazy. So, before you come up with a final figure, and before you sharpen your scalpel, sharpen your pencil and try to be reasonable." Not really the same, you say. Well, I say that the doc and I

are both artists who just happen to be working in different mediums. And, as my Indian friend would proudly remind us, whether working in wood or in brains, artists don't bargain.

A Perfect Bargain

When I arrived home from work late one winter afternoon, Arlene met me at the door with a mischievous grin. "We have an unusual visitor. He's been waiting for you for nearly an hour in the playroom." Having spent half the previous night at the veterinary hospital where I had to make the heart-wrenching decision to "put down" my canine buddy of fourteen devoted years, I was in no mood for surprises. But it seemed that I had no alternative, so I reluctantly followed her into the playroom to meet Casey Capuano.

There I found him, comfortably sprawled in my antique barber chair, which he had commandeered as his base for inspecting my roomful of carousel art. Dr. Capuano was a large, middle-aged man, a dentist by profession and a craftsman by choice, who welcomed me warmly (into my own home) and apologized profusely for his intrusion. Through the carousel grapevine, he politely explained, he had heard that I might have a basket case (a badly beat-up horse in need of repair) that he could buy and restore.

I did have one, but I was planning to restore it myself. Unlike charming Celeste (see the chapter "It Ain't Over till It's Over"), this old nag was no symphony in shimmering silver—he was more like a cacophony in crumbled charcoal. Although both horses had been carved by Charles Looff, a Danish American woodcarver, there was a significant difference between them.

Celeste had been carved in the late 1880s, a time when Looff had learned to understand the value of accurate anatomy and to appreciate the beauty of curved lines. This old nag was a product of his early years;

it was stiff and awkward, its trappings were like railroad tracks, and its mane was flat and stringy. Further, one of its legs was missing and would have to be carved from scratch. However, when properly restored, the horse would become an excellent example of the American primitive style as it existed before the flamboyant Coney Island carvers worked their magic on the world of the carousel. And, as such, I wanted to be the one who properly restored it. In short, I didn't want to sell it. But I hadn't reckoned with the persuasive powers of Dr. Casey Capuano.

When I admitted to having a basket case in my workshop, the mighty Casey cajoled, he coaxed, he charmed—he even whined a bit— and succeeded in wheedling his way into my shop to see the old nag. When I pulled it down from the storage rack, his eyes sparkled as if he had just seen a tooth that needed a $2,000 root canal job. He wanted that horse; you might even say he lusted for that horse.

But—I still didn't want to sell it. An old carousel-trading buddy had once told me how to deal with situations like this: Quote a very high price; if the client accepts it, he's happy because he's got his horse and you're happy because you made a lot of money. Remember, he explained, it is a business, and they're only pieces of wood. (Knowing his love for carousel art, I don't think he really meant the part about pieces of wood, but, all in all, it was good negotiating advice.)

So, I did just that. The high price only momentarily cooled Casey's ardor. After a brief pause, he came back with a very reasonable coun- teroffer. When I refused it and held to my original price, he kept raising his offer until he got within a couple hundred dollars of the asking price. His willingness to bargain responsibly compared with my arro- gant stubbornness made me feel like a real bastard. That, coupled with the residual emotional distress over my dog's death, led me to empa- thize with him and reluctantly, very reluctantly, to sell him the horse.

Even as we were loading it into his SUV, I was mentally kicking myself for not setting a higher price and, worse yet, for being foolish enough to even let this demented dentist inside my shop. Matters were made even worse when, a few weeks later, I ran across a set of auction

results featuring an identical horse in a similarly battered condition that had sold for nearly five hundred dollars more than the price I had charged Casey.

About a year after our encounter, Casey, as promised, sent me some pictures of the restored horse. Even though I was pleased to see that he had made a decent job of it, I couldn't help feeling that he had bullied me into selling him that horse. Just a few months after I received the photos, I ran into a carousel friend who had met Casey at an antique show and had been invited to his home to see the restored horse.

"For a first-time restorer, he did an outstanding job. There must be a connection between rebuilding teeth and restoring horses. He painted it in original colors and put it on a high display platform that gives it a lot of presence. All in all, it's very impressive and he's very proud of his work. But, is he ever pissed at you! He thinks you took advantage of his hunger for a basket case and his ignorance of the carousel market to overcharge him—badly overcharge him, he says. Gerry, don't ever give that guy a chance to work on your teeth."

It was a perfect bargain.

A Valuable Volkswagen

For another perspective, let us look at the curious case of Mr. Hockmeister.
He didn't bargain with me; he made me bargain with myself.

Mr. Hockmeister drove up to my home late one fall afternoon
in an old, battered Volkswagen and brought two newly made
eighteen-inch-square mahogany pedestal tops to my workshop door.
He was building a dining room table, he explained, and he wanted a
design carved on the pedestals that would be visible through the glass
tabletop that he was going to place on them.

He reached into the pocket of his shabby jacket—just the kind
you'd expect the owner of an old, battered Volkswagen to wear—and
handed me an intricate drawing of a traditional floral design element
that, by chance, was quite similar to one I had done a few years earlier
for another client. After searching through my files, I found the origi-
nal commission sheet and saw that my fee had been $300. But that was
for only one carved floral element; this job would require four of these
designs, bringing the total cost to $1,200.

It was clearly too much to charge someone like Mr. Hockmeister.
I knew I had to lower the price. Besides, I further rationalized, he was
a fellow craftsman, and carving the designs would be an enjoyable
and challenging exercise. So this time, without being asked, I willingly

"sharpened my pencil" and set a price of $800, an amount which he immediately accepted. Mr. Hockmeister left the pedestals on my bench, put a 50-percent deposit in my hand, and cheerfully drove off in his battered Volkswagen.

The carving went well, and a few weeks later, I called to let him know that the pedestals were done. He told me that I had caught him at just the right moment; he was going into Manhattan that very afternoon and was taking a route that would bring him within a couple of miles of my home, so he could easily pick up the carvings on his way.

A couple of hours later, a lustrous black Mercedes pulled into my driveway, and out stepped an equally lustrous Mr. Hockmeister. He looked as if he was on his way to a photo shoot for *Gentleman's Quarterly*: black double-breasted cashmere blazer, blue oxford shirt, repp tie, tan slacks, and tasseled loafers—the full centerfold.

He was delighted with the carved pedestals and carefully placed them on an immaculate quilt in the immaculate trunk of his immaculate Mercedes. When Mr. Hockmeister handed me a check for the $400 balance (which I put into the pocket of my shabby jacket), he told me that the carpenter who had made the pedestals would certainly be pleased to see how well they had turned out.

That night I threw out my pencil sharpener.

Passing It On

I got my inspiration for this essay from an intriguing English movie titled The History Boys. *It relates the story of a talented group of English middle-class students who are being prepared for entrance exams to Cambridge. Toward the end of the film, one of their teachers reveals the source of his deeply felt desire to help these youngsters become all that they are capable of being: "Those of us who think we have acquired a good sense of what life is really about have a special obligation; we have to pass it on." And "pass it on" is exactly what I've done with my infatuation with the world of woodcarving. For more than forty years, I've passed it on to kids as young as eight and to seniors old enough to be my father. In fact, one of them was my father.*

I pass it on not simply because of my strong personal commitment but also as a tribute to the memory of my mentor, Gino Masero. Gino and I spoke of many things during the days when we shared a workbench. Perhaps his most memorable words were these: "We use our hands to make the wood say something, for now and for later. Never forget it Gerry: communicating, that's what us woodcarvers are about."

So that is why I offer a brief tale about the great pleasure that can come to those of us who communicate through our unusual medium.

The Cleaning Lady Is a Woodcarver

Each summer for six years during the 1990s, I taught a carving course at the Herschell Carrousel Museum in upstate New

York. This unique institution was established in the original North Tonawanda factory where Allan Herschell once built thousands of inexpensive carousels.

In the second season of carving classes, one of my best students was a tiny blond woman in her early thirties who made her living as a cleaning lady in a prosperous Pennsylvania suburb. She had done a little carving with power grinders and X-ACTOs but had never used actual woodcarving tools before taking my course. Because Nancy was highly motivated and had a natural eye for form and line, she made rapid advances, advances that were almost measurable on a daily basis. At the end of the two-week course, the two-foot-long carousel horse that she created was easily the best of a good bunch.

When she returned to Pennsylvania, she sent me an occasional note about her activities and would usually enclose a photograph or two of her most recent carving projects. I was always pleased to hear from her and delighted to see the continual improvement in her skill. One Friday afternoon, about three years after her course had ended, Nancy phoned me. Her voice bubbling with excitement, she told me that she wanted me to be the first to know that her life had just undergone a dramatic change.

"I finished cleaning my last house at eleven-thirty this morning! No more vacuuming and mopping for other people, ever again. I'm selling enough carvings and doing enough private lessons to make a living as a carver. It's not a great living, but it pays as good as house cleaning and it's much better work. I just wanted you to know that you and your course gave me the courage I needed to make the break."

And maybe, just maybe, plucky ladies like Nancy are why we pass it on.

The Woodcarver Who Couldn't Carve Wood

Here's an incident where I did a very bad thing in order to produce an uncertain good ending. You decide whether this caring carver cared too much.

I once prided myself on being able to work with just about anybody who aspired to be a woodcarver—from psychopaths to psychologists, from kindergarteners to senior citizens, and from rank beginner to advanced sculptor—and to be able to offer them something of value that they did not have before they met me. A brash and immodest statement, you might say, but I wholeheartedly believed it—that is, until I met Tom Gunderman.

He was the worst woodcarving student I ever saw. Hopefully, I'll never see his like again. Tom Gunderman was a gray-haired, taciturn, middle-aged man who wore gray clothing and spoke in gray sentences. A dark-gray cloud hovered over his head while he worked, lightening up only for a moment while he ate his customary lunch of an American cheese sandwich on white bread—with mayonnaise.

In the one week he spent with me at my caricature-carving course in the Farmers' Museum, I don't recall him ever interacting with the

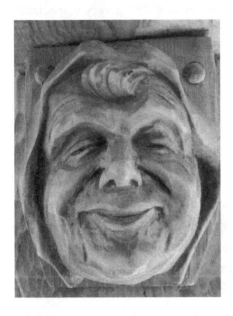

other students or even smiling at their continual attempts to brighten the day with humorous comments. He was a man who seemed to live entirely within himself. Yet it was quite obvious to me that he wanted to succeed at this new thing he had undertaken. From among the tools sets I had recommended, he had bought the most expensive one and, given his limited range of emotions, seemed eager to learn to use it properly.

But he couldn't. No matter how hard he tried and no matter how much time I spent with him—there were only seven other students, most of whom caught on rather quickly and required little one-on-one instruction—he couldn't seem to make progress. I would use my old trick of carving on one side of the face and having the student replicate it on the other. It had worked well with countless students, but when I would return to Tom's carving, not only had he failed to copy it accurately, he had fooled around with my example and made it practically unrecognizable. I began to suspect that he lacked a normally developed visual intelligence and could not mentally process the shapes and lines I was creating for him to copy.

This back-and-forth went on for four days. The other students were making genuine progress, exchanging tips, and comparing their work. It had all the makings of a very successful class, except for Tom. He did not participate in the exchanges; he worked alone and doggedly chewed away at his woodcarving. He didn't show any frustration with his lack of progress, nor did he seem to express any resentment when

he stole furtive glances at the other carvings. The fact that nothing I could do seemed to help Tom troubled me greatly. The seven other students would all be going home on Friday with a very respectable piece of facial caricature; Tom would be going home with a blob.

When the daily class ended Thursday afternoon, that's when I did the bad thing. After they had all gone, I went over to Tom's carving, reshaped the basic face, restored the eye cavities that he had obliterated, remodeled the jowls and chin, and added broad lines around the mouth. I was careful not to do too much—I didn't want the other students to notice and I was counting on Tom's lack of visual perception to help—but I did do just enough to permit Tom to produce a recognizable human face to take home.

It didn't work. Friday morning, Tom, who seemed not to notice the changes, started carving with his normal determination and, as normal, began muddying up the carving. I kept intervening to protect my changes and preserve the face, but he seemed unconsciously determined to prevent me.

And then a bit of good luck came. Late in the morning, Tom grimaced a bit and quietly said to me: "I've got a stomach cramp. I think I have to take a bathroom break." I barely waited until the classroom door closed before I jumped on his carving. The other students must have thought I was crazy as I worked frantically on Tom's face. Three or four of them stopped to watch the devil do his dirty deed. I broke out in a sweat while my hands raced around the face as if they were guided by a mystical source. I just had to put it right before he returned. And I did. Now, all I had to do was keep Tom's hands off it as much as possible.

It was when he returned from his break about ten minutes later that I had my inspiration. "Since this is the last day and you've all done so well, would you guys mind if we cut the class early today? We can take our lunch break now, then work until two o'clock and call it a week." And that's just what we did. I spent much of that afternoon work hour with Tom, who again seemed not to notice my changes, and I was successful in preventing him from doing any further damage.

So it was that all eight of my students went home with a credible piece of woodcarving and my class at the Farmers' Museum came to a happy end. Yet, to this very day, whenever I see someone eating an American cheese sandwich on white bread, I think of the grim, gray Tom Gunderman and fervently pray for two things: the first, that he remain satisfied with the carving he took home and not tamper with it; and the second, that he never again darken the doorway of my wood-carving classroom.

The Ballad of the Bread-Knife

Jack Pelletier wasn't deaf. He was, as are most men in their late sixties, a little hard of hearing. I guess that's why he jumped up on the big workbench and began—But, hold on, I'm getting ahead of myself. So, let's start again.

Shortly after my carving class at the North Tonawanda carousel museum had begun, Jack had taken me aside to tell me about his hearing problem. He asked me to look directly at him when I was explaining things because it would make lipreading easier. "Sometimes I pretend that I understand the words and fake it, you know, like smile and nod my head. But this class is important to me, and I want to learn as much as I can."

He was an apt pupil, affable and bright, yet sometimes almost childlike in his enthusiasm for his newfound hobby. As much as he wanted to be recognized as a competent woodcarver by me and his nine middle-aged classmates, he couldn't repress his inclination to tell an inappropriate joke, make an occasional off-color remark, or otherwise draw attention to himself. In short, he wanted us to all know that good old Jack was in the room.

The Jumping Jack thing occurred toward the end of a two-week course. I conducted seven-hour sessions every day during which each participant was given personal instruction in carving his own small carousel horse. Since I feel that an informal classroom environment eases the inevitable tension that comes from learning a new skill in

front of other people, I had encouraged this diverse group of carvers to interact by chatting freely about their backgrounds and by helping each other out. Harry was a dentist from Ohio who made boomerangs. (As a farewell gift, he gave me one that all the students had signed. Try as I might, I never could make that damn thing come back to me.) Steve owned a cesspool-pumping service on Long Island and had started his carving career by making walking sticks. Jumping Jack, who hailed from Vermont's Northeast Kingdom, told us that he passed the long winter evenings by carving duck decoys, drinking more than he should—and memorizing poetry.

It was lunchtime in the workshop, a valued hour of relaxation for the students who were usually a bit stressed by the intense concentration required by the long morning's work. We had, as usual, ordered an assortment of sandwiches, subs, and salads from the nearby deli, and I was in the process of distributing them. "We've got a meatball here, a ham sandwich, and here's a salad. Who ordered the salad?"

That's when Jack jumped up on the big workbench and shouted out: "Hey Gerry, did you say you want to hear a ballad? I've got a great ballad for you." And with that, he began to recite:

> A little child was sitting on her mother's knee
> And down her cheeks the bitter tears did flow.
> And as I sadly listened I heard this tender plea,
> 'Twas uttered in a voice so soft and low.
>
> "Please Mother don't stab Father with
> the BREAD-KNIFE,
> Remember 'twas a gift when you were wed.
> But if you must stab Father with the BREAD-KNIFE,
> Please Mother, use another for the BREAD."

When he finished, like the polished performer he was, Jack paused for the applause. His colleagues, who had sat in stunned silence during his impromptu recitation, slowly stood up and clapped softly. But Jack,

obviously well pleased with his performance and oblivious to their discomfort, picked his ham sandwich out of the deli box and sat down next to Steve, the cesspool guy, who had ordered the salad that was the cause of all the ruckus.

I swear it happened just like that—at the Allan Herschell Carrousel Museum in North Tonawanda, New York, on a hot June day in 1989. Well, maybe I might have gotten the sandwich stuff a bit confused, but the rest is true, all true. As Casey Stengel used to say, you could look it up.

The World According to Joe Romano

During my years as a classroom teacher, I sometimes used my woodcarving activities as a motivational device. Here, in the recreated words of an actual student (name changed), is a whale of a tale with some completely unanticipated outcomes.

I was one of Mr. Holzman's students at Herricks High School. Him and Mrs. Thompson, they taught me in something they called a humanities course—English and history, with a little art thrown in. And we all got on pretty good. Not in the beginning though. I guess that's because we were some real bad-asses. They kept us away from the other kids by putting us in one room for three hours with the two teachers—and then we went home. There were twelve of us—seven guys and five girls. We had all failed just about everything the year before. And we came from screwed-up families. Most of us were doing drugs and all the boys had gotten in fights with teachers. Me included—but I didn't just punch a teacher, I cold-cocked a principal!

Anyhow, they told us that the reason they put us together in one room is because we all had real high IQs and that we should be able to graduate if we really tried. And they told us that this was going to be our last chance. If we didn't pass this humanities class, then they

would make us leave school. So most of us guys worked real hard and everybody graduated except Donny, who was an asshole. One day he even insulted Mrs. Thompson. And she was a real nice lady. So, after class, I told him I would beat the shit out of him if he didn't apologize to her. I'm a big guy and I punch hard and he knew it. So he went up to her desk the next day and said he was sorry. But he wasn't.

Mr. Holzman, he brought in some of his carvings one day and told us about them. I was so wound up when he finished showing them that I shouted out: "Hey, I finally got a teacher who can do something." So he offered to teach us how to carve and all of the guys and three of the girls wanted to. He got everybody a set of those X-ACTO knives and we went to work.

I carved a whale that came out so good that I wanted to give it to Mrs. Thompson for Christmas. I asked Mr. Holzman if it would be all right. He looked at me and then at my whale and then he got tears in his eyes and sort of choked up and said yes, it would be a very good idea. So I brought it up to her desk and told her it was a present for helping me so much. She got all teary too. Some teachers are real crybabies.

Anyhow, like I said, we graduated and I went to work for my uncle. After a while, he helped me start my own business—the Awesome Trucking Company. And I did real good—I owned seven trucks. And, when I remembered some of those pictures Mr. Holzman had shown us during art class, I had them all painted real nice with stuff like flames and skulls. They were beautiful things. And I made a lot of money with those trucks.

I even got married and had a kid. That's how I saw Mr. Holzman again. It was about fifteen years after I graduated. He was running a fundraiser fair for his carousel called Pennies for Percy, and he was asking people to donate pennies. I had a mess of them, so I took my little girl and my pennies and went to see him. I walked toward him and said, "Remember me?" He hesitated for a minute like he was fishing for a name. Then, with a big smile, he shouted out, "Joe? Joe Romano!"

I dropped my bag of pennies and gave him a big hug—so he couldn't see that I was crying. It's nice when someone you like remembers you. We talked about old times, and I offered to help him with his project if he ever needed some trucking done. And a few months later, he did, and I sent a truck and a driver over to help him out. Then I moved to Florida—I do some business in South America now—and lost contact with him.

When I came back to visit Long Island a few years later, I read an article that said he had finished the carousel so I called him up and asked when it was open. He told me that it was temporarily closed but he would open it just for me and my wife so we could get a ride. And he did. That carousel and that ride, they were beautiful.

Like I said before, I finally got me a teacher who could do something.

Diogenes Does Brooklyn

In mid-May of 1951, the price of Good Humor ice cream bars went from 11 cents to 12 cents. This tiny bit of economic trivia lies at the root of my tale about late-life redemption.

I was a Good Humor man that spring. Or, more accurately, a Good Humor boy because, in those days one could not drive a truck or even ride a bicycle cart until he reached the age of eighteen, and I was only seventeen. So I was given a yellow pushcart instead of a white bicycle rig and assigned to a park in the Bay Ridge section of Brooklyn, a location that required a daily schlepp of two miles—each way. (I was a night school student at Brooklyn College and desperately needed temporary day work to support myself.)

Most of my regular customers were young kids with whom I had a comfortable relationship. However, on the devastating day of the price increase, things got a bit unpleasant. Many of them had come to the park with only 11 cents and hard-hearted Holzman sent them away without their ice cream fix. (After all, I only got 2 cents commission per bar.) But, after a steady stream of pitiful pleas of "Mister, trust me for a penny," I relented and gave a temporary credit line to some of my regulars. I'm pleased to say that most of them brought that extra penny on the next visit, but, true to human nature, at least half a dozen of them stiffed me.

Now, lets move ahead exactly fifty years. In the spring of 2001, when making appearances as an occasional lecturer for the New York State

Council for the Humanities, I had been invited to address a meeting of the Bay Ridge Historical Society. I prefaced my talk on the history of American carousels by telling the audience of about one hundred and fifty Brooklynites about my childhood Good Humor experiences in Bay Ridge and lightheartedly challenged any deadbeats who were in the audience to make good on the pennies they owed me.

The talk went quite well, the Q&A was unusually lively and, all in all, it was a delightful evening. As I began packing up my slides, a well-dressed guy about my age, walked up to me with a smile on his face and a five-dollar bill in his hand.

"This should cover what I owe you. The way I figure it, what with fifty years interest, inflation, and the overall increase in the cost of living, five bucks is a fair settlement. And by the way, it was a chocolate nut bar."

I tried to refuse the money, but he was absolutely insistent, saying, "I'd be lying if I told you that I've had sleepless nights over that penny, but it has come to mind every now and then. This is the last thing I expected to happen tonight, but I'm really glad it did."

We had a nice chat. He was a Brooklyn College grad, a member of the historical society, a life-long resident of Bay Ridge—he lived two blocks from his childhood home—and a longtime carousel buff who had frequently taken his children and grandchildren to ride the nearby Prospect Park carousel. We exchanged contact information and promised to keep in touch but, we didn't.

I wish we had.

Bobby or Bullshitter?

For a number of years, I did occasional gigs for the Cunard Cruise Line as an artist-in-residence on their long-distance cruises. Our favorite voyages (my wife always accompanied me—I guess she didn't trust me alone with all those voluptuous South Seas maidens) were those that sailed through the South Pacific. In exchange for free first-class accommodations, I would present illustrated folk-art lectures in the theater and conduct periodic carving demonstrations on an outdoor deck. Sounds like a crime-free environment? In fact, on these seemingly bucolic voyages, villains peered through every porthole and malefactors stalked every gangway.

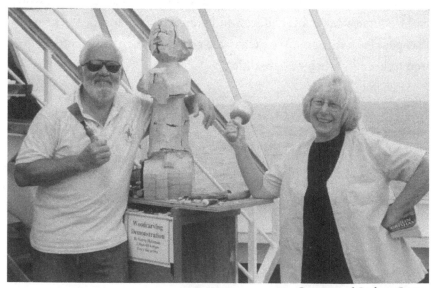

Courtesy of Graham Lowe

On our first voyage, in 1988, we were forced to wait on the Los Angeles dock for nearly three hours while a small army of uniformed and plain-clothes officials swarmed over the QE2. Finally, some sort of all-clear was quietly given, and we were allowed to go aboard. No explanation was offered for the delay, and we didn't learn the reason until a month later when the ship reached Australia. By then, we had become quite friendly with the steward who worked on the deck where I had set up my carving bench. He was a very personable chap in his early thirties, well-spoken, and quite sophisticated. Although Donald seemed overqualified for his position, he performed his menial duties cheerfully and efficiently. Arlene and I often wondered why a guy like this would take a job like that. Anyhow, we greatly enjoyed each other's company and agreed to meet for dinner in Sydney's Chinatown during the ship's two-day layover (such fraternization between guests and serving staff was forbidden on board the QE2). It was there, over a delicious dim sum platter and a well-chilled Australian chardonnay, that Donald solved our perplexing double mystery with a single simple explanation.

He was an undercover operative for Scotland Yard who was investigating two serious but unrelated problems on the ship: drug smuggling and institutionalized theft. What we had seen in Los Angeles was the result of his first investigation. He had discovered several hundred pounds of marijuana hidden in various parts of the ship and had identified two of the smugglers. He had surreptitiously passed this information to American authorities without revealing his own identity to the QE2 security people because he felt to do so would jeopardize his ongoing second investigation, the nature of which he could not reveal to us.

Buttressed by the wine and the camaraderie born of a month at sea, we were enthralled by both the teller and by his tale. However, toward the end of the dinner a couple of remarks that Donald made caused the little man who lives in my stomach to give me such a hard kick that I decided that Arlene and I would do well to re-examine the events of

the evening. One of the reasons I married my woman is that she came fully equipped with a built-in bullshit detector, a device that, over the years, has saved us from the clutches of many a scoundrel. When we returned to our cabin, we ran Donald's data through her analytical machinery but, unfortunately, couldn't get any sort of useful reading.

The next night, we sat in a dockside Italian restaurant and watched the QE2, her hull and masts outlined by a sparkling string of lights, sail out of Sydney harbor with Donald back on board, presumably well positioned to continue his investigation into institutionalized theft. It would be another year before we would have another chance to decide if he was really a bobby or simply a bullshiter.

Shortly after we returned to the States, I was invited to Cunard's New York City office to meet with the executive in charge of ship management, a very British chap we'll call Mr. Chipping-Camden. He was interested in having me carve a life-size full-round version of the Cunard-logo lion that would be used to decorate one of the restaurants on the QE2. At my suggestion, we decided it would be best for both of us if they would commission me to carve a one-foot basswood model before we embarked on such a major undertaking. Mr. Chipping-Camden and I drew up an informal written agreement confirming the price, and I departed promising to return in three months with the model.

And return I did. Mr. Chipping-Camden was clearly delighted with the model and promptly handed me a check for the agreed-upon price. He said he would be in touch with me within a few weeks to finalize the arrangements for the full-size piece. After some talk about the amount of time it would take—I estimated about a year—he said he would have a couple of his decorators at the next meeting to discuss details like color, finishes, and textures.

I never saw Mr. Chipping-Camden again. After waiting over a month for the promised next meeting, I called the Cunard office and was told that he no longer worked there. Over the next few months I made a number of attempts to follow up on the carving commission

but every attempt met a dead end. Evidentially, the lion carving was Mr. Chipping-Camden's personal project, and he had gone off to a lion den somewhere in the wilds of Africa—and taken my commission with him.

But I did see Donald again. The following year, I had occasion to go to London and, more out of curiosity than friendship, I contacted him. Yes, he was still working with Scotland Yard but only as a part-time consultant because he had opened his own private security business. Arlene and I met him and his fiancée at a grand old pub in the heart of Kensington, where he, once again, explained everything over dinner. It seems that Mr. Chipping-Camden was running a very lucrative fiddle through his position at Cunard. He had worked out an arrangement with various ship suppliers around the world that involved overbilling and underdelivering. The details were complicated, Donald said, but the takings were considerable. When Donald presented the results of his investigation to the Yard and to Cunard, some sort of deal was cut between all the parties, and, to avoid unwelcome publicity, Mr. Chipping-Camden was allowed to disappear quietly into the night. As Donald was explaining all this at dinner, his mobile phone, which he had placed on the table at the beginning of the evening, began to ring (this was before the advent of miniature cell phones, so his was a pretty hefty piece of machinery). He picked it up, listened closely for a minute or so, made some cryptic remarks and hung up. "I've got some people doing security for an Arabian prince, and they tell me he just received a death threat. I'm afraid we're going to have to cut the dinner short and leave. I'll contact you tomorrow."

Not only did they leave the pub, but they left me with the check. I never heard from Donald or saw him again.

Bobby or bullshiter?

It's your call.

How the Devil Do You Carve a Ship's Figurehead?

Well, the first thing any sensible carver of ship's figureheads would do is to find himself a proper ship. Never one to do things in a small way, the ship I found for my carving caper was the star of Cunard's fleet, the celebrated QE2. It turned out to be a felicitous choice both for me and the Queen's Australia-bound passengers, many of whom dallied daily to watch as I joyfully—and loquaciously—struggled to transform a three-foot-high block of basswood into a curvaceous windswept maiden.

This exercise in chiseling and gouging took place on the Los Angeles-to-Sydney segment of the QE 2's 2002 world cruise. During this twenty-three-day journey, every afternoon that the ship was at sea, I would set up a portable workbench on an outside deck and carve on my ship's figurehead for about three hours. As I worked, I littered the floor with woodchips and filled the air with a running commentary on the art of woodcarving, the peculiarities of human anatomy and the vitality of American folk art. However, I must admit, there were moments when I succumbed to the intoxication generated by an appreciative audience and found myself making uncommonly witty remarks about shipboard life and offering extraordinarily sagacious observations on the nature of the human condition.

My audience was a diverse and dynamic one. On any given day, it would number about seventy-five curious observers who were constantly coming and going. Some would stay for just a few minutes, others would linger for a half hour or so while a few fascinated folks pulled up chairs and stayed for a couple of hours each day. This latter bunch, numbering about a dozen strong, became my carving groupies.

And what an incongruous group of groupies they were—a former professor of social work from England who made a video documenting the carving's evolution, a naturalized American businessman who had trained as a carpenter in Holland just after World War II, a rather plump middle-aged American woman who frequently flirted with me, a former BBC executive from Yorkshire who had recently undertaken a second career as a furniture restorer, the CEO of an electronics company from Alabama who collected carousel horses, a dentist from Nebraska who was fascinated by the carving tools, and, the most conscientious member of the group, a middle-aged Frenchman who studied my every move: "I learn by watching, I will carve one of these when I get home."

The informality of the carving sessions encouraged a delightful sense of camaraderie among these regulars. They felt free to analyze and criticize my work, my work habits, and even the astuteness of my wise and witty observations. To soften these blows to my ego, on a number of occasions a deck steward appeared with a cold beer courtesy of one of these self-appointed critics. Nor did they limit their reproach to me. One hot afternoon, I was carving with my back to the audience when a slight, elderly woman who usually sat quietly through the boisterous sessions, tapped me on the shoulder and, with a wicked twinkle in her eye, whispered, "John has fallen asleep." Since she clearly expected me to do something, I stopped carving, walked to the seat where John, who happened to be my most vocal critic, was indeed sound asleep. To the great glee of the other groupies, I loudly ordered him to wake up and, as he shook himself out of his stupor, threatened to send him to the captain if he ever dared fall asleep again. John reacted to his

scolding with great good humor. For the remainder of the voyage, he continued to be my most vocal critic, but he never fell asleep again.

A number of crew members were also frequent visitors: an Indonesian sous-chef who did the ship's ice and vegetable carvings (it was with great pride that he told me about the woodcarving traditions of Bali); the QE2's captain, who cheerfully ordered me to work faster so he could see the finished figurehead before I disembarked in Sydney (he brought his wife to the last session so she could meet me); and, the best of the lot, the assistant cruise director, who came the first day to

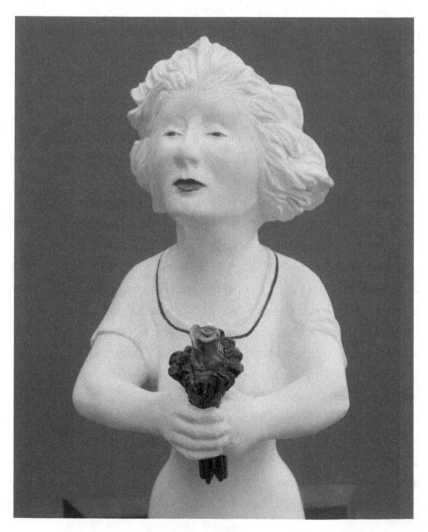

evaluate my presentation and was so taken with the goings-on that he returned for a few minutes every day thereafter to admire the carving and to enthusiastically join the groupies in their good-natured heckling. The day before the last carving session, he publicly presented me with a very impressive certificate, rolled and tied with an elaborate red ribbon. Emblazoned with a picture of the QE2 and filled with flowery phrases, it announced to all and sundry that "Gerry Holzman was the finest carver of ship's figureheads aboard the QE2—during the second week of February 2002."

Apart from these experiences, the carving provided a social lubricant that made it easy for my wife Arlene and I to interact with other voyagers. Although she sometimes objected to being asked if she was the "carver's wife" (which didn't bother me a bit, because at home, I'm frequently introduced as "Arlene's husband"), we both enjoyed the comfort we would sense from strangers who would come up to us and pleasantly inquire, "How's the carving coming?" It was a great icebreaker for them and for us.

So, what good came of it all? Well, as I promised at the outset, I did show a lot of folks how to carve a ship's figurehead and, in the process, created a fairly decent piece of sculpture. My wife and I helped some of our fellow passengers meet people they might not have ordinarily met, and, best of all, we ourselves encountered a delightful English couple with whom we established what another celebrated traveler once aptly described as "the beginning of a beautiful friendship."

Not a bad bit of chiseling for a wily old woodcarver, eh?

Strangers on the Deck

I was leaning on the rear-deck railing in the late evening as the ship glided gently through the warm South Pacific waters. The quiet was soothing and soul-satisfying. An older man walked over and began to chat. He had attended a couple of my carving demonstrations, so the conversation began with woodcarving and moved to different ways of making a living in America and the UK. He told me that he was a recently retired policeman and offered up some tales about some of his unusual cases. I was a bit surprised when he freely admitted that sometimes, in the excitement of a drug bust, he would supply his own "forensic" (his word) and pretend to have found it on the culprit. "Sometimes you have to make proper things happen." A few moments later, he steered the conversation to wives and the boredom of retirement: "We get tired of being with each other and need a change of scene. That's why we go on cruises—mostly in the Mediterranean."

We stared at the ocean for a few quiet minutes, and then, out of the blue, he said: "If my wife came out here one night and leaned too far over the rail—she's that tall women you saw me with this afternoon—why she might just fall into the ocean and no one would miss her for hours." We lapsed into silence again—then came the Hitchcock moment. He casually asked me, "Do you get on well with your wife?"

He immediately looked away without waiting for an answer, probably sensing that he had said too much and had gone too far. So he brought the conversation back to his adventures in the London

constabulary and, after a couple of rollicking anecdotes, excused himself and returned to the inner deck.

A few days later, he reappeared at one of my informal demonstrations and cheerfully introduced me to his wife. And then, with a wink only I could see, said, "I enjoyed our conversation the other night. We'll have to continue it when you're not so busy. Maybe one night we can meet in the lounge for a drink."

Perhaps he was only a lonely man seeking a kindred spirit or a bored chap who simply wanted to reminisce about his stimulating past, but his friendly overture caused my little man to deliver a solid kick to my stomach. So, fantasizer and coward that I am, I never did have that evening drink with the retired London cop. But I must admit that, every one-in-a-while, I type the phrase "passenger overboard" into my internet search engine. A recent search brought up this tidbit:

> The body of a British woman who fell overboard from a cruise liner was recovered from the sea off the coast of Spain last night. The unnamed female passenger, believed to be in her late seventies, was spotted by the crew of the Aurora, which was sailing from La Coruna to Barcelona, according to sources at P&O Cruises.

I wonder if she was a tall woman.

As long as I'm writing about wives, I should briefly mention this pleasant middle-aged chap on the same voyage who was being pushed about the deck in his wheelchair by a husky companion. We met them when they attended one of my carving demonstrations and stayed around afterward to chat. Although at first the conversation revolved around woodcarving, it soon became apparent that they were less interested in the woodcarver and more interested in the woodcarver's wife.

Although flattered at first by the unsought attention, Arlene soon learned that her admirer had been crippled by two broken kneecaps, that he and his buddy were from New Jersey, and that they both worked

in the cement industry. These were red flags that even a country girl brought up in the backwoods of Central Islip could understand. So she wisely decided to put the kibosh on the budding friendship and remain true to the chiseler from Long Island who, for all his failings, still had two fully functioning kneecaps.

Of course, if she hadn't, I'm sure my brand-new buddy from the London constabulary would have cheerfully thrown her overboard.

I shall be telling this with a sigh,
Somewhere ages and ages hence,
Two roads diverged in a wood, and I—
—Robert Frost

"I Shudda Gone to Saskatchewan"

I don't want to convey the impression that the profession of woodcarving is all peaches and cream. Although there are definitely more good days than bad days, every once in a while, the plate of life becomes too full and my obligations and my responsibilities seem overwhelming. That's when I think about my father-in-law and Saskatchewan. Here, in pretty much his own words, is a story he once confided to me.

You bet your sweet ass I shudda. It was all my call. But I was too young and too dumb to make the move.

It was 1919, and I had just gotten back from the big hookup in France—I spent a year in the trenches over there. I was a poor eighteen-year-old Jewish kid from the lower East Side when I joined up. I enlisted because I was tired of the family bitching, the small, crowded apartment, the lousy food, and the filthy streets. I wanted to

get away from all that crap. But I didn't. All I got was a different kind of crap.

I was gassed twice, shot at more times than I can remember, and lost some hearing in both ears. And there was still lousy food, still lots of bitching, and, instead of dirty streets, we had muddy trenches—and fleas. So I guess I didn't make out too good. After hearin' all that, I know it might sound crazy to you, but now I'm glad I went. Me and my buddies had some great times in Paris. And I'm proud that I served my country and proud to be a veteran—You know, I was one of the guys that started the American Legion post here, and I was even elected commander twice.

But, enough of that. I guess you want to know, why didn't I go to Saskatchewan? But maybe first, I should tell you what was goin' on in New York when that job in Canada opened up. I heard about it from one of my army pals who wanted me to go up there with him. The job was with Western Union, building new telegraph lines. He said it paid real good and that Canada was a great place to work. And he said it was just like Paris—women everywhere. So I was thinkin' that I should go. The only trouble was I was goin' out with a girl and she wanted to get married and have kids. She was the only nice girl I ever was with, and I liked her a lot. But she had trouble too. She came from some big-time Jewish family in Massachusetts. And they didn't like her getting hitched to a guy from the streets.

So, back in 1919, I had a tough choice: get married to a nice girl, settle down in a small, quiet town in Massachusetts, get a steady job, and raise a family—or go to Saskatchewan.

I shudda gone to Saskatchewan.

Of Mice and Men—
and Woodcarvers

*Robert Burns, the Scottish poet, commented on the hazards of hope when
he wrote:*

> The best laid schemes o' mice and men
> Gang aft agley,
> An' leave us nought but grief an' pain,
> For promis'd joy.

*So far, most of my tales about woodcarving have been upbeat and
hopeful. But there have been moments in my wanderings when I have
encountered the harsh reality that lies at the core of Burn's poem. Here
are some of them.*

Lunch Break

Herb was the head of buildings and grounds for a large educational
institution in western New York State. When he introduced himself
to the rest of my woodcarving class at the Adirondack Folk School, he
explained he was a pretty good carpenter and thought his skill in that
area would help him in learning to carve, something he had wanted to
do ever since seeing Armand LaMontagne's carving of Babe Ruth at
Cooperstown's Baseball Hall of Fame.

There were six other adult students in the class, two of whom were
women. They ranged in age from a youngster about twenty-five to a

retired state assemblyman in his mid-seventies. They were all equally eager to begin the three-day course in caricature carving. Having taught carving for over thirty years, I have developed a good feel for the essential nature of particular groups, and I was pleased with the good vibes that this group generated. Although I generally have my students work on their portrait carvings individually, I try to encourage a feeling of camaraderie so that they feel comfortable sharing their problems and their progress with each other. And—somewhat selfishly—the relaxed atmosphere that usually ensues makes for a more comfortable teaching situation.

Since I work one-on-one with each student, by the end of the first day I usually know who is going to do well and who is going to have trouble creating those elusive three-dimensional shapes in a basswood blank. Both the women had an excellent visual sense and, in a triumph for the feminist movement, had made more progress than any of the men when the class ended at four o'clock. But the youngster and Herb were having some considerable trouble determining how and where to remove the waste wood. Further, they both seemed discomfited when they looked around at their classmate's carvings.

The next morning I concentrated my attention on these two slowpokes. By mid-morning, they had pretty much caught up to the others. The young fellow had recaptured his confidence, but Herb seemed to have lost his initial enthusiasm. I suspect he may have been disappointed that his carpentry background wasn't as helpful as he had anticipated.

We broke for lunch at noon and the class resumed at 12:45. But Herb and one of the women weren't there. I told the class to start without me and went out to the parking lot to look for them. I found the woman asleep in the front seat of her car. When I woke her she was flustered and apologetic but assured me that she was sound and well. "It was just a catnap before I went back to work." She hadn't seen Herb since we all left for lunch. After looking around the parking lot for his

car and seeing no sign of it, I went to the school office and asked the secretary if she had seen him.

"Yes, he was here about a half hour ago and left this note for you."

The note was written on the back of one of the introductory guide sheets I had distributed on the first day of class.

> Gerry,
>
> I'm leaving and going home. Don't take it personally. You are a good teacher but I just couldn't get the hang of the thing. I'm usually pretty good with my hands. I have to be in my job. This is the first time I ever failed at something like this, and it really hurts. After you tried to help me this morning I knew that I would never be able to carve that face as good as the others and I didn't want to stay and be embarrassed. That's why I left. It wasn't your fault. I just couldn't do it.
>
> Thanks for helping me
> —Herb

The Lovely Young Couple Who Stayed for Dinner

My buddy Bruno had sent them to my home workshop on a late fall afternoon. They had just bought a small carousel horse from him that he had restored and were looking to buy more folk art for a gallery they were opening in Virginia. They were about to be married, they said, and had pooled their money to undertake this new adventure

They bought a half-size cigar store Indian without quibbling about the asking price and also gave me a $250 deposit on a small walnut weathervane horse that they wanted me to carve. Because they were such an amiable, affectionate couple who more than satisfied the concerns of the little man who lives in my stomach, I also agreed to consign a ship's figurehead worth around $2,500. Although not one of

my better pieces, it was almost life-size and its folksiness would fit in well with their gallery offerings. My hope was that it would be the first of a long line of consignment pieces that would give me access to this upscale suburban Virginia market.

Arlene was so taken with the genial young couple—they were from our daughters' generation—that she invited them to stay for dinner. We had a delightful evening together during which they offered to represent me in Virginia and solicit custom commissions. We parted with warm hugs and good wishes for our newfound friends. About a month later, we received a tastefully designed invitation to the opening of their gallery, but it was too far for us to attend.

I finished their weathervane horse in late spring, sent them a photo, and asked for the full payment so I could arrange for its delivery. (This was in 1997 before email had become ubiquitous). The letter was returned stamped "Not at this address—no forwarding information available." A phone call produced a disheartening recorded message: "That number is no longer in service."

I called telephone information and got the names and numbers of antique shops and galleries in the area. A couple of phone calls later, a sympathetic antique dealer, who by sheer chance was located across the street from our "friends," told me that they had closed their shop the previous month without any notice, packed their entire inventory into a Hertz rental truck, and disappeared. A series of calls to the local chamber of commerce, the Better Business Bureau and the Virginia attorney general's office were largely unproductive.

We had been had. Aside from that obvious fact was the disconcerting notion that we had so badly misjudged their character. Inevitably, we became a bit more cautious in our future interactions with strangers and lost a tiny, but nevertheless precious, piece of our openness.

Although I ultimately sold the commissioned weathervane horse to a close friend at a bargain basement price, my ship's figurehead was gone forever, and that lovely young couple did indeed . . .

> "lea'e us nought but grief an' pain,
> For promis'd joy."

The Grand Victorian Ball

"Won't we have a jolly time, eatin' cake and drinkin' wine"
—Nineteenth-century minstrel song

They ate the cake and drank the wine, but I sure as hell didn't have a jolly time.

Here's why.

One of the members of our carousel advisory board who belonged to the local chamber of commerce had a smashing idea for a fundraiser. She was a regular participant in a Victorian dance group and reported that the fellow who ran the program was willing to organize a grand Victorian ball to benefit the carousel project. We eagerly accepted the offer. Donald, the dance guy who belonged to a prominent Wall Street

firm, went one step further; not only would he organize and run the dancing phase, he would also donate the cost of the band. All this in exchange for being the grand marshal at the ball and getting full public credit for his effort and generosity.

We made the arrangements for the rental of a ballroom in a restored mansion that had been converted to a private girl's school. We also did the publicity, provided the refreshments, and handled the ticket sales. Since the trailer-mounted carousel band organ had a good selection of nineteenth-century music rolls, a couple of our guys brought that along and set it up at the entrance to the mansion.

In keeping with the festive atmosphere, we made it a black-tie affair for the men and a ballroom gown night for the women. The event lived up to its name—it was truly a grand affair: over fifty couples came, the ballroom was decorated with all sorts of carousel art, and the local assemblyman topped off the evening by reading a proclamation from the state legislature commemorating the event and lauding the entire Empire State Carousel project. Donald was charismatically gregarious, chatting up strangers and friends alike, and he obviously greatly relished his role as grand marshal. The music was lively, the crowd was wildly enthusiastic—to this day, I cherish a vivid visual memory of the childlike smile of delight on the face one of my best buddies, Joe McCormack, as he led the entire assemblage in a highly spirited cakewalk.

As the enchanting evening approached its end, Donald took me aside and explained that there was a minor hitch in the financial arrangements. He had taken his daughter to the emergency room a couple of days ago. Because of some confusion over the insurance, he had to write a large check that depleted his checking account. He asked me to give him a carousel check to cover the $1,000 cost of the band. He in turn would give me his personal check for $1,000 which he asked me to hold until the upcoming Wednesday, when he would have replenished his account.

I readily agreed to this reasonable request from our benefactor and wrote the check, which he wanted made out to him personally. He handed over his dated check for the same amount.

The Grand Victorian Ball was a modest financial success. After paying off the building rental, the refreshments, the publicity and printing costs, it looked like we would end up with about $900. Not that much but certainly not bad for a thoroughly enjoyable night's work.

Our pal in the chamber of commerce called Thursday morning and, in an agitated voice, asked if I had deposited Don's check. When I said no, she urged me to deposit it immediately, telling me she had heard via the grapevine that he was in some financial difficulty and that the check might bounce.

It did—higher than the Queen Victoria statue outside Buckingham Palace.

The eventual bottom line? We were the collateral damage of Donald's Ponzi scheme. It seems he had a minor job in a Wall Street brokerage house but he used their letterhead, his attractively printed newsletter, and a glib tongue to convince gullible "clients" that he was the principal in a highly profitable but nonexistent division of that company. When the Suffolk County District Attorney finally nailed him, it was discovered that his primary investments were in blue-ribbon assets like a Mercedes for him, a BMW for his wife, a condo in the Bahamas, and a gourmet kitchen in his home (Don liked to cook almost as much as he liked to dance). Why he schemed to cheat the carousel project out of a measly $1,000 in exchange for his ephemeral evening of egotistical ecstasy is something I hope he'll have to one day take up with Robbie Burns.

The Woodcarver's Wife

No, it's not about Arlene—this is about Betsy, another woodcarver's wife.

Betsy and her woodcarver husband, Walter, were about halfway through an eighteen-month odyssey when we met them. Walter, a longtime woodcarving enthusiast, had recently retired from his job as the postmaster of a large California town and decided to tick off the top item on his (their?) bucket list: They would buy a large, luxurious motor home and use it to travel in comfort to all the forty-nine continental states. Not having traveled much outside of California, they planned to see all the places they had only visited in the movies and on television. Along the way, Walt would visit with woodcarvers, while Betsy, who been an architectural student before she dropped out of college, would sketch buildings and study the history of the regions. In order to help finance this grand scheme, they would simplify their lives by selling their California home and all their unnecessary possessions. In the course of the journey, their (his?) expectation was that they would find the perfect place to retire. After they found it, they would sell their motor home, buy a low-maintenance house, settle down in their newly discovered utopia and travel no more, forever.

We learned all these things about them in the space of one very intense afternoon at our home on Long Island. A friend who had written some articles on woodcarving had brought them to us after Walter contacted him in search of carvers he could visit. They pulled up in front of our home in a thirty-five-foot-long land yacht that was so massive that our neighbor, who had an unusually long and wide driveway, generously offered to provide a temporary parking place. "But only for the afternoon," Frank cheerfully cautioned.

They were an amiable couple and Arlene and I took to them immediately. The obvious first step in beginning our relationship was to step inside their motor home. Nearly as big as my motorless home, it was well designed, tastefully furnished, and seemed eminently livable.

After the tour ended, Arlene took Betsy into our house while I ushered Walter into my converted garage that, for very carefully selected audiences, I sometimes refer to as "my studio." It should be noted here that Arlene is a Kitchen Table Lady, an exemplar of that elite subgroup of human females who listen well, nod appropriately, and generally make their visitors feel comfortable about sharing their deepest secrets and darkest thoughts.

Walter and I spent nearly two hours in my studio talking woodcarver talk and doing woodcarver things. And, drawing on that unique chemistry generated when one carver meets another, we had bonded. When Arlene called us into the dining room, it quickly became apparent to my practiced eye that she had just finished chairing one of her Kitchen Table Lady sessions. The tip-off was the slight trace of redness in Betsy's eyes and the subtle sense of sadness that permeated the room.

I don't think Walter noticed anything out of the ordinary. We drank some tea, ate some scones (Arlene uses an old family recipe given to her by a South African cousin to produce the best scones in the English-speaking world), and engaged in a highly informative (for us) discussion about the fascinating experiences they'd had so far and about their travel plans for the remaining year.

I was sorry to see them leave and greatly envied them their intriguing odyssey. Afterward, as we discussed our reaction to this unusual visit, I told Arlene that Walter was in hog heaven: he had said it was the best time of his entire life, seeing things he thought he would never see and meeting people he could never hope to meet. He couldn't wait to get behind the wheel and resume their stimulating and thought-provoking travel.

Arlene had an entirely different story to tell. Betsy was miserable. From the get-go, she had been reluctant to undertake the eighteen months of unbroken travel, but it was so important to Walter that she didn't have the heart to hold back. She missed her home, her family, her neighbors, her garden, and the comfort of familiar things and familiar places. The worst part of it, Betsy had said, was the campgrounds. It

wasn't the physical environment that upset her, since they stayed at the best parks available; it was the struggle of having to re-introduce themselves every three or four days. While she enjoyed meeting new people and visiting long-forgotten friends, she wanted to do it from a position of stability, not from one of constant motion.

My Kitchen Table Lady sat down at our dining room table and mused aloud: "Their trip has all the makings of a good TV series, but I wonder if it would be written as a comedy or a tragedy."

Breakfast with Charley

Before Charley's wife, Joyce, left that Sunday morning, she had carefully set the table for our after-breakfast snack in the sun-filled dining room. A freshly made pot of steaming coffee stood on a trivet; cartoon drawings of chickens danced on our coffee mugs and on the matching snack plates. Even the place mats featured frenetic fowls—Joyce loved chickens, and she indulged this one obsession by displaying painted and sculpted images of them everywhere in the house.

"I've put out some picture albums for you and Charley to look at. Don't let him go downstairs or upstairs, he falls so easily. And don't trust him alone, he's a sneaky devil. Help yourself to those corn muffins; they taste better than they look," she cheerily said as she departed for her meeting with the accountant to prepare their annual income tax return. "I'll be back in a couple of hours. The phone number is on the telephone if you have to reach me."

I echoed her cheerfulness. "Take your time. I have the whole morning free."

As the door closed, Charley and I stared a bit warily at each other across the table, a beautifully crafted red oak trestle-style piece that he had made from scratch some twenty years ago. We both knew that I was there in a new, expanded role: I was no longer simply a friend and a professional colleague who had come to visit, I was also his "sitter" for the morning.

"You look great. Charley." I overlooked the two bruises on his fore-head as I poured coffee into our cups. And he did look quite good. His pleasant seventy-three-year-old face was clean-shaven and unwrinkled. His eyes were clear behind his new glasses. Joyce had neatly dressed him in a starched blue shirt and clean, pressed khakis.

"I ... I ... get ... wor-se ... ev ... every ... day." The smile momentarily left his face as he fought to get the words out, shaking his head in frustration when they wouldn't come forth. After he finished his struggle to talk, the smile returned but this time he cocked his head slightly and stared me straight in the eye as if he were daring me to disagree.

After an uncomfortable moment of silence, I offered a safe response: "You honestly do look good—and the physical therapy should take hold soon—you'll be better by spring." Here I mustered up an unconvincing smile—"and that's only three weeks away. Before you know it, we'll do another project together, like the characters from children's literature that we carved for the Islip public library."

Courtesy of Mary Schubart

Embarrassed by the transparency of my white lie, I looked away, fixing my gaze on the maple serving stand. Charley's eyes followed my head movement, and his face brightened.

"That . . . is . . . c-c-cuh—curley . . . may . . . may . . . may-PLE." The final syllable practically exploded as he forcibly willed it into being.

"You made that for Joyce?" He nodded proudly and pointed to the large matching hutch that was also professionally crafted in the still-popular Mission style.

"How long ago?"

He held up his left hand—his right arm hung motionless—and opened and closed his fist three times.

"Fifteen years ago?"

He beamed and nodded affirmatively. And then, a dark cloud came across his face.

"No . . . more . . . no . . . m-m-more."

The sad silence was blissfully broken by the festive sound of Westminster chimes. We both turned to look at the grandfather clock that stood at the end of the dining room as it announced the hour.

"That's tiger oak, isn't it Charley? It's a gorgeous piece of work. You should be very pleased to be surrounded by so many lovely things that you've created."

Once again the room was brightened by Charley's sweet, hesitant smile, but the atmosphere was quickly dampened as he labored to repeat those heartbreaking words: " I . . . cah . . . ca-n't . . . No . . . m-m-m . . . more"

We looked at the pictures in the albums Joyce had left, which included many of the extraordinary woodworking projects that we had done together over the years: the Erie Canal barge boat for the carousel, a calliope trailer copied from an old-time trolley car, a ten-foot-long baroque facade carving in oak and—Charley's favorite—a charming, full-size carousel mule that we named Sal. As we turned the pages, he smiled frequently with recollected pleasure and proudly pointed out some of the woodworking subtleties that he had introduced.

When we finished with the albums, I told him some slightly exaggerated tales of my adventures during a recent New Orleans vacation and spoke hopefully about all the changes that spring would bring. He listened and smiled a childlike smile that contained a mixture of understanding, appreciation, and approval.

After that, for what seemed like a very long time, we avoided each other's eyes and stared out the dining room window, concentrating our attention on the birds fluttering around the ornate feeder that he had made just two short summers ago. This unintended silence set me to reflecting on the unfairness and the unpredictability of our lives and thinking how wise Charley had been to use so many of his good days to do so many good things.

We were both a bit relieved when Joyce returned. I accused her of deceiving me for the first time in our twenty-year relationship: those corn muffins tasted *worse* than they looked.

I'll go back next week to sit with Charley so Joyce can have a few hours alone. I'll tell Charley some more white lies about our tomorrows, and, of course, he'll know I'm lying.

Here Come the Judge

We woodcarvers, being human, have an urge to create and, being human, also possess an accompanying urge to seek approval for what we have created. When we have exhausted our loyal cheering squads of family and friends, we sometimes foolishly turn to public competitions. In the course of my career as a moderately successful woodcarver, I have been called upon to judge many of these carving competitions. But, to place that in proper perspective, I must begin with the first time I sought official approval for one of my own creations.

I had been carving with X-ACTO knives for five years and, somewhat arrogantly, thought I had become a proper craftsman. A recent trip to Saint-Jean Port-Joli, a Canadian village with a woodcarving school and a picturesque Main Street dominated by carving shops, had given me the idea of creating my own version of one of their specialties—a group scene. So I began searching for a good subject.

My inspiration arrived with a PBS broadcast of Eugene O'Neill's play, *The Iceman Cometh*. Since all the action for this dismal commentary on our human condition takes place in a barroom filled with a diverse array of life's losers, it seemed like a perfect source. I cut out a 12" × 15" pine floor, added a bar complete with bar rail and spittoons and began populating the scene with characters from the play. Each figure was about five inches high and painted with soft-finish artist's

acrylics. The bar scene contained a burly, bald bartender who was chatting up a floozy with her legs provocatively crossed, a passed-out bum with his head on the bar top, and a couple of guys deep in discussion on some earth-shaking topic that only they understood. Haranguing them all, and waving a finger warning of impending doom, was Hickey, the play's central figure, who was quite imposing in his striped jacket and straw hat. I thought it was a splendid piece, as did all the steadfast members of my local support system. But that wasn't enough meat for my hungry artistic soul.

So, naturally, I entered a carving competition.

The contest was conducted during the Christmas holiday season by my own group, the Long Island Woodcarvers Association. As program chairman, I organized the event and invited A. J. Blinderman, a woodcarver and collector who had written a number of books and articles on this increasingly popular hobby, to be the sole judge at the event.

Although there were about twenty entries in the human category, most of them were uninspired figures copied from how-to books. All the usual suspects were in attendance—gnomes, cowboys, witches, hillbillies, even a Santa Claus. However, standing out from this unimpressive gathering, were two decent carvings: a somewhat overly ambitious eight-inch copy of Daniel Chester French's Lincoln and a five-foot-high cigar store Indian, beautifully executed by my buddy Bruno Speiser. My six-figure barroom was the only group scene and, as I proudly noted, the only truly original piece in the competition. Bruno and I agreed we were evenly matched for the blue ribbon.

Lincoln won first prize. A miniature ship's figurehead came in second, and Santa Claus got the bronze. My barroom ended up with an honorable mention. Bruno, whose magnificent cigar store Indian finished completely out of the money, was furious. (When I spoke to him this past July to congratulate him on his ninety-second birthday and told him that I was doing a story about the carving contest, I discovered the passage of thirty-eight years had not yet dimmed his sense

of injustice.) As for me, I took no comfort in the fact that I had beat out all those goddamn gnomes and witches.

Why? What was the rationale for what we thought to be such an absolutely unfair verdict? That's the question I rather forcefully, even a bit emotionally, put to the elderly and scholarly A. J. Blinderman at the end of the evening. His courteous and instructive answer was clearly intended to calm me down. He said he was very much aware of the role personal taste and philosophy played in making judgments and knew other dedicated woodcarvers might disagree with his views.

"American woodcarving is a very old craft that should emphasize American values. The Lincoln Memorial is a magnificent symbol of our nation. The winning carver made a wise choice, and he copied it very nicely. While shop figures are popular examples of American folk art and the carver did a credible job of reproducing one, to be honest, if you've seen one cigar store Indian, you've seen them all.

"Sure, your barroom scene was clever and was competently carved, but it didn't draw at all from our American woodcarving tradition. It didn't relate to anything in the past. I don't mean to be disrespectful when I say it is more like a comic book page than a woodcarving. Please try to understand—we have to protect and preserve our traditions."

His answer, rather than consoling me, brought me close to irrationality. As I followed him out the door, manically clutching my dishonored barroom scene to my wheezing chest, I shouted out, "But what about jolly old Saint Nick? Even that fat little bastard beat me out."

"Oh that?" Here, Jolly Old A. J. smiled, "You must admit, the carving was certainly in keeping with the season." Still smiling, he lowered himself into the driver's seat of his beautifully restored woody station wagon, and, as Clement Clark Moore is my witness, I heard him exclaim, ere he drove out of sight, "Happy Christmas to all, and to all a good-night."

"Tell Me, Mr. Judge…"

When it comes to judging carving contests, like Melville's Bartleby the Scrivener, "I prefer not to." But, every once in a while, I've had to.

The carving club in Queens had contributed a nicely carved frame to the Empire State Carousel project. And now the president had asked me to help judge their annual carving contest. Feeling obligated to return a favor, I reluctantly agreed but, remembering my near-maniacal confrontation with A. J. Blinderman ten years earlier, I insisted that there be at least one additional judge. The president assured me that I would be one of three judges, all of whom would share equal responsibility.

The parking lot of the community center was almost full when I arrived. I guessed there were over a hundred people there—carvers, wives, husbands, and loyal supporters. I was warmly greeted by the president, who quickly told me he had some good news and some bad news.

"Which do you want first?"

The little man who lives in my stomach gave me a kick. "You decide," I replied.

"This is the best crowd we've ever had. There are sixty-eight entries. And a lot of the work is great. We charged a five-dollar entry fee, so we're going to be able to give cash prizes as well as ribbons. There are going to be some real happy carvers tonight when you announce the results."

"When I announce the results? I don't want to be the head judge; let one of the other guys do that," I said.

"That's the bad news. The other two guys couldn't make it. Herb canceled this morning and Lenny called about half an hour ago; he had a car accident and won't be able to come." Here he offered what might charitably pass for a smile and said, "It looks like you're the man."

My little man gave me a really hard *zetz*. He knew that this wayward woodcarver had just wandered into a hornet's nest. But to be fair to these carvers who had invested some much of themselves in their work, I had to get on with it—and try to avoid getting stung.

Upon close inspection, most of the sixty-eight entries weren't "great." But, thankfully, a half-dozen or so were quite good, and the first prize selections in the various categories did not prove too difficult. It was the second, third, and honorable-mention prizes that provided the most trouble. My experience has been that the poorer carvers, who sense their inadequacy, are often the most insecure and vulnerable. That's why I dislike the judging process: it's so subjective and so highly arbitrary, and it often hurts the people who can least afford to get hurt.

Enough of that; on with the show. My favorite category was, as always, the human figure. Judging here was a piece of cake. The easy winner was a group scene in a Western bar (was I compensating for my *Iceman Cometh* bar scene?). In full round and about six inches high, it was well composed and very competently carved. While Blinderman would have approved of its historical connection, for me, the best parts were the expressive faces of the anatomically correct figures and the originality of the overall concept.

One of the worst carvings in this human category was a four-inch-high copy of the General Sherman equestrian statue in Central Park. The carver had clearly undertaken something that was well above his pay grade. The overall work was crude, the carving of details was slipshod and careless, and the anatomy—both human and horse—was inaccurate. Even the varnish finish was runny and blotchy. The carving was, to quote a five year-old English friend of mine, *quite horrible*.

Can you see where this is going? If not, just hang in there for another minute or two.

As the president correctly predicted, there were a lot of happy carvers that night when I announced the results. As for me, I was happy to get out of the community center without being sent to sleep with the fishes (hey, this was Queens). But I had repaid my obligation and, all in all, it hadn't really been that bad.

As I walked toward my car, a bulky middle-aged man approached me. He was cradling something in his hand. Shades of A. J. Blinderman! He was holding his carving of General Sherman.

"Tell me, Mr. Judge, why didn't I win the blue ribbon?"

There was hurt in his voice—and a strong hint of menace. He was not asking for an explanation or a carving critique. He was asking for retribution.

He thrust General Sherman toward my face.

"Or at least a red one . . ." Here, his voice trailed off as he muttered, "Or even honorable mention. Why?"

My first thought was to remind my distressed antagonist that General Sherman, by way of explaining his horribly destructive march through Georgia, had famously declared, "War is hell, but, to be completely honest, it is not nearly as bad as judging a woodcarving contest in Queens."

Wisely, I decided to stick to a very simple explanation and combine it with a brief lesson in basic artistic values. Surprisingly—and somewhat disturbingly—I found myself channeling A. J. Blinderman. I began by explaining, in some detail, why the cowboy bar scene had won, not why he had lost. "Different carvers have different values. I highly value originality and feel that copies, while great for training purposes, have no place in competitions."

I gently removed General Sherman from his protective, paternal hand and ran my finger over the horse's mane and tail—in truth, the only adequate parts of the carving—and complimented him on the skill with which he had shaped them.

My positive, nonconfrontational approach didn't work—he glared at me for a moment and defiantly grabbed the carving back. As he belligerently marched off, I could hear the drums beating and the bugles blaring. I quickly got into my car, locked the doors, and sped away toward the safety of Suffolk County.

But I'm certain, just as my carving buddy Bruno and I still lick our wounded egos over the injustice imposed upon us by A. J. Blinderman thirty-eight long years ago, that this rejected carver of General Sherman would be very pleased if I ended up in Jamaica Bay, just like Luca Brasi, the Godfather's buddy.

An Emerging American Primitive

My dad was in his late sixties when, inspired by my example, he took up woodcarving. I tried to help him all I could, but—as those of you who have been in a typical father-son relationship know full well—it is often difficult to teach an old dad new tricks.

I gave him an instruction book, a vise, and some basswood blanks. I topped it all off with a basic X-ACTO carving kit, which had the additional value of freeing him from the onerous burden of learning how to sharpen tools. For, you see, my father was not a handy man.

Simply put, though he was often very enthusiastic and sometimes even daring, he was not a master of his physical world. He belonged to the "give it a zetz" school of home repairs—a school that believes that 87 percent of all material difficulties can be solved by sharply striking the offending object. A case in point was the inoperative small humidifier on his hot-air heating system that he asked me to repair. After explaining what I thought to be the problem, I asked my dad for an adjustable wrench. He told me he had misplaced his but that I probably wouldn't need it anyhow. "Always the professor. It's not that complicated. Just give it a zetz!" And with that, he sharply slapped the cantankerous humidifier. His impulsive zetz broke the tiny clogged pipe, and a small stream of water began spraying the utility room. "Now look what you made me do, you klutz. Do something, do something!" After I managed to calm my father down, I plugged the pipe and told him to call the plumber. I marked it off as one of those treasured moments

that bond father and son together. This intergenerational scuffle should provide some sense of the nature of the teacher-pupil relationship I am about to describe.

He was, predictably, quite proud of his first carving of a mountain man, which was, predictably, too flat, too square, and too crude. But, after all those years of zetzing and klutzing, I was ready for my old man.

"It's good, very good for a first piece but, Dad, it's a bit too squarish."

"Two squarish?" He was perplexed and disheartened by my comment.

My mother, who was sitting in on the critique and was obviously very pleased with her husband's first effort, belligerently echoed his remark: "Two squarish? What the hell does that mean? You're the college boy in the family. Speak English." I was being double-teamed.

I patiently explained that he, like most beginning carvers, was reluctant to take enough wood off the edges. Since it was such a common problem, I had devised a dramatic lesson to deal with it. After placing the figure in dad's vise, I picked up a small woodcarving chisel that I had brought expressly for this purpose and chopped off all four edges of the newly carved but still-square block.

My parents looked on in horror. My mother, as always, was the first to react. "What the fuck are you doing? He worked all week on that."

My father, as always, was more reserved, but even more upset. "You ruined it! Now I have to carve the arms and the legs all over again." He paused and accepted the inevitable. "Show me how to fix it."

He watched and appeared to be listening intently as I re-carved one of the arms. Then I had him repeat the lesson by re-carving the other arm. We followed the same procedure with the legs. I was very pleased: a lesson well-taught and a lesson well-learned.

When I returned a month later, my father proudly showed me three more mountain men. They were all too flat, too square, and too crude.

"But Dad, they're still too squarish. Where's the model—the one we carved together?"

"Oh, I threw it out. Your mother said it was too much your work and not enough mine. She likes my stuff better."

My mother was sitting in her favorite rocking chair, puffing vigorously on her omnipresent cigarette and glaring at me with a look that said, "Don't screw around with my husband."

Foolishly, I did, by making my father feel the square edges of his woodcarving and then feel the rounded edges of his own body. As before, he seemed impressed and promised to try again. But, as before, it made no difference—his woodcarving work remained unchanged.

This "too squarish" business went on for three more years until, thankfully, my father sold most of his carvings to a folk art dealer from California (which was more than I could do). He paid Dad $10 a piece and bought about twenty of them, which he probably sold in his San Francisco gallery for a couple of hundred dollars each as prime examples of an emerging American primitive artist. Satisfied by his success in the world of woodcarving, my father then took up painting as his next hobby.

I never dared tell him, or God forbid, tell my mother, that all of his paintings were, predictably—too flat and too muddy.

However, if the truth be told, I did keep two of those squarish carvings of his. Yeah, they are too flat, too square, and too crude but I think they are absolutely

charming and, as I will my father, the emerging American primitive artist, I shall always cherish them.

Felix and Oscar

A few years ago Jim Beatty—one of my closest friends, a longtime carving buddy, and my chief associate in the Empire State Carousel project—died a premature death. I offer the eulogy that I delivered at his funeral to illustrate the unique bond that can develop between those of us who work with our hands.

Jim Beatty was my brother. Not my actual brother from birth but my spiritual brother from life. We worked together for over thirty years, and he enriched those years for me, and for my family, beyond belief.

We had so many bizarre adventures together—adventures that I never would have attempted on my own—like the time we locked the keys inside our truck in Waterloo and had to hitch a ride into town wearing our flamboyant carousel costumes so we could be in time to lead the parade for Sam, the carousel bear. And I'll never forget the day that Jim spent an entire hour setting up our portable ticket booth so I could photograph it—and then spent another hour taking it down only to hear me say that I had forgotten to put film in the camera. His reaction to my embarrassed admission was to laugh with delight as he cheerfully went about the task of setting it up again.

Jim was the epitome of physical grace. He was a high school quarterback, a champion fly fisherman, a highly competent golfer, and, in

general, a master of his physical world. He could confidently back up a band-organ trailer, accurately cut a board to a sixty-fourth of an inch, gracefully climb a high ladder while holding a bulky sign, effortlessly put razor edges on dull tools, make gold leaf shine like the sun, and carve crisp roman letters with rapid, bold strokes of his knife.

On the other hand, I didn't learn to jump rope until I was twenty-one, nor could I cast a fly without getting my line tangled in a tree. We were truly the Odd Couple of the woodcarving world. I was the Oscar who played the klutz to Jim's ever-competent Felix. Unlike me, Jim didn't shed stray hair onto clear varnish finishes, nor did he dent carousel animals when he carried them through narrow doorways.

Jim preferred to compare us to Laurel and Hardy—"Well, Gerry it's a fine mess you got us into this time"—which, I guess, might be the more accurate parallel, because I sure as hell had gotten him into some truly remarkable messes. Yet we worked happily together for over thirty years despite the occasional misfortunes that such a relationship must inevitably endure.

We were able to do it because underlying all these grand adventures was something powerful and fundamental; none of them would have been possible without the energy, tolerance and wit that were so much a part of Jim's basic nature. I'm sure you all know that Jim was an irrepressible imp, at times even a bit of a rogue, but this tendency toward playfulness was always tempered by his inherent sense of decency and his unwavering sense of kindness. In all our years together, I cannot recall a single moment when he consciously hurt another human being. I sometimes think that Jim was sent to earth to show the rest of us how important it was to be kind to each other.

A look at one of our Laurel and Hardy messes will offer a revealing insight into the kind of guy Jim was. I like to call it the Coliseum Caper.

We had been invited to be the lead attraction at a craft show in the Nassau Coliseum. It involved moving in about ten carousel animals, our ticket booth, and a wide variety of other stuff. All in all, the displays filled a good-size box truck.

What we thought was going to be a mom-and-apple-pie moment turned into a bizarre clash with three different unions over who had the right to drive, the right to unload, and the right to set up displays—the one hundred craftspeople who were exhibiting or the seventy-five union members who demanded work. After first being locked *out* of the Coliseum on Friday morning and later being locked *inside* the Coliseum on Sunday night, we were finally allowed to take down our displays and go home.

Jim and I were physically and psychologically exhausted. The craft show was successful despite the union harassment, but it had been a marathon of three fourteen-hour days. We arrived at our Islip building around midnight on a dark, drizzly night. Toward the end of the grueling three hours that it took us to unload and stack the pieces of our elaborate carousel display, with rain and sweat running down my fatigued face, I muttered innumerable unprintable curses and said to Jim: "The carousel stays in the building from now on. If anyone wants to see it, let them come here. This is the last time we'll ever do stuff like this again."

Jim, who was just as wet as I was and who had just driven the large truck thirty miles through the rain, gave me his widest Howdy Doody smile and said, "Oh, come on Gerry. Sure we will. It wasn't that bad and some of it was sort of fun—Sure, we'll do it again, but OK, maybe not for a while."

Jim was right. We did do it again in Syracuse and again in Ithaca and again in Albany—and again and again—for twenty more years. And, I suspect, if the gods granted me an opportunity to ask him to do it once more, he would grin, his eyes would twinkle, and he would simply reply, "What time should I get there?"

Perhaps the best way to explain the Jim Beatty I knew is to let him do it himself, using the words he once offered to a TV interviewer: "Woodcarving has changed my life. It's been almost a spiritual experience. I was able to involve myself physically, emotionally, and creatively in a way that I was never able to do before."

I'll close this tribute by borrowing a verse from that old Broadway musical *Paint Your Wagon*. The lyricist might have had Jim Beatty in mind when he wrote these words:

> His heart was made of holidays,
> His smile was made of dawn.
> His laughter was an April song
> That echoes on and on . . .

Go well, my brother, go well.

The Captain and the Carver

Jim Beatty was a procrastinator. That was his original sin. For the moment, let's put aside the facts that he was one of the finest sign carvers in New York and New England, one of the most decent and generous men I've ever known; a loving husband, a doting father, and a faithful friend; a trout fisherman whose angling skills even Isaac Walton would envy, and someone whose charismatic personality and impish sense of humor combined to make into a grand storyteller. Simply put, he was one hell of a good guy and a joy to be around.

But all this virtuousness must give way to that one inescapable fact: Jim Beatty was a procrastinator. And not your everyday, run-of-the-mill sort of procrastinator, Jim was a grand champion, he was the

prince of procrastination. If you think I exaggerate, just sit back and let me tell you the story of Captain Jinks of the Horse Marines.

In the spring of 1976, Jim glued up two five-foot-long basswood blanks of Captain Jinks so that he and I could each carve our version of that legendary folk figure. Jinks was a highly stylized post–Civil War shop figure who, because of his bright uniform and arrogant pomposity, was almost as popular as the ubiquitous cigar store Indian. They even wrote a song about him:

> I'm Captain Jinks of the Horse Marines,
> I give my horse good corn and beans,
> Of course 'tis quite beyond my means,
> Though a captain in the army.

But, unlike real life, in the world of folk art, the Indians waxed while the captains waned. Jim and I had decided to revive this image and try to use our two carvings as prototypes for a whole line of retail shop figures. Our goal was to have them ready for the upcoming Christmas season.

I am a fairly obsessive sort of carver and, even though we were doing these figures in our spare time, I was able to present Jim with my completed Jinks in early July. When I proudly brought the brightly painted figure to his shop—we had each converted our home garages into carving workshops—I was naturally curious to see how his was coming along.

It wasn't.

He had made a few exploratory cuts around the head and the base. Other than that the blank was still a blank. He saw my disappointment and quickly appeased me by saying, "I've been saving it for the summer; I'm going to start on it next week and have it done by Labor Day, just as we planned."

There were all sorts of festivities on Labor Day weekend, but Jim's Captain Jinks couldn't participate. You see, he was still pretty much a blank slate. Since this was speculative, spare-time work and we had

actual commissioned jobs that had to be carved, I reluctantly accepted his promise to have it done by the New Year.

Of course, he didn't. But it was hard to fault him because he willingly—and skillfully—did the paid work and our carving business was prospering. So he set his next deadline for Memorial Day—as you can see, Jim liked to work toward holidays.

In the spring of 1977, we caught a break. *Newsday*, the dominant Long Island newspaper, wanted to publish a photographic centerfold on us for their Sunday magazine. We had two weeks to get ready. Good old Jim dug Captain Jinks out of his foxhole and, working feverishly, had the body roughed out in time for the shoot. His undeveloped, unpainted figure offered a vivid contrast to my completed captain, which appealed to the photographer, and they were featured in the centerfold.

That newspaper centerfold combined with our carousel-carving activities to spark a constant succession of print and video feature stories over the next twenty-five years. And Jim and Captain Jinks were always ready for them. Whenever a camera beckoned, the Great Procrastinator would firmly clamp Jinks to his workbench, grab a gouge and mallet, put on his little-boy smile, and—lordy lordy—how the chips would fly! The captain and the carver were a photographer's dream come true.

But in between these occasional, highly animated photo shoots, nothing happened. Nothing. Jim remained obdurate. Jinks remained comatose.

Jim never told me why he couldn't finish the carving. In fact, he always insisted that he was working on it whenever he had some spare time and would have it ready by some upcoming holiday. Eventually, I gave in to the inevitable and stopped asking him about it.

Jim died in 2012. He left behind a loving family, a great number of grieving friends, some magnificent woodcarvings, and—as might be expected—an unfinished Captain Jinks. Thirty-six years had passed

since his birth, and the good captain was still enclosed in his basswood prison. The prince of procrastination had failed to set him free.

His wife stuck the carving block in the loft above their garage, hoping that one of his daughters might finish it. But that was not to be. When she sold the house a few years later, she called and offered the captain to me. It was an offer I could not refuse.

Jinks was about two-thirds finished when I first clamped him to my carving stand to give him a thorough examination. Although Jim had done an excellent job of shaping the basic figure, there was still a good bit to be done before the details could be developed and completed. To celebrate the beginning of the work, I had brought a glass of wine to the shop (Sangiovese, one of my favorites). Borrowing an ancient, well-recognized West African custom of propitiating the tree's spirit before cutting it down, I poured a small libation on the rough shape that would soon become the good captain's head and thanked Jim for his gift of friendship. Then I took a healthy swallow of wine, picked up my large #7 gouge, and went to work.

The carving went well (sometimes it doesn't). The ease with which the work progressed brought back memories of a large portrait of Teddy Roosevelt I had done years earlier. I had been anxious about being able to do an accurate likeness, but I needn't have worried—the old Rough Rider all but leaped out of the wood. I had anticipated spending a month, or more, on the portrait; I completed it in less than two weeks. It was as if the spirit of TR was helping me bring him to life.

I had the same sort of mystical feeling as I worked on Jinks. But this time, it wasn't the spirit of Jinks that was lending a helping hand— it was the Great Procrastinator himself who had somehow wrangled permission to return. I don't know how the old bastard did it, but I swear he was in my shop that summer doing his best to make up for those thirty-six years of unfulfilled promises.

So it was that Jim Beatty and I finally finished carving Captain Jinks on Labor Day weekend (Jim's favorite date) of 2017. I put one of our Beatty and Holzman brass plaques on the base of the carving, and

in the back corner, where I usually carve my name and the date of completion, I carved both of our names and the dates 1976–2017. I'll leave the mystery of that forty-one-year gap to some future folk-art historian.

Splendiferous Carvings that Never Were

Herein I offer a trio of tales about woodcarvings that almost came to be but, for good or for ill, never saw the light of day. However, the splendid adventures they provided were well worth the effort they required.

I once became involved with an energetic, frenetic, and dangerously charming promoter who had a suite of offices in the Trump Tower on Fifth Avenue. Although he had a normal name, among ourselves, we called him Rich Guy. When my carving partner, Jim Beatty, first met Rich Guy during a working lunch at an upscale Manhattan restaurant, his description of the encounter said it all: "I feel like I've just been licked to death by a demented duck."

But demented ducks don't have office suites in the Trump Tower nor possess the ability to spin tantalizing tales of future grandeur. So that's why a sunny fall afternoon found us in a dingy Trump Tower freight elevator accompanied by one of my life-size, hand-carved Indians.

Rich Guy was very impressed with the sales potential of the cigar store Indians. "I'll start by putting them in high-end tobacco shops in Berlin, London, Paris, Rome, and New York. My only concern is that

you fellows won't be able to turn them out fast enough. And, as good as they are, they can't just be ordinary Indians; we have to come up with a gimmick."

The gimmick we finally agreed on (I can't recall the marketing mastermind who first suggested it—maybe because it might have been me) was to build cigar and tobacco humidors into the back of the Indian: one in the small of his back and two in his butt—one on each cheek. There were also cigar and pipe lighters involved, but I'll leave their location to your imagination.

When we had finished plotting our grand strategy, Rich Guy brought in his photographer and they had an intense discussion about how to shoot the Indian that we were leaving in his office; was it to be with the Hasselblad system or with a pair of Leicas with interchangeable lenses? (This was in the film era, before the days of digital.) Though it really doesn't have any bearing on this tale, for the record, I should say they finally opted for the Hasselblad.

His parting words: "You fellows go home, sharpen your tools and start putting together a prototype. I'll contact you in a couple of weeks with the pictures and our preliminary marketing literature. Then, I'll introduce you to my great, good friend Johnny Carson and put you on his show. Get ready for a fast and bumpy ride—this is going to be huge."

Because the process of carving tends to make you cautious—just cut a little bit here and trim a little bit there—we decided to wait for the arrival of the marketing literature before performing a major proctologic procedure on the unfinished Indian still in my workshop.

Well, you guessed it. Two weeks went by—no pictures. After three more unresponsive weeks, I called his office. Rich Guy, the secretary explained, was in the UK working on a recording campaign for a rock band. No, she knew nothing about the cigar store Indian project but she would have Mr. Rich Guy contact us as soon as he returned.

As far as I know, Rich Guy is still in the UK beating the drums for that rock band because he never called me nor did he ever send any of those nifty pictures his photographer buddy took with the Hasselblad

system. Worst of all, he didn't even introduce me to his great, good friend Johnny Carson.

So, about six weeks later, it came to pass that Jim Beatty and I could be spotted on Fifth Avenue carrying a life-size cigar store Indian on our shoulders. New Yorkers, being New Yorkers, hardly took notice of us as we put him in our van and drove him back to Long Island. And there he joined his partially carved brother-in-bark, a very traditional cigar store Indian who I completed a month later with his butt fully intact—and without a cigar lighter.

Then there was this guy from the Sons of Norway. When I picked up the business phone and heard a thick Scandinavian accent, my first reaction was that one of my buddies was having some fun with me. But it soon became apparent that Sven Nilsen was a real guy and that he was dead serious.

He was calling in his capacity as the president of the local chapter of the Sons of Norway and wanted me to design and carve a sixteen-foot bar in the shape of a Viking longship featuring a dragon-headed prow. We talked for nearly a half hour as he described his concept of the bar. All they wanted from me was the basic construction and the carving; they would make it into a working bar. He offered to send me a drawing and some general written details.

The drawing and details contained enough information so that I was able to come up with a reasonably accurate estimate. The figure, as I recall, was somewhere around fifteen thousand dollars. When I called Sven to give him my ballpark estimate, I could almost hear his shocked silence, and then I did hear his incredulous "That much? So much! I'll talk to the bar committee and call you back."

He didn't.

But I must admit that every once in a while, in the wee small hours of the morning when I wake to pee and try to fall back asleep, I have a delightful vision of a sixteen-foot bar filled with bearded, horn-helmeted, drunken Vikings sloshing their frothy flagons of mead as they loudly offer toasts to the magnificently carved dragon-headed prow and to the wandering woodcarver who created it.

I'll close this collection of curious cock-ups with a tale about the time a famous TV star and her consort performed a dance just for me. Let's call her Fiona. And we'll call him—Andre. They wanted a custom carving for the newel post on the stairway of their summerhouse in eastern Long Island, so an artist friend who had done some mural work for them suggested that they contact me.

Just like the caper with the Sons of Norway, it began with a phone call from a complete stranger, but this time one who spoke with a French accent. Recalling my earlier experience with Sven, I listened courteously to his request and quickly decided it was a genuine inquiry. Accordingly, Andre and I arranged to meet at his summer home on the upcoming Sunday at about ten in the morning.

Their spacious, well-designed home was attractively sited just a few hundred feet off the Long Island Sound. When I drove up, precisely at the stroke of ten, Andre and Fiona were sitting on the veranda having breakfast with a friend. Although Andre and the other fellow were neatly attired in chinos and polo shirts, Fiona was wearing a fluffy white beach robe with what I graciously assumed was a bathing suit underneath. Having seen her on TV a couple of times, I was surprised at how small and slight she seemed in person.

After greeting me pleasantly and making some brief small talk, Andre told me that they had had a late night and were just finishing their breakfast. He pointed to a large Adirondack chair at the far end of

the veranda and suggested I sit there and wait until breakfast was over. Then, he said, they would give me their full attention and we could get on with the business of the day.

I certainly didn't expect a full English breakfast but, gee whiz, I sure as hell would have at least liked a cup of coffee to take to my place of exile. Well, the sun was shining brightly, the view of the Sound was lovely, and the Sunday *New York Times* was on the coffee table (the one without the coffee), so I passed a reasonably pleasant twenty minutes while I waited for Andre and Fiona to fully recover from their "late night."

When I was finally summoned to their side, I brought out my "brag book" and showed them photos of a wide variety of my work. Apparently impressed, they took me inside for a tour of the downstairs, which was tastefully furnished, appropriately decorated, and featured a captivating mural painted by our friend. We stopped at the newel post. It was topped with a crudely carved and badly finished statue of a man and a woman dancing. For just the right words to describe it, I defer to Charlotte, my five-year old English critic, who would have cheekily said, "It's quite horrible."

Fiona and Andre seemed to agree. They had commissioned it the previous year, paid for it in advance, and, after living with it for nearly a year, had decided that it had to be replaced. Fiona asked, "Could you do one that was more graceful and . . . and more resembled us?" Andre was uncharacteristically quiet.

That's when I made them dance for me. With the aroma of the unoffered coffee still in my nostrils, I pulled out my camera and suggested that they pose in various positions. As they danced, I would periodically call out: "Stop." It was a bit like musical chairs, and much more fun—for me. A couple of times, when they were standing still, I had them adjust their position before I took the picture. I particularly enjoyed Andre's discomfort with being told what to do.

I promised to call them in a few days with a quotation and a time frame. When I figured the cost, I used my New York City numbers

(after all, they did have a Manhattan apartment), which are about 30 percent higher than my regular prices, and then, then I self-righteously added 10 percent for that missing cup of joe.

When I called, Fiona answered the phone. She was quite amiable but noncommittal and said she would discuss the price with Andre and get back to me.

I saw her two weeks later—on television—but she didn't mention anything then, or ever after, about the carving. I guess their dancing days are done.

Take It or Leaf It

The finely detailed drawings from the architect showed cascades of leaves weaving in and out of seemingly endless vines. The leaves themselves were carefully shaded and alluringly curved to emphasize their three-dimensional nature. These three 12" × 18" walnut panels were going to be a challenge not unlike the tasks that Gino had set before me during my English "apprenticeship." Filled with a discomfiting array of bevels, contours, and hollows, this leaf-panel design for an exclusive Manhattan club would require all the skills and artifices I had learned in twenty years of carving.

It all began when I accepted a two-part carving commission from a New York City contractor who was coordinating the remodeling of the club's interior. The other part, the elaborate top of a very large cabinet, was much less challenging, even though it was ten feet long and three feet high. Because its basic elements were similar to those found in many of the signs that I had previously carved, I was not nearly as concerned about its execution as I was about its smaller companion pieces, those glimmering, shimmering leaves.

I did the large piece first. As I had anticipated, it was the proverbial "piece of cake." Although it took a lot of time and a good bit of muscle (it was white oak), the carving moved along smoothly, presenting no unusual problems, and everything worked out perfectly.

As my eyes moved approvingly, and even admiringly, along my completed handiwork, one of them suddenly broke ranks and fixed its anxious gaze on the leaf drawing that was hanging on the adjoining wall. The other eye loyally followed, and for one very long and very

disheartening moment, we all glared at our looming nemesis—those damn leaves.

"In for a penny, in for a pound, said I to myself, said I." And hoping those two Briticisms would evoke the ghostly guiding hand of my mentor, I set the first blank walnut panel next to the architect's drawing and began planning my attack. It quickly became apparent that lighting was going to be the key to victory. If all those bevels, hollows, and contours were to be brought to three-dimensional life, the carving could only properly progress if the work was alternatively lighted from the top and from the side. So I rigged up a carving stand with two easily adjustable spotlights and engaged the enemy.

Ignoring standard military protocols, I went at the leaves with everything I had and left nothing in reserve. Though offering some resistance at first (walnut is a dense hardwood, but it quickly gives way to a sharp tool and a sure hand) the leaves slowly began to emerge from the solid. As the waste wood fell away from the leaves in the front, the vines surfaced in the rear. Thanks to Gino's insistence upon ambidexterity, I was able to consistently switch hands and confront the rapidly emerging leaves on both the right and the left flanks.

It was a rout, the first stage of what would soon be an unconditional surrender, even though there remained at least two days of cleanup work on the battlefield. But, for all practical purposes, the first leaf panel was done—and so was I. Exhausted, I looked at the clock for the first time since the battle had begun. It was just past nine at night; the opening cut had been made right after lunch. Eight hours of intense concentration with only a couple of breaks for tea and for pee. And, I was quick to remind myself, those bloody leaves had two more panels in reserve.

The next morning, I readjusted the spotlights and eagerly began the cleanup, trimming the bevels to catch just the right amount of light and shaping the contours to create the shadows that would accentuate the depths. The entire operation took a little over two more days

but, to paraphrase my old buddy Andy Sabini, "Those leaves, they was perfect."

Using the completed original panel as a model, I was able to comfortably finish the other two leaf panels without any of the anxiety and apprehension that had so dominated that unnerving first day. The leaves reflected the light in a way that accentuated their depth and gave them life; they conveyed the illusion of incessant movement, as if they were being caressed by a gentle, nurturing wind.

When the contractor picked up the carvings, I could see that he was very pleased. A few days later I received a note from the architect thanking me for so faithfully following his drawings and for producing some truly commendable carving. Practically speaking, I was even more pleased when the very substantial check for the outstanding balance cleared the bank.

But as things worked out, I was too quick to rejoice.

About two years after my triumph over the leaves, my wife and I were aimlessly wandering around central Manhattan one afternoon when we unexpectedly came upon the club where my work was installed. When we went inside, I explained my involvement to the manager and asked to see the installations. He complimented me on the work, told me where it was located, and left us to wander at will. In a spacious room, well lighted by large, high windows, I saw my ten-foot-long oak cabinet top piece. It had been lustrously finished with a dark varnish that accentuated the strong oak grain. Two craftsmen who had never met had somehow combined their efforts and produced a thing of beauty. But I had more important fish to fry. Where the hell were those leaves?

They were downstairs, the club manager had said, in the barroom. We walked into a dimly but warmly lit paneled room. The walnut bar and the traditionally mirrored backbar were exquisitely finished and the whole place evoked the elegance of a bygone era. But—I didn't see my leaves.

I asked the bartender. He was momentarily perplexed: "Leaves? Leaves?" And then—"Oh, the leaves, they're under the bar top. Move the bar stools aside and bend down. You'll see them there. There's three panels filled with them. Hey, just a minute, I've got a flashlight here. It's hard to see them without it. They look pretty good when the light hits them just right."

I took the flashlight. I turned it on. I aimed the beam. I saw them.

They had been installed upside down.

What to do?

Eleanor Roosevelt, a woman for whom I have enormous admiration, once asserted that, "It is better to light a single candle than to curse the darkness." However, in this particular situation, because the statute of admonition has run out and the politics of rectification are too perilous, I choose to leave my candle unlit and simply defer to the wisdom of an ancient Arabian proverb: "The tree of silence bears the fruit of peace."

And that is why the prince of darkness shall forever reign in the basement barroom of a prestigious Manhattan club.

The Man Who Loved Too Much

Oliver was the curator in charge of storage and inventory in a small museum, and he had a fondness for carousels. When he heard about my Empire State Carousel project, he contacted me with an unusual offer. Oliver was involved with a nonprofit cultural organization that was storing parts of an antique carousel in his museum, and he thought they might be willing to donate one of their animals to our project. So he gave me the names and addresses of two key people and suggested that I write them requesting a donation.

It was one of the easiest transactions in the twenty-three-year history of our carousel. Two months after I wrote, the director of the organization sent me a letter formally agreeing to donate a 1920s-era wooden carousel pig. He told me to contact Oliver and work out the delivery details.

When I got there, Oliver proudly gave me a tour of the storage area. It was a huge, high-ceilinged building with row on row of very wide shelves containing neatly arranged antique furniture and art objects that had been donated over the years. Because they had limited public display space, an inordinate amount of the museum's collection was in storage.

After we loaded the pig into the van, we agreed to remain in touch, a promise that we both kept. I saw a good bit of Oliver over the next couple of years. Very knowledgeable and well respected in the folk-art world, he became a valued colleague.

Our carousel was in the final stages of development when I got a phone call from Oliver. He had an unusual carousel ride—a revolving bench ride known as a lover's tub—in his museum that had been left there by the same group that had donated the pig. He said that if I wanted it, they would willingly donate it, but this time I wouldn't even have to formally request it. In short, it was ours for the taking.

Never one to turn down a donation, I drove to the museum the next day where Oliver helped load the tub onto our truck. He told me there was no need to write a letter of thanks; it was a minor piece, and the organization was glad to be rid of it. Like the pig, it was in rough shape, but, again like the pig, we were able to restore it to pristine condition, and we made it an attractive part of the Empire State Carousel.

Though you might think that should be the end of Oliver's story, it is, in fact, only the beginning of a grand story—a grand larceny story, if you please.

When the carousel was getting ready for its public opening ceremony, we sent personal RSVP invitations to our key supporters. Oliver was one of the very few who did not respond. So Arlene called him a couple of times and left messages on his office phone, but there was no response. We looked for him at the opening, because I wanted to publicly thank him, but he didn't appear. We had lost a good friend.

About six months after our grand opening, a story appeared in the newspaper about a museum official who had been arrested for stealing an enormous number of valuable antique items from the museum collection. We had found Oliver.

But, because it was our Oliver, it wasn't a normal theft. He sold nothing. He kept everything he stole in his home, where he integrated the items into his own furnishings and lovingly lived with his borrowed beauties. And when he had filled his own home, he bought a small house nearby that he tastefully furnished from his museum cornucopia.

According to the newspaper story, he would frequently pour himself a glass of port, light a fine cigar, put on some light classical music, and sit back and blissfully enjoy the splendor that surrounded him.

Oliver was not a common thief; he was an aristocratic art collector who had simply discovered an unusual way of collecting.

The authorities went easy on him. The stolen items had been kept in impeccable condition, and—not surprising—none were missing. Everyone seemed to understand that he hadn't stolen for profit; he had stolen for love. So what if Oliver lost his job and served a few months in jail? It was a small price to pay for all those years of fine wine and fine antiques.

And how did they find out about his theft? Well, it seems that he was going through a messy divorce, and his wife, or soon to be ex-wife, had alerted the police. Otherwise, because he alone supervised the museum inventory system, he might never have been caught.

For those of you who always look for a moral, you could say that it was the presence of love that led Oliver to steal and the absence of love that led Oliver to jail.

After the full story came out, we were more than a little concerned about our recently acquired lover's tub. Was it more of Oliver's booty or a legitimate bequest? For obvious reasons, that tantalizing question must remain forever unanswered.

Mon Frère En Bois

When my brother, who was the CARE director in Haiti during the 1970s, invited me to visit the island country, I jumped at the chance to experience this unique culture and meet some of the local woodcarvers.

Brother Larry had made arrangements for a car and driver/guide, a very personable and knowledgeable young woman who was fluent in the three local languages—Creole, French, and English. Marie and I spent two very full days together touring local historical sites and, best of all, visiting with local carvers. The most memorable moment was the day that Andre Dieubon, "the best woodcarver in all of Port-au-Prince," welcomed me into the brotherhood of Haitian carvers.

Marie took me to meet Andre at his studio on the edge of the city. His carving benches, and those of his two assistants, were under a metal-roofed, open-sided structure that was attached to a fully enclosed building; the back of the building contained his five-room home, and the front served as a shop for selling his carvings.

Andre spoke limited English, and I, despite four years of high school and college language courses, spoke even more limited French. But somehow, helped by Marie and our common profession, we managed to communicate quite well. After a delightful half hour of swapping stories, sharing carving techniques, and laughing together, Andre put his arm around me and told me that I was his "frère en bois"—his brother in wood. He then suggested that I go into his shop and see some examples of his finished work.

The shop, which was tended by a young man who spoke fairly good English, was filled to overflowing with carvings of all sizes, shapes, subjects, and complexities—chickens, market women, beggars, musicians, even some stylized abstractions.

My carver's eye quickly zeroed in on a beautifully executed one-foot-high relief of a Black Madonna holding a Black baby Jesus. Because none of the carvings were marked, I had to ask the shop assistant for the price. "Fifty dollars," he quickly replied. It seemed high, given what I had seen in some of the other shops, but there was no questioning the carving's quality and, remembering my Indian guru, I was not inclined to bargain, even with a shop assistant who apparently didn't realize that I was a fellow woodcarver. Then the obvious thought arose—I'll ask my brother in wood for the price without telling him about the $50 quote. That wouldn't be bargaining with an artist; it would just be looking for professional courtesy.

So I went outside to talk with Andre. In response to his questioning look, and with Marie's help, I told him how impressed I was with his Haitian Madonna and that I was thinking of buying it. He seemed quite pleased with my selection, explaining that it was the first time he had carved a Madonna as a Black woman and felt that he had made her very beautiful. Then he put his hand on my shoulder, cocked his head to the side and, smiling warmly, said, "Et le prix? Pour mon frère en bois, un prix special—seventy-five dollars."

That black Madonna serenely looks out at me from her central spot above my workbench where she every day reminds me that $75 is a small price to pay for such great beauty—and for such grand friendship.

It Ain't Over till It's Over

Her name was Celeste. She was a symphony in shimmering silver with a flowing black mane that swelled and curled like the crest of a surging waterfall. Her maroon and red trappings were delicately edged in gold and embellished with colorful assortments of flowers. Even though her piercing glass eyes and strong open mouth suggested great vitality, she was old—so old that, on some of the high points of the carving, well-worn wood showed through her alligatored silver paint.

Oh God, how I loved that horse. But, I didn't dare buy her without Arlene's approval, for Celeste was, even in the early days of the carousel-horse craze, exceedingly expensive.

Tom Watson was selling Celeste because he and his wife were splitting up after just three years of marriage and were turning their joint assets into cash. So I arranged for Arlene to see the horse at Tom's house but cautioned her that the high asking price might be negotiable and suggested that we establish a verbal code for communicating our feelings. "If you really like the horse, say, 'I thought it would be bigger.' If you don't like it, say, 'I thought it would be smaller.'" It was a variant on the good cop–bad cop approach that I thought would work well.

When we walked into Tom's living room a couple of days later to see the horse, Arlene, who has an instinctive flair for the bargaining process, went to the heart of the matter by quickly and cleverly

exclaiming, "Gerry, she's absolutely beautiful!" The good cop had shot the bad cop right between the eyes.

Because Tom was a decent sort who very much wanted to sell the horse, the bad cop finally did manage to get a few bucks knocked off the price, and a deal was made.

But hold on now, that's not the end of the story—no, not by a long shot.

I arranged to pick up the horse the following Saturday afternoon. However, Friday night, Tom called me to tell me that he and his wife had reconciled. As he explained it, when he told her that he had sold Celeste, she began to cry and, life being what it is and men and women being what they are, they ended up in each other arms. He apologized profusely for putting us to so much trouble; I, in turn, wished him well and expressed the hope that they would live happily ever after.

But—they didn't.

About fifteen months later, out of the blue, a phone call came from Tom. He told me that he was in the final stage of a divorce and Celeste was once more for sale. "Do you still want her? And, even though the carousel horse market has risen, I'll honor last year's price."

The next day, I drove up the long circular driveway to Tom's house with a pack of crisp hundred-dollar bills in my pocket and sunshine in my heart. When I rang the doorbell, a young woman opened the door, she was pretty and her eyes still showed signs of tears earlier shed.

"You must be Gerry. I'm Beth, Tom's wife. Tom is too embarrassed to talk to you. So I'll explain. We've patched it up again—and this time for good. And we're keeping Celeste. She's like a symbol of our marriage. If we keep her, we keep our marriage. We're both so sorry, really sorry, for bothering you so much. We hope you do understand."

What I did understand was that my love for this superb silvery steed was to remain forever unrequited. But, in my disillusionment, I had forgotten Yogi Berra's wise observation, "It ain't over until it's over."

Before the year was out, I got another phone call from Tom. It was over. He and Beth had signed the divorce papers that morning and he

wanted the "damned horse," the symbol of their marriage, out of his house and out of his life. Was I still interested? And, despite the fact that prices on the carousel horse market were still going through the roof, he again offered to stick to the original agreement.

I immediately went to the bank and, for the third time, got a new pack of crisp hundred-dollar bills. And early that evening, for the third time, drove up Tom's long circular driveway.

The house was completely dark, and there was no sign of life.

Shades of Berra! "It was déjà vu all over again."

I slumped over the steering wheel, cursing Tom, carousel horses, and a multipartisan array of gods. Celeste, the love of my life, was less than fifty feet away. Separated from me by only a fragile wooden barrier—and by my reluctance to commit a felony—she was never to be mine.

I sat in my car for fully five minutes, experiencing a wide variety of emotions. I wasn't angry; I was hurt, humiliated, frustrated, and, above all, incredulous that something like this could keep happening to me. As I began to slowly drive away, a pair of headlights appeared at the other end of the driveway. The lights flashed and the horn honked. Tom sprang out of the car and came running toward me. He was full of apologies. Unexpectedly, he had to work late and had no way to contact me.

If you ever come to my house, take a walk into the living room. There, in front of a rough-cut wooden wall, stands a symphony in shimmering silver with a flowing black mane that swells and curls like the crest of a surging waterfall. And I expect when you see my lovely Celeste, you'll agree with the good cop who once so astutely declared: "She's absolutely beautiful."

How to Be an Artist

It's knowing when to stop," proclaimed Gloria. "There was this nerdy guy next to me in my airbrushing class. We each had a piece of paper with a big circle on it. The instructor told us to use the airbrush to make the circle into a ball. This guy started spraying color before I even picked up my gun. In about thirty seconds his circle looked just like a ball—a shiny red ball. It was unbelievable! Then he spent the next ten minutes trying to make it rounder and turned that ball into a muddy-looking circle. He was a real nerd. He didn't know enough to stop. That's the difference between a mediocre artist and a good one. It's knowing when you've done enough. Yogi Berra, he said, 'It ain't over till it's over.' Well, a good artist knows when it's over."

Phil had an entirely different perspective: "Wait until tomorrow—that's what you have to learn."

"One summer, I was working outside on the picnic table whittling this little sailor out of a piece of white pine. By late afternoon, I thought the little guy was looking real nice and felt the carving was going great so I decided to finish it before supper. The light started to go and then the mosquitoes came, but the carving was still going good so I kept at it and finished just as it got dark. He looked pretty nice, so I put him on my dresser where he would be the first thing I saw in the morning."

When I woke up and saw the carving in the bright morning light, it was a real downer. The little sailor was awful. It wasn't at all the way I thought it was. It was full of mistakes. Big mistakes."

"I went too fast and got sloppy. I didn't take the time to step back and study it. I should have put it aside and finished carving it the next day. Ever since then, I wait until tomorrow and am never in a hurry just to get something finished."

"Toss it around," Gino insisted. "Don't be afraid to toss it around. That's the best way to shape hair. Lots of flowing curves that chase each other and graceful lines that dance. Lots of variety. No monotonous railroad tracks. Take a chance and see where it goes."

After a few more minutes of showing me how to loosen up my carving style, my mentor went off in another direction and offered some philosophical advice.

"And it has to look right no matter where you stand. Don't be careless with one spot just because it's on the bottom or in the back. It doesn't matter if other people won't notice it; you'll know it's not right, and so will your god."

- Know when to stop
- Don't be in such a hurry
- Toss it around
- You'll know it's not right, and so will your god.

Four practical suggestions for being a successful artist. And, in another more important sense, four pieces of sound advice for getting through this troubled world.

Creativity

There are some sweet day-dreams, so there are,
that put the visions of night to shame
—Charles Dickens, *Martin Chuzzlewit*

As any respectable New Yorker knows, the source of our majestic Hudson is a tiny trickle from a small Adirondack lake that the Indians called Tear of the Clouds. Its shorefront is a well-wooded and serene place that, on misty autumn mornings, evokes all the enchantment of ancient Arthurian legend. Although somewhat isolated, the lake's location is well known, and it is easily found. However, more enchanting than Lake Tear of the Clouds and much harder to find is the source of our ideas, the core of our creativity—that mystical grove of quiet darkness where our dreams are born.

A SECRET PLACE
For each,
There is
A secret place.
On a hazy mountainside
In a far distant region
Of my ever restless mind,
Lies
A deeply shaded,

Densely wooded glen,
Lighted only
By a quiet darkness.
A soft and peaceful place
Is my secret place,
A private garden
Where
Fantastic follies freely sprout
And
Different drummers dare to doubt.
Though sometimes
When I draw near,
A remorseful tear
Might slowly well,
It is still the place
The only place,
Where all my dreams
Can safely dwell.

For me, the task of understanding this elusive process of creativity has been simplified somewhat by the practice of keeping a journal, a habit which provides an opportunity to get some retrospective sense of the myriad forces and emotions that were quietly at work on me and within me while I was busily at work on the wood. From its pages, I get an overview of the transition that occurs as an idea undertakes its meandering and unpredictable journey, a journey that starts when a vague, abstract vision enters my mind and ends when a solid tangible form emerges from the wooden block.

> *6/26/86—Carving for me is like an adventure, it's exciting, stim-*
> *ulating and generates a great deal of apprehension and*
> *anticipation—I know how I want it to turn out, but I'm*
> *not sure I can control all the variables. When I carve ideas*
> *fall like rain—one line suggests another; a flow develops; a*

negative cut suggests a positive form—all of this goes on with-out deviating from the basic pattern. "You live in England but that doesn't mean you can't take a brief side trip to Wales or Scotland. Side trips up a wrinkle or down an eyelid," as Gino once said.

8/12/89—Sat down to breakfast this Saturday morning and with-out any warning, ideas began to fill my head almost as if it was bursting—grabbed some paper and began to write them down as they poured out—where do they come from? The Tom Sawyer *project is born—one idea builds on another—almost like a chain going overboard—they flow so fast I can't keep up with the pen—and then it stops! And I must strain for the nuances.*

11/18/88—I'm bursting with creative energy. It comes from my caving tools, from my pen, from my lips—and my head is so full of ideas that I can't physically deal with them all. Can it be that once the flow of creative energy is let loose, it moves like water flowing through a crack, getting increasingly larger and more powerful until it finally become a torrent? I feel today as if I am simply a medium through which all these ideas flow—it is my responsibility to select the viable ones, put them into coherent form and make them tangible . . . It all seems a bit messianic—careful, careful.

1/4/89—A downer since Xmas—having trouble working steadily. I'll have to analyze these dry periods to see if they're chemical (regular). There seems to be only so much creative energy available—once I use it up, I have to wait until the reservoir refills—perhaps tomorrow . . .

1/5/89—Good working day today—felt better and pushed a lot of paper that has been waiting for months . . . (I guess the reservoir refilled.)

3/2/91—I often wonder whether it is a curse or a blessing to have a fertile imagination and the concomitant ability to make highly unusual ideas become real. My mind is never still— even in sleep—I sometimes wake up and make notes in the dark. So many possibilities and the never-ending compulsion to put them into effect—I sometimes want to be Siddhartha during his final stage of life and simply sit quietly by the stream of life instead of constantly making plans to dam it or divert it.

A curse or a blessing? A recent informal study in England suggests that there is a link between artistic creativity and schizophrenia. While the findings of the study are far from conclusive, it offers the highly speculative theory that a creative mind is the product of a mild form of schizophrenia. In the classic, destructive form of schizophrenia, a patient looks out at life through a hazy window, sees a distorted view of the real world, and acts upon this warped view as if it were real; in the mild, constructive form suggested by the study, subjects appear to possess the ability to see through *two* windows. The first offers a vista they share with "normal" people; the second provides a view of an alternate reality they alone can see. These quasischizophrenic artists are sufficiently grounded in reality to understand that the view in this second window does not actually exist. But they are often so captivated by this alternative view that they feel compelled to employ a great deal of their talent and their time to give it life so that others may see it as well.

And what happens when you put a bunch of these quasischizo-phrenics together in the same room and try to make them all look out the same window? Walt Vandergrift, a transplanted Mississippian who somehow ended up as president of the Hudson Valley Woodcarvers Club, found out the hard way. Walt took on the responsibility of coordinating the carving of the three-foot-by-four-foot frame that his upstate club wanted to make for the carousel project. After much

heated discussion, they finally agreed that their frame would depict a variety of scenes from the west and east banks of the Hudson and have some sort of unifying theme on the top and the bottom. (I'm told it took three meetings over a four-month period to reach this point). That was the easy part; the difficult part was to decide the actual overall design and the subject of the scenes. Walt provided a bit of Southern folk wisdom to describe the difficulty of dealing with creative people.

> It was a tough job working with all those crazy Yankee woodcarvers. I asked them to draw stuff from the Hudson Valley that they wanted to carve on the frame but, at first, everybody brought in different kinds of drawings—all different sizes, all different shapes, all different subjects. Why, those guys had more ideas than a hungry hound dog in a butcher shop

But they did do it. The frame they produced was a credit to Walt's people-handling skills and to the talent of the Hudson Valley Woodcarvers Club. To my eye, it is one of best-designed and best-executed pieces of folk art on the carousel. It contains crisply carved scenes of such Hudson Valley landmarks as Washington's headquarters at Newburg, the Rhinebeck Aerodrome, and the West Point Military Academy. It even includes a profile carving of FDR with his omnipresent cigarette holder and his jutting chin. And they solved a major design problem by joining the two sides of the frame with a very appropriate carving of the Tappan Zee Bridge on the bottom and a Catskill panorama on the top. I guess they all finally found the same window.

However, this sort of large-group exercise in creativity was limited to the carving clubs and the quilt-making guilds. Because most of the other creative design work was done individually, the completed carousel designs largely reflect the workings of a single mind. And because the single mind with which I'm most familiar is my own, I am pleased to offer the reader an opportunity to stand in front of my

own special window and take a peek inside. (In truth, I am also very familiar with one other mind—my wife's, because she has, on many an unhappy occasion, given me a piece of it.)

Perhaps the obvious place to begin is with the overall concept of the carousel. The basic idea—a merry-go-round composed of riding animals indigenous to the state—was borrowed from Rich Brogan up in the wilds of Alaska, a place where the dark days and the winter winds often combine to give birth to some rather unusual offspring. (See Representative Don Young's "bridge to nowhere.") Although the Great Alaskan Carousel Project was forced into limbo due to a lack of funding, Brogan's idea haunted me all through the spring of 1983. I didn't want to let it go, because it represented freedom on so many different artistic and personal levels. But I didn't have a clue about what I could do to help him bring his idea back to life.

I have a clear memory of the moment of its resurrection—or more accurately, its reincarnation. It was on the Memorial Day weekend while I was sitting on the back porch of our Middleburgh farmhouse looking idly at the small hilly meadow behind us and hoping I would not have to take up my chainsaw and do combat with the relentless, encroaching woods that so obviously wanted their territory back. As I looked out, admiring the burgeoning beauty of our upstate spring, a skunk suddenly appeared at the edge of the meadow. It paused for an instant, raised its splendid tail like a martial pennant, and began to nonchalantly stroll across the open field toward the opposite woods, seemingly fully aware of its ability to dishearten both man and beast. Because that skunk moved with such elegant dignity, I felt it deserved to be immortalized as a piece of sculpture.

As I visualized the process of creating a skunk carving, my mind wandered along obvious and familiar paths: The wood? Basswood, because it would be painted. Who would paint it? Me or my daughter. The glue-up? The raised tail would be weak and need to be dowelled deeply into the body. The fur? Sharply carved with flowing curves or superficial and bristly? I played with the idea of carving this skunk,

almost like a cat toying with a mouse, pushing it around and chewing on it, just letting it all happen. I was doing something I love to do: mentally playing with images and watching them take fascinating forms, shapes, and turns as they evolve into something completely unanticipated. (Incidentally, recent research into mental imaging suggests that such activity can actually develop new synapses in the brain as effectively as the actual physical process.) And besides, there was another benefit: the more time spent thinking about carving the skunk, the longer I could put off the work of trimming back the trees on the edge of the meadow.

Somewhere in my mind, somehow in my thoughts, as it almost always does, the idea began to lazily meander and drift down uncharted streams. *Carve a carousel skunk . . . with an English saddle—or a western saddle. Carve a carousel woodchuck with enormous teeth—but he might look too much like a beaver. Let's see, what other animals live in our woods? A bear, a fox, a porcupine—no, not a porcupine. A snake? How the hell could anyone ride a snake? A deer—yes, a deer—a buck or a doe . . . Of course, a fawn.* And then, the explosion. I know of no other word to describe it. *A New York State carousel! I don't have to go to Alaska—no Great Alaskan Carousel. I'll make an Empire State CAROUSEL! I'll stay right here and do it here—and do it bigger and better—THE EMPIRE STATE CAROUSEL.*

In retrospect, it all seems to be such a simple and obvious transition. "Brogan can't build an Alaskan carousel so why don't I build a New York State one?" Why did it take four months and an arrogant skunk to make me see it? I don't know. I guess the answer lies somewhere in that quiet darkness where our dreams dwell.

After the initial explosion, it just flowed out as it always does. Each image, each idea came with a built-in link that pulled in another idea; it didn't take but a few hours for the entire chain to be rolled out. My job: to get some paper and copy it down accurately as it materialized. I felt somewhat akin to a secretary taking dictation from the boss. But

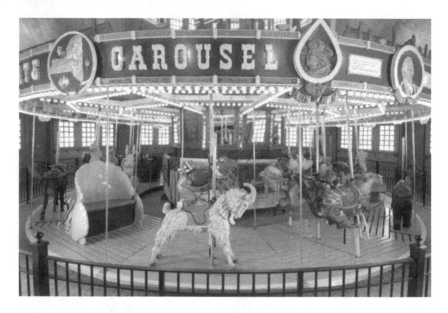

not exactly the same, because I didn't know then, nor do I know now, who that boss is.

> *5/30/83—The title changes—a phoenix emerges from the ashes of the Great Alaskan Carousel—now it has become the Empire State Carousel and I am its father and mother, its creator. And all because of that skunk . . . Spent most of Memorial Day weekend putting the ideas on paper. I never cease to be amazed by the way that writing . . . clarifies and organizes an idea. Obvious, I guess, but the act of writing certainly does breathe life, reality, and structure into nebulous and amorphous concepts. The Empire State Carousel exists—eight typewritten pages are its birth certificate—and what better place to born than on the back porch of our Middleburgh farmhouse.*

I guess one day soon, given all the evolving technological advances in neural imagery, the mystery surrounding the creative mind will no longer exist. The minds of Einstein and Michelangelo will be as easy to read and understand as are the primers of Dick and Jane. But, as for

me, I don't look forward to that day; I sort of like things the way they are. In much the same way that some things are best left unsaid, some things are best left unexplained. As Francis Pharcellus Church wisely observed in his classic essay, "Yes, Virginia There is A Santa Claus," "You tear apart a baby's rattle and see what makes the noise inside but . . ." once you do, all that remains is a torn rattle, a few stones—and no sound.

Richard Rodgers, the musical half of Rodgers and Hammerstein, provided another view of the creative mind in his musical *No Strings*. Written shortly after the death of Oscar Hammerstein, it was Rodgers's first attempt to do both the words and the music. One song from that score epitomizes his feelings and, I suspect, the feelings of all his fellow artists, whether they be painters, sculptors or poets: "The sweetest sounds I ever hear are still inside my head, the kindest words I ever know are waiting to be said . . . "

Doug Mackenzie, a friend whose vocation as a Spanish teacher and avocation as a jazz piano player provided him with a special insight into the world of mental sound, once explained, in a somewhat similar fashion, how it all worked for him. "I hear the notes inside my head and I play them just a split second after I hear them. It's easy for me even though I'm always a few notes behind the music I hear . . . It's like having a tape recorder in your head and simply copying off the tape."

And who put the music on Doug's tape recorder? Isaac Bashevis Singer, the Yiddish novelist and Nobel Prize winner, suggests a source: "There are powers who take care of you. If you're a doctor, you get sick people; if you're a lawyer, you get cases; if you're a writer, the Almighty sends you stories."

I found a similar thought in my journal, one that I had expressed years before I came across the Singer quotation.

10/6/89—Sometimes I just sit and sit and let my thoughts disap-
pear—I sit in a trance-like vagueness (I guess it's almost like

meditation)—and wait, and wait, and wait for God to send me an idea.

Rudyard Kipling evidently had comparable experiences but, rather that worry about sources, he suggests that one just sit quietly and remain receptively passive: "When your daemon is in charge, drift, wait and obey." A contemporary of his, William S. Gilbert, may well have been following this sage advice when the answer literally fell out of the blue. Vainly seeking inspiration for a new operatic theme, he was startled from his fruitless reverie when a Japanese ceremonial sword fell off its display hook on his study wall. And the enchanting result of his drifting and waiting? *The Town of Titipu*, or, as it is more commonly known, *The Mikado*.

Interested in obtaining another perspective, I explored the same idea of internal inspiration with Gloria Scheib, a very talented friend who specializes in intricately detailed pen-and-ink drawings. We compared my profession of woodcarving, a three-dimensional art in which the creative process requires the subtraction of material, with her profession of drawing, a two-dimensional art in which the creative process occurs through the addition of lines. Our discussion centered around what we saw in our mind's eyes during the creative process. Since we are both realistic, representational artists, we equally depend on external images and expend considerable effort to acquire good-quality visual references. But we found, because of the particular nature of our individual work, the way our minds process and use these images differs significantly.

Woodcarving as a typical subtractive art is a tricky business, because you have to train your mind to see lines and shapes within a block of wood. There is a classic story, probably apocryphal, about someone asking Michelangelo how he went about transforming a block of marble into a horse. His devastatingly sarcastic reply: "You take your mallet in one hand and your chisel in the other; then you just carve away everything that isn't a horse." Gino Masero explained

the process a bit more kindly but in much the same manner: "You have to work your way down to it." A few years of hard work and fuming frustration were the price I paid to discover what and where it was. It, I was to learn, was a point in three-dimensional space whose location is revealed to the mind of a woodcarver only after he has experienced years of hard work and fuming frustration.

Gloria doesn't have to look for it. Somewhat like Doug Mackenzie hearing his own internal tape recorder, she sees pretty much the entire finished picture in her mind. "All I do is copy the images onto my art paper." She makes it sounds so easy. And to make me even more jealous, she told me that she usually sees the picture in full color. (But she didn't mention the hard part—all those hours of research to find reference photos that she uses to achieve the exquisite accuracy that her detail-loving daemon demands of her.) How I envy her; she simply stops drawing when the picture in front of her is identical to the picture in her head. I, on the other hand, in my never-ending search for it, must continue chiseling and gouging and slicing and trimming and sanding and scraping until that mystical voice inside my head benevolently releases me from my herculean task by softly saying, "OK, Gerry, you can stop now. It's finished."

But even Gloria, like all mortal artists, must suffer the agonizing pain inflicted by those unrelenting imps—Anticipation and his cruel cousin, Separation. I found this entry in my journal, made the day she presented me with the completed pen-and-ink drawing of the carousel.

12/4/83—Picked up finished framed drawing from Gloria— MAGNIFICENT—every bit as good, even better than, I had hoped for. She somehow got right inside my head and took out the picture exactly as I had envisioned it. Coffee and cake and conversation with Gloria and Harry. We talked of many things, but her eyes kept straying to her drawing. I know exactly what she was thinking, because I've been there many times myself: "Pretty damn good—does he know how good

*it is? Does he appreciate the work that went into it? Should
I have made the turkey a little smaller, that saddle blanket
a bit redder, the quilt a lot larger?" For an artist, looking at
a finished piece of art is like coming back from a bombing
mission and conducting your own debriefing. You had put
your whole being into it, it absorbed your every waking and
sometimes even your sleeping moments—decisions about
color and line came during breakfast or in the shower—it
was never far from you and then, suddenly, it's over. It's
gone—this thing that occupied your life is yours no more—a
stranger has taken away a piece of your eternal soul. Forever.*

As another way of exploring some of these disparate musings, let
me take you through the creative process involved in one of my favor-
ite carousel carvings—Freddie de Frogge.

Freddie was inspired by a menagerie figure on a World War I–era
Herschell-Spillman carousel. That original piece was a "naked" frog,
quite realistically carved, wearing an abbreviated jacket, short pants,
a white shirt collar, and a bow tie. Since I had already "borrowed"
the entire idea for a state carousel from an Alaskan and elaborately
expanded the basic concept, it just took one more short step down that
slippery but well-traveled artistic slope for me to borrow the design of
an individual animal and transform it to accommodate my own needs.

Although the original idea was a product of the past, this process
of transformation was very much a creation of the present, which, to
complicate things a bit more, reached back into the past—but it was
my private past that it embraced, not that of the original frog designer.
Before I sat down to study that Herschell-Spillman frog and figure out
how to make it mine, I had already completed the *obvious* first stage
in the creative process—I had developed my skills, done my research
and found my muse. The *mystical* second stage began when I stared at
the photo of the carousel frog and asked myself three basic questions:
"What message do I want to convey? How will it connect to New York

State?"—and, most important to me—"What will I do to make people smile?" The questions having been asked, I, like Kipling, let my daemon take charge while I drifted and waited for the answers. I don't remember how long it took—at least a couple of hours, perhaps an entire morning, and certainly, a cup or two of tea, and maybe, even a walk up the street to get a candy bar. While I waited for the big answers, I kept one of those yellow legal pads next to me and jotted down words, both relevant and irrelevant, that floated down. Eventually the daemon did arrive with the biggie, as he nearly always does, and this is what he told me: "Remember that song they made you sing in your freshman year at college? You know, the one that ended with: *It's all a great big puddle and I'm just a little frog, Rum, tiddley um tum—tum, tum.* That's the answer. You—the frog should be you—in college at Albany—during the time when you were a bit too full of yourself and thought you were a real hot dog."

And that was it. Freddie was to be my autobiography. The rest was relatively easy and good fun. The tiny bow tie became quite large and was a replica of my first red polka dot bow tie—it was not a clip-on mind you, but a real, honest-to-goodness bow tie that I actually learned to tie myself. The small jacket was transformed into a one of those big-man-on-campus varsity cardigan sweaters, and the short fancy pants became a pair of chinos. Since the legs were quite long, I added the pair of argyle socks that had been knitted for me by my college girlfriend. Freddie's awkward flippers were enclosed in my first white bucks, which had the obligatory thick, red rubber soles.

To add depth to the character of Freddie/Gerry, to show his erudition, and to make people smile, I portrayed him as a slightly smug, somewhat self-important scholar. Two books form the back of the saddle: *A Gourmet's Guide Entomology* and *Famous Frogs of New York.* (Freddie's entry takes up three full pages while Kermit's barely fills one) In his webbed hand, he carries another book, which is entitled *Rana.* This has a double meaning: on the one hand, it parodies Zola's *Nana,* which I was required to read in my junior year, and on the other, it

refers to Freddie's family background: the species, *rana pipens*, one of which I delicately dissected in my sophomore biology class, is the frog most commonly found in New York State. The entire portrait of the old woodcarver as young frog is epitomized by the pennant he carries in his other webbed hand—"I ♥ New York—bugs." And, of course, Freddie is smiling, smiling as only a genuinely self-satisfied frog can smile

His first name was obvious from the start. Like the others, it had to have an alliterative quality so it was a straightforward matter of choosing between Frankie, Floyd, and Freddie. The patronymic, *de Frogge*, though not quite politically correct, was audibly suggested every time I heard the phrase, Freddie *the* frog; I playfully added the extra "ge" to give it an aristocratic flair.

Voilà, Freddie de Frogge, SUNY Class of '54!

I guess old Kipling had it right. Creativity is quite simple—just "drift, wait and obey."

Why?

For everything we do, there are the good reasons that we freely offer to the public and then—then there are the real reasons which we wisely keep to ourselves.
—Attributed to Winston Churchill

Why? Why build a carousel? They all asked me that. The reporters, the TV interviewers—even the school kids who came to visit our workshop. I certainly don't resent the question. It is an obvious one, and I usually enjoy answering it. In fact, the very act of responding has forced me to continuously analyze and monitor my motives. At the completion of what sometimes comes out as a sound bite of an answer, I occasionally hear that small, soft voice admonishing me: "Come on, come clean, there's more to it than that. Tell 'em the whole truth."

But the whole truth isn't easy; my motives were mixed at the onset of the project and have become increasingly complex as the years have worn on. The reasons of 1983 are not quite the same as the reasons of 2021. The lines between Churchill's "real reasons" and his "good reasons" have become so blurred that I am no longer sure what all the reasons are, nor can I reliably distinguish between the "real" and the "good."

But, what the hell, why not give it a try? So here they are—the good reasons, the real reasons, and whatever lies betwixt and between. You'll have to sort it out for yourselves.

The facts are these. I was a fifty-three-year-old part-time wood-carver who left a secure, well-paying and relatively prestigious middle-class job in 1987 to build a full-size merry-go-round that no one but me seemed to really want.

At a family gathering a few weeks into my leave of absence from teaching, a leave that evolved into a permanent departure, I experienced the first of what came to be typical reactions to the carousel-building scheme. While chatting with Sam Shapiro, Arlene's older cousin who owned a suburban Boston appliance store, I was asked how soon I expected to become a principal. When I explained that such a move was quite unlikely because I was on leave to build a carousel, his face darkened and took on an incredulous look. The stunned silence that accompanied this expression was eloquent and foretold the response I would so often encounter during that frazzled first year. Sam needed no words to express his disdain for me and his pity for my wife; his face said it all: "A *meschuggenah* [madman]. Poor Arlene, just like her mother before her, she married a real meschuggenah."

Perhaps Sam was right, and I was then, and am still, a madman. Like Zorba, I would want to think that the source of my madness lay in my desire to cut the rope and be free. In a self-serving response to Sam, let me offer a couple of rhetorical questions: Who is better off? Who leaves the world a better place? Meschuggeners like me or all those sane appliance salesmen like you?

Phooey on you, Sam Shapiro. I'm with Susan B. Anthony, whose words I have made a permanent part of the Empire State Carousel: "Cautious, careful people, always casting about to preserve their reputation and social standing, never bring about reform."

Was that a real reason or a good reason? You decide.

Here's another reason—a very simple one, succinctly put, but in an entirely different context—by Edmund Hillary when he was asked why

he risked so much to climb Mount Everest. His unforgettable reply: "Because it was there."

I'm certainly not audacious enough to compare myself to Hillary, but I am practical enough to borrow his reasoning: I built the carousel because it could be done. Building it represented a challenge—the challenge of seeing whether one determined individual could take a slightly bizarre idea, shape it into a viable project, and guide that project to completion. And more important, this work would be done by an individual, not by an existing, established institution. It would be done, not in the way that the astronauts went to the moon but more like the way that Lindbergh crossed the Atlantic—on my own. It would be another way of saying that one person working outside the increasingly suffocating corporate and institutional structures could still accomplish something of significance and value (even if he had to make use of corporate and institutional money to do it). It short, it would be a test, a test of all the skills I had acquired as a woodcarver, a teacher, a writer, an administrator, and a public speaker. And, in undertaking that test (or quest), who knew what unanticipated adventures would present themselves and what enticing side roads would unexpectedly appear. It could be like one of those Norse sagas that my friend Gino was so fond of.

Or maybe there was something else at work, a challenge fundamental to the creative soul.

IT COULDN'T BE DONE BY EDGAR GUEST

Somebody said that it couldn't be done,
But he with a chuckle replied
That "maybe it couldn't," but he would be one
Who wouldn't say so till he'd tried.
So he buckled right in with the trace of a grin
On his face. If he worried he hid it.
He started to sing as he tackled the thing
That couldn't be done, and he did it.

Somebody scoffed: "Oh, you'll never do that.
At least no one ever has done it";
But he took off his coat and he took off his hat,
And the first thing we knew he'd begun it.
With a lift of his chin and a bit of a grin,
Without any doubting or quiddit,
He started to sing as he tackled the thing
That couldn't be done, and he did it.
There are thousands to tell you it cannot be done,
There are thousands to prophesy failure;
There are thousands to point out to you, one by one,
The dangers that wait to assail you.
But just buckle in with a bit of a grin,
Just take off your coat and go to it;
Just start to sing as you tackle the thing
That "cannot be done," and you'll do it.

During those stimulating twenty-three years of uneven progress, I became nearly as infatuated by the process of building the carousel as I was with the vision of the completed merry-go-round. There were moments of euphoria and high elation—the unrestricted $20,000 start-up grant from Scrabble and Trivial Pursuit mogul Dick Selchow; those four full minutes of national TV time on Tom Brokaw's evening news; the glorious grand opening of the carousel in 2003. And there were moments when we watched in despair as these soaring balloons of progress were punctured by political malice and economic realities and sent plummeting earthward: a $250-an-hour lawyer who took months to file simple incorporation papers and a badly torn leg muscle that prevented me from carving for three months. And the cruelest blow of all, just three weeks after the grand opening came the grand closing because our building was deemed unsafe for public occupancy.

But whether the winds that propelled the Empire State Carousel have been good or ill, the voyage certainly has made my juices flow and

has enriched my life in ways I never could have anticipated. Deep into the trough of my middle years, it provided me with a chance to expose F. Scott Fitzgerald for the false prophet he was: in my American life, there could be a second act.

The process of building the carousel provided me with an entrée into the worlds of art, politics, corporations, and journalism. While I certainly haven't penetrated into the center of these esoteric worlds, I have gone far enough inside to discover some intriguing relationships that, in turn, have given me a much better understanding of the society that I live in. In the course of my carousel travel, I have made friends in communities throughout New York and have become an authority of sorts on the state's geography, topography, local legends, back roads, and place names. Thanks to the Empire State Carousel, I can now spell Shenendahowa and Skaneateles without consulting an atlas, translate Tonawanda—the place where the water ends—and show you the exact spot in Middleburgh where Revolutionary War–hero Timothy Murphy tore his leather britches sliding down Vroman's Nose. Along the way, I learned how to pull a trailer, paint with an airbrush, write a press release, change music rolls on a band organ, and read an architectural blueprint. But best of all, because it could be done and I did it, I was able to bring a little bit of Zorba's madness into my life.

During those twenty-three years of "tackling the thing that cannot be done," I had the good fortune to be able to carve approximately half of the Empire State Carousel—twenty-three portrait panels, seven folklore panels, nine riding animals, two chariots, two State medallions, and the major portion of a band-organ facade. The variety and the magnitude of that carousel work, combined with some commercial commissions that routinely came along, enabled me to master the skills needed to be considered, in Gino's words, "a proper woodcarver." I got to do it all—ornamental work, classical swags and drops, incised and raised lettering, deep and shallow relief, full-round sculpture, precise portraits, even a bit of heraldry. I got proper calluses on my hands and proper edges on my tools. I even reached the point where I

stopped feeling self-conscious when I was introduced to audiences as a master carver. In fact, I still clearly remember the moment in 1992 when I filled out a tourist entry form at Heathrow Airport and, without hesitation or thought simply printed the word "woodcarver" in the occupation box. For me, it was like a rite of passage. It was Act II.

Our Legacy: The Things We Valued

It is my firmly held belief that each generation has an obligation to identify, preserve, and perpetuate those elements of its cultural heritage that have been of value during that particular generation's brief moment of existence. The Empire State Carousel is based on that belief; it provides a foundation upon which a comfortable cultural middle ground can be built. This carousel has no academic axes to grind, no political constituency to satisfy, no ethnic biases to proclaim. It is simply a joyful place to visit where youngsters of all ages can come together and, hopefully, begin to identify and appreciate the common threads that hold together the fabric that we call New York State. It is indeed, to use my wife Arlene's delightfully descriptive slogan, "A museum you can ride on."

With its creation, I have provided my generation with a splendid platform, a "bully pulpit" if you will, where we have worked together to satisfy our obligation to transmit the things we value—those sights and sounds in which we found beauty, the ideals that motivated us, the myths that have fired our imaginations, and, perhaps most important, the fiery spirits of the people who have inspired us.

However, it must be kept in mind that the carousel doesn't pretend to be a platform for the promulgation of authoritative history, if indeed, there be any such thing. Fully aware of the dangerous nature of arrogating truth, I have not yielded to the temptation to present idealized history in the style of those nineteenth-century elementary school hagiographies that spoke adoringly of George Washington's cherry tree and Honest Abe's borrowed book. On the other hand, I

have not accepted the cynicism of Napoleon's blanket dismissal of history as "a lie agreed upon." The carousel's version of truth might be best described as reliable inspirational history, history that admittedly embellishes and polishes here and there but history that never loses sight of the fact that the events of the past are created by and recorded by flawed creatures with faulty memories. If it doesn't always accurately show what New York was, it certainly always strives to show what New York imagined itself to be.

Just as it is normal for an entire generation to want to transmit its most cherished values and traditions, it is also natural that individual members of a generation would want to leave behind some tangible personal evidence that they once walked this earth. Most commonly, we leave a genetic heritage through the simple biological act of producing children and we leave a physical legacy by paying someone to erect a cemetery marker. That's it. For most ordinary people, these two phenomena offer the only permanent public evidence that they once existed. Sure, there are the Henry Fords, the Thomas Edisons and the Rembrandts and the Mozarts, even the Hitlers. And of course, there are all those rich folks and politicians who love nothing better than putting their names on buildings and highways. But for the rest of us mere mortals, that's usually it—kids and tombstones.

During the decade of the 1990s, my three daughters gave me the gift of grandchildren—two from each, a grand total of five grandsons and one granddaughter. While some might say, in these days of exploding populations that three children and six grandchildren are enough of yourself to leave behind, I am egotistical enough to want something more tangible and more permanent. And I want their children—my great-grandchildren—who I will probably never know, to know me.

I want them to see the Empire State Carousel and understand who Gerry Holzman was. I want them to walk up to Freddie de Frogge and chuckle with appreciation as they look at this charming, pretentious creature who sports such a silly smile. And I want them to ask why I put those ridiculous white bucks and argyle socks on Freddie's webbed

feet. I want my great-grandchildren to touch the carved books behind the saddle and admire the way I made the wooden covers look like soft leather.

I want them to ride the carousel when it is packed with laughing, happy people and join them as it carries the riders into its fantasy world—a world of band-organ music, flashing lights, shiny jewels, and shimmering mirrors, a world filled with whimsical carved animals who seem to come alive—and I want my great-grandchildren to know that their great-grandfather created that world—for them, and for all who came with them, and for all those who come after them. But, to satisfy my "soft, small voice," I'll have to come clean and be completely honest; I also want the carousel to say for me. "I was here. I was here for just a little while and this is what I did."

That's the selfish side of the egotistical coin. The altruistic side bears the stamp of all my fellow craftspeople and artists who shared the task—and the glory—of creating the carousel. Whether they be a Joyce Muller whose three hundred stenciled symbols look down from the rafters or an Ellery Barnaby whose big brawny moose stares out from the platform or a Bob Grauer who restored the entire antique mechanism, a thousand other artists and craftspeople can proudly say to future generations, "We were here. We were here and this is what we did!"

Henry David Thoreau defined an artist as someone who has the ability to improve the quality of another person's day. Although this is a broad and potentially controversial definition that could be easily stretched to embrace such diverse groups as doctors and undertakers or barbers and basketball players, I sort of like the direct simplicity of the concept and feel comfortable applying it to the carousel. To improve the quality of another's day—it's a phrase that gets to the heart of what the project is all about.

A true artist creates because he must. Possessed by a daemon who must be placated by an endless array of offerings, each one better than the next, an artist creates because he has to find an appropriate

outlet for his enormous creative energy—an energy that can be best described as an intense, internal physical pressure only eased through the actual physical act of creation. It is much like a boiler that will burst unless its steam is released and put to work.

If one accepts this description, the act of artistic creation must appear to be a selfish act. And that is certainly true. But herein lies the magic of the carousel. The selfish force that drives its artistic creators results in an altruistic product—delightful objects that improve the quality of another's day. The colorful patterns of the quilts, the delicate feathers of the songbirds, the whimsical charm of the riding animals, the booming magnificence of the band organ—all of these enrich the lives of both those who create them and those who experience them.

And for me, the satisfaction is doubled. Not only have I propitiated my own creative daemon, but I have provided a thousand other artists with the same opportunity. And I guess that's not such a bad way to spend twenty-three years of your life.

The Woodcarver and the Winemaker

During the twenty-three years we spent creating the Empire State Carousel, nearly one thousand people were involved in the project. Although we recruited a few key artisans, most participants volunteered without being asked.

The people who came were a surprisingly diverse group, but even more surprising was the sheer variety of the creative things that they could do. They ranged from a quilter whose mother taught her to sew in a Cooperstown farmhouse by the light of a kerosene lamp to an inmate from Dannemora prison who carved a section of the upper canopy molding (how he got the cutting tools, I'll never know).

By way of explaining the mystical process of orchestrating the artistic creativity that became so much a part of our carousel project, I once again turn to Isaac Bashevis Singer's insight: "There are powers that take care of you. If you're a doctor. you get sick people . . ."

Singer was right on the mark. We were running a woodcarving project so, of course, we got woodcarvers. And who did the powers send us? Andy Sabini, an eighty-two-year-old retired roofer, machinist, woodworker—and winemaker.

I'll let Andy explain, in his own words, (edited from our carousel oral archive) how and why he got involved in the carousel project:

> While I was cleaning out my garage, I found a set of my father's old carving tools. They was in pretty good shape, so I looked around for something to do with them. Then I remembered about some guy running a woodcarving project in Islip, and I drove over. This guy, Gary, [despite being corrected innumerable times, Andy persisted in calling me Gary] he looked like a pretty good fella, so I showed him my tools and asked if he had anything he wanted carved. I told him if he gave me something and he didn't like the way it came out, why he could just take it and throw it in the fireplace—there'd be no hard feelings on my part.
>
> Well, Gary looked at me for a while—I guess he was trying to size me up—and then smiled. He said yes, he might have something. I told him it had to be real simple because I never did do much carving before. He went upstairs and came down a couple of minutes later with a picture of the Statue of Liberty and a cutout piece of wood that sort of looked like her. He said, "Take this home and see if you can make it look like the picture."
>
> That's how it started. I worked all day on the piece of wood. Most of it came out good, but I couldn't get the eyes right. Then I got a great idea. I took two small nails and hammered them into the eye sockets. It was like the statue was looking right at you. It was perfect.

> I brought it back to Gary the next day. He kept turning
> it around in his hand and he looked kinda funny. Then he
> looked up at me, just like the day before, still trying to size
> me up.

I'll interrupt Andy here and offer my version of the moment:

When Andy walked into our workshop, his face was highlighted
by a wide smile. Cradling his little black schnoodle in one arm, he
confidently held out the carved Statue of Liberty in the other hand.

My first reaction was one of total dismay. It was much too flat and
square, the drapery was lumpy, and the torch resembled a crude stick.
But the ultimate shock came from his use of shiny metal brads for the
eyes. Trying to hide my disappointment, I looked up at Andy and saw
a very obvious expression of pride—that powerful emotion so familiar
to me—the pride of creation. His old, well-weathered face said it all:
"Hey, look what I just did." I wisely kept my mouth shut

I looked at the Statue of Liberty a second time, this time not with
the eyes of a critic but with the soul of an artist. It really wasn't that
bad. In fact, the more I looked, the better the carving appeared. It was
as if it was undergoing a metamorphosis in my hand. In that very long
moment, many conflicting thoughts crossed my mind, chief among
them being a bit of wisdom presented many years earlier during
my public school years by a ninth-grade student of mine who had
chided me about setting unrealistically high standards: "Just remem-
ber, we're not all little Mr. Holzmans," cautioned fourteen-year-old
Gerard Pelletier.

Then and there, I made a decision that ultimately changed the
entire artistic concept of the carousel—it no longer had to be the finest
carousel ever carved; it simply had to be an honest expression of the
artistic souls of ordinary New Yorkers.

That said, I'll let Andy continue:

> And then Gary, he said, "It's just what I wanted. No fire-
> place for this carving. In fact, I want twenty-two more."

And he went back upstairs and brought down a whole box of those cutouts.

So I carved him twenty-two more. And when I finished those, Gary, he brought out twenty-three Empire State Building cutouts, and I carved them. After that, he kept giving me lots of cutouts—buildings from all over the State, and I carved them.

He kept me busy for almost two years carving those buildings. One time, there was a snowstorm and I had run out of carving blanks and I got bored just watching T.V. So I drove ten miles in the snow to Gary's place and got some more blanks.

Gary was always friendly with me, but I use ta worry that he would stop giving me work to do so I tried to stay on his good side. That's why I started giving him the wine.

I make my own wine; it's real good, but it's strong stuff. The first time I brought him a bottle, he looked at it a little funny maybe because it was in a big glass soda bottle. I guess, like he always does, he was sizing it up. I made him a little toast so we could drink together, and I could see if he liked it. Well, he sure as hell looked like he did. So I brought him a bottle every couple of weeks to keep him happy. It must have worked, because Gary, he kept giving me those blanks.

All together, I did one hundred and thirty-eight carvings for the carousel. But the ones I always liked best were the Statues of Liberty with those shiny eyes. They was perfect!

Boids by Marshall

John Marshall was an elementary school custodian who created hand-carved birds in his spare time. But these creations were not just your ordinary, everyday sort of carvings; they were anatomically accurate, exquisitely detailed and flawlessly painted bird carvings that would have satisfied even Old Man Audubon himself.

John had grown up in Brooklyn so, of course, he called his creations "boids." Although his wife was somewhat bothered by his habit of keeping dead boids in the refrigerator for reference, his family was generally supportive of his pastime. In fact, his son had business cards printed that proudly proclaimed "Boids by Marshall." And it was one of those cards that first brought John and me together.

I can't recall how I came across his card, but, at the time, it offered the perfect solution to a pressing problem. I had been looking for a unique gift for my wife to commemorate our twentieth wedding anniversary and a Boid by Marshall sounded like just the ticket.

Arlene was fascinated by the routines of a pair of mourning doves that had established their home territory on our front lawn. She liked the way they would interact with each other and greatly admired their overall appearance. She was particularly taken by their subtle brownish-gray coloration and their blue and white tail feather display.

So it was that I met John at his modest home, which turned out to be just a few blocks from mine and not much further than that from the school where he worked. He was a short, slight man, wearing wire-rimed glasses and simply dressed in worn and wrinkled gray cotton work clothes. I guessed he was in his early sixties, about twenty years

older than me. To the kids and the teachers, he must have appeared as a completely ordinary and unimposing guy—a stereotypical custodian, if you will. But when we entered the small enclosed sun-porch that was, at once his workshop and his aviary, it was immediately apparent to me that John Marshall was an artist. The shelves were filled with at least two dozen birds on all sorts of perches and in all sorts of poses. Looking as if they had just dropped in for a quick afternoon worm, the birds were alert, watchful, and seemingly ready to fly off at the slightest hint of danger. You had to touch them to be assured that they were wooden carvings and not actual flesh and blood.

In that moment—although we had grown up in different places in different generations and lived and worked in two different worlds—I knew John and I were colleagues, fellow artists in wood. And colleagues we remained until he died in Florida a few years ago.

Some sense of the boid man of Long Island can be obtained by reading excerpts from a letter he sent me not long before his death. He had bought a copy of my Empire State Carousel book and had written this thank-you letter in response. The letter was on lined notebook paper punched with the requisite three holes, and, except for the cursive signature, it was written entirely in capital letters.

DEAR GERRY,

IT WAS VERY NICE THAT YOU SENT YOUR BOOK. THANK YOU . . .

OUR CARVING CLUB PROJECT WAS TO FIX A SMALL CAROUSEL THAT SOME MEMBER HAD. I CARVED A HORSE THAT LOOKED LIKE A MULE. SO I DID ANOTHER ONE WITH THE HELP OF A BOOK FROM THE LIBRARY. I AM SENDING YOU A PICTURE . . .

YOUR BOOK ON YOUR CAROUSEL IS GRATE [sic] IT BROUGHT BACK OLD MEMORIES. THEY WERE THE BEST DAYS—JUST A LITTLE HISTORY. I MOVED TO

FL. IN 1988. AND IT WAS A GOOD THING. THE TOWN IS SMALL. NO TRAFFIC LIGHT—THATS SMALL.

GERRY IF YOU HAVE ANY BOOKS THAT YOU COULD RECOMMEND I WOULD LIKE TO HERE [*sic*] FROM YOU. THIS IS THE FIRST LETTER THAT I WROTE SINCE I LEFT FOR THE SERVICE IN 1942 . . .

KEEP IN TOUCH

John Marshall

I HAVE NOW REACHED MY 90 BIRTHDAY [*sic*] AND LET ME TELL YOU THINGS CHANGE BUT YOU KNOW

This letter should in no way be misconstrued as an attempt to belittle John. I have presented it to show the simple sincerity of the man and as another example of the way a common interest can encourage deeply dissimilar people to find their common humanity. But perhaps most important is the fact that this is the first letter John Marshall had written in sixty-eight years. And he wrote it to me. I felt greatly privileged and deeply honored to have gotten it.

John didn't have a mourning dove on his shelves the day I visited his home, but he willingly offered to carve one for me. The price was modest, very modest, considering the excellence of his work. He brought the finished carving to our house a few weeks later on the very afternoon of our anniversary. I had prepared Arlene for his visit, but I hadn't properly prepared her for the superb quality of his boids.

My wife is a straightforward, emotional woman who rarely holds back her feelings. She took the bird, which John had attractively mounted on a tree branch, and turned it round and round in her hands. Caught up in the exquisiteness of the overall presentation, she got a little teary, kissed John on the cheek, and thanked him warmly. "It's absolutely beautiful," she said, "We'll treasure it forever."

After John left, Arlene confided, "I was hoping he'd show those beautiful tail feathers and have it mounted it on the ground because that's how I see them most of the time. But, it's so skillfully done, so lovely, and he was so proud of it, I didn't have the heart to say anything. So, I'll keep it and love it for its beauty."

A couple of months later, I drove John to a meeting of my carving club so that he could decide if he wanted to join it. During the ride, he asked me about Arlene and the mourning dove. At first, I was politely complimentary but then, forthright fool that I am, told him of her reservations. He took it quite well and immediately offered to take it back and carve another. Of course, I refused his gracious offer, but he insisted.

The following month, when he delivered the newly carved dove— tail feathers in full display and tastefully mounted on a rough-cut board—Arlene was ready for him with a teary smile and a freshly baked apple pie to take home. It was the beginning of an enduring friendship.

John joined the carving club and became involved in the Empire State Carousel project by carving two songbirds for it. He showed me how to carve and paint birds and, most helpful, he taught me how to use a burning pen to create ultrafine details like the feathers. He had even concocted a Rube Goldberg–style device that used different wattage lightbulbs to vary the heat of these pens.

I, in turn, tried to show him how to use the various carving gouges, but he preferred his knives, files and burning pens. Although John came to our public museum/workshop every once in a while and we would sometimes meet for a cup of coffee at the local diner, he was never completely comfortable outside his sun-porch workshop. Our restrained friendship was centered on sharing carving experiences, and, though it was strong and genuine, it never extended beyond that core.

One evening, while I was showing his mourning dove to some friends, I realized that I hadn't seen John in quite a while. After making some inquiries, I learned he had retired and moved to Florida. As far as

I know, there had been no goodbyes anywhere; he just left Long Island and moved to the small town that had no traffic light.

And for years, that was that. He must have seen my book advertised somewhere and ordered a copy from our carousel office, where no one knew his name and consequently no one thought to tell me about it. And then, the letter arrived. In response, I sent him some suggested book titles, brought him up to date on our few mutual friends and promised to keep in touch. I put him on the carousel's mailing list, so he must have regularly received our newsletters, but I didn't hear from him again.

As I write these words, I realize that the loss of contact is much more my fault than his. I write letters all the time; he wrote only two in sixty-eight years.

John, I'm sorry.

But John, take comfort in the fact that Arlene and I still cherish your boid. It proudly sits on the table by our front door so everyone who enters can see it. And John Marshall, I'll always be grateful for your gift of friendship—and for that letter.

There Are Many Roads to Rome

I met Bruno Speiser early in my carving career, when we happened to be assigned side-by-side exhibition spaces in an outdoor art show. We were among a half dozen craftsmen competing for the first prize in woodworking. When I examined the quality of the large Indian face that he had carved, I knew I had lost the competition. Fortunately, the judges where not as sharp-eyed as I was, so I got the blue ribbon while Bruno came in a very gracious second. And, in the mysterious way that these things happen, we became close friends.

It was Bruno Speiser who first introduced me to the world of the carousel, way back in the mid-seventies, a time when the Bicentennial craze had focused attention on that hitherto neglected area of American folk art. A self-taught amateur art restorer and conservator, Bruno had used his boat-building and metallurgical skills to bring all sorts of antiques back to life. Because he had a long-term fascination with amusement parks, he became particularly interested in carousel art and developed some very practical techniques for restoring carousel horses. He had a couple of basket cases—badly broken horses with missing and/or rotted parts—in his home workshop and offered to sell me one and show me how to restore it. By accepting his generous offer, I had, without realizing it at the time, found my American counterpart of Gino Masero.

In teaching me how to restore that carousel horse, he also introduced me to the romance and the fantasy of the carousel world and

to the practical economics of buying and selling carousel art. Because Bruno was a master craftsman who tolerated nothing less than perfection, his informal course of study on Long Island was an ideal complement to the lessons I learned from Gino in England. And because he and his wife Beth willingly shared their business acumen with me, I learned how to navigate the choppy waters of the antique marketplace and was able to use those skills to supplement my carving income.

We became an unlikely pair—the neat, precise, cautious, pious German Lutheran and the messy, casual, impulsive Hungarian secular Jew. Early on in our friendship, he shrewdly and succinctly put his finger on the difference between our approaches to woodcarving when he said, "I'm a craftsman, you're an artist." It's not that he saw one as being superior to the other, nor did he feel that being an artist precluded having some of the qualities of the craftsman, and vice versa; he simply felt that, because we approached a task with instinctively different attitudes, we would usually get very different results. Bruno elaborated on the distinction by explaining that he knew, at the outset of a every job, exactly what he was going to create—its size was predetermined down to the millimeter, its exact color was selected on test boards, its precise shape was made first in clay or Styrofoam. Since I was an artist, he continued, I knew generally what my product would be like, but its final form could only be determined by a series of lucky and unlucky accidents and by impulsive inspiration. In short, he copied; I imagined.

I guess Bruno was mostly right, but he didn't factor in the underlying irony of the relationship. I envied the precision of his work and he envied the looseness of mine, so we both, consciously and unconsciously, continuously strove to fight with our natural instincts and emulate the other.

Remember my laid-back approach to my annual autumn custom of carving faces on white birch trees? I never picked out the tree in advance. I would just meander through the birch grove until one caught my eyes. Nor did I usually know what kind of face I would create until I saw the contour of the tree. And then, I would just let the

chips fall where they may until I got tired or the early-fall light began to fail. The carving was done when it was done. The work was as much about easing my soul as it was about creating a carving.

Now, for purpose of comparison, lets take a look at the way Bruno handled the job of carving hundreds and hundreds of identical fish scales on Benny, our five-foot-long carousel brook trout. First there was the test board. He had precisely drawn three sets of fish scales on a scrap piece of basswood. Each set had been cut with a different contour gouge; each was beveled and trimmed to catch light from a different direction. He would select one set and carved it on Benny.

The rows for the scales were located by the use of locator dowels. After he finished shaping the basic carving block, he inset five one-eighth-inch dowels at various places on the fish body, points which he used to transfer his measurements for body details and decorative trappings from corresponding points on his Styrofoam trout—a five-foot model he had created from his five-foot-long, anatomically correct drawing of the New York brook trout, our official state fish. Two days later, after endless cups of coffee and ceaseless measurements, the scales were done. Every row was in exactly the same place as its counterpart on the drawing, every scale was identical to the one next to it, each was tucked under its neighbor at the same precise angle, and every bevel reflected just the right amount of light.

Spontaneous faces on white birch trees and identical fish scales on a wooden brook trout—each the measure of a man and each entirely appropriate to its situation.

Or, if you want to look at it from an entirely different perspective, the coupon caper offers a perfect illustration of the difference between us. Accompanied by our wives, we went to dinner one evening at a restaurant that had advertised a coupon special—20 percent off two dinners. When the check arrived, Bruno reached into his jacket pocket and produced a small envelope from which he removed his neatly trimmed newspaper coupon, securely scotch taped to a 3" × 5" index card. I, in turn, extracted my mangled coupon, which I had carelessly

torn out of the paper, from the depths of my pants pocket, smoothed it out a bit and, somewhat apologetically, placed the humble, wrinkled offering on the check tray alongside Bruno's unblemished index card.

Different-looking coupons, but we both got our 20-percent discount. Different approaches to carving, but we both produced very respectable pieces of sculpture. Even now, as I watch Bruno's Clarissa Cow and my Bucky Beaver whirl round on the outside row of the Empire State Carousel, I would like to think they are each a bit better than they might have been had Bruno and I not had the opportunity to influence each other. I know that our interaction made me more of a craftsman, and it is my sincere hope that it has also made Bruno more of an artist.

Epilogue

At an early point in our friendship, I introduced Bruno to another carving buddy, Jim Beatty. Because there was good chemistry between the three of us during a couple of projects we worked on, we made what turned out to be a disastrous decision. Like Harry Truman and Edsel Ford before us, we became failed businessmen, a title we justifiably earned by engaging in the opening and relatively rapid closing of a commercial woodcarving shop.

Out of this venture came the awareness that sometimes, when you carve it—they do not come. We discovered that being competent and creative woodcarvers does not automatically make you into successful businessmen. The day-to-day demands of the business world—bookkeeping, marketing, and catering to customers—proved to be too tedious for our expansive creative souls. So after just eighteen months of keeping shop, a period when we barely covered our expenses, we ended our business venture and closed the shop. But, while we failed in one sense, Beatty, Holzman and Speiser Woodcarving Incorporated did succeed in another: Jim, Bruno and I built a treasured relationship that we maintained throughout our lives.

I was asked to deliver the eulogy at Jim's funeral, and Arlene and I had the honor of being the only nonfamily members to be invited to Bruno's ninetieth birthday celebration.

As my old English mate was wont to say, "We're lucky fellows, us carvers."

Another Way?

Never forget that, Gerry—communicating,
that's what we're about.
—Gino Masero

"Hello, I'm Angie—I'm handicapped."

That was the usual way Angie C. introduced himself to visitors at our carousel workshop. During the carousel's construction period, our workshop was open to the public every Saturday, a time when our docents offered informal tours. We required these regular volunteers to study and master a basic information packet about the project before we appointed them as docents; Angie was self-appointed and had no use for a packet of information, because he could barely read at a first-grade level.

He simply appeared one Saturday morning and enthusiastically took up his duties without knowing what they were. I recognized him as an irregular attendee at our woodcarver's association meetings, where I had seen some of his carving work, which was fairly good. From that earlier involvement, I knew he had some sort of verbal communication problem that went beyond a simple speech impediment. But because he was generally a pleasant sort of a guy who had an appealing child-like demeanor, most of us accepted him and had no qualms about his aberrant behavior. Despite his obvious speech problem, Angie had few social inhibitions. He would readily introduce himself to strangers and

then conduct one-sided conversations about himself and his wood-carvings. For good measure, he would often carry a small bag of carvings with him and, unasked, show them to people.

And that is exactly how he behaved at the workshop. He would pick out visitors—he particularly liked couples—and attack them. But his tactics were badly flawed, because he held nothing in reserve and gave them everything he had up front, sometimes adding an unintentional shower of spittle for emphasis. When we first realized what was going on, some of us would undertaking flanking movements and were able to save the visitors from Angie's well intended but unnerving verbal onslaughts. (To make it worse, Angie was a "close talker.") However, as the Saturdays wore on, it became more and more apparent Angie was driving visitors away and that someone had to talk to him.

So it was that one Saturday morning, I reluctantly stepped up to the plate and took Angie aside. His face, initially open and expectant, became expressionless as I explained the problem. The proposed solution had seemed a sensible and practical one to our docents: they suggested that we not ban him outright but just limit his exposure to the visitors. Instead of coming every Saturday and staying all day, I told Angie we wanted him to continue working with us but wanted him to come every other Saturday for half the day.

Although his face hardly changed, I instantly knew from his body language that I had hurt him—badly. He picked up his small bag of carvings, said something about starting the new schedule now, and he left. The following Saturday, he didn't show up, nor did he appear the Saturday after that. I had stepped up to the plate and struck out.

What to do? I got his address from one of the guys in the carving club and went to see him. Angie lived in a small, neat modern home near one of the Long Island state parks. He worked in their sign shop, where he built signs he could not read. A teenage girl answered my knock and, when I told her who I was, politely invited me into an immaculate, well-furnished living room and called out for her father.

Angie greeted me with a wary, inquisitive look. Surprised by the normality of his living situation (I had expected something along the lines of two-room bachelor pad), I somewhat awkwardly tried to explain the reason for my visit. My apology took the form of offering to set up a small bench for him at our workshop where he could carve while interested visitors could watch. And if would like to do that instead of doing tours, I said, he could come every Saturday morning.

His smiled, said OK, and stuck out his hand to seal the deal. He called out to his wife who evidently had been listening in the hallway, and she rolled herself into the living room in her wheelchair. After she and I chatted a bit, Angie invited met to see his workshop.

It was a small, well-lighted room that had been added to the back of the house. There was a good-size workbench neatly accompanied by all the familiar tools. But it is the rows and rows of shelves that took me aback. They were filled with carvings ranging in size from four to eight inches; on display were close to a hundred of Angie's pieces in varying stages of completion. Those that were finished, about half of them, were his version of human and animal figures copied from the popular workbooks. However, he had somehow managed to infuse the sterile, commonplace patterns with his unique childlike nature and make them entirely into his own. They were enchanting.

I was immediately captivated, took a dragon and a dog off the shelf, and offered to buy them. Instead of being pleased at making a sale and flattered by the approval that it implied, Angie's face fell and his voice rose, "They're not for sale, they're for me!" And then, indignantly, almost like a child having a tantrum, "Nobody can have them. They're mine!"

Having had somewhat similar feelings during the very early stages of my career, feelings that my mature—and mercenary—manner helped me overcome, I thought I understood. But it instantly became clear that this was different, because his anger quickly dissipated and a sly smile came over Angie's face. "But I might trade you—if you have something I like."

So that's how I ended up with Angie's dog while he captured my Victorian match seller. His foot-long polychrome dog had been faithfully copied from a stuffed animal, stiches and all. Although it was wood, Angie had used his extraordinary talent to make it look soft, cuddly, and absolutely charming. I had carved my eight-inch-high match seller, which was based on a Gustave Doré drawing, in intricate detail out of a well-seasoned piece of English oak that Gino had given me. Angie may have had trouble speaking, but he sure as hell had no trouble seeing. He had picked one of my best pieces to add to his private collection

At first, the new workshop arrangement seemed to be working out well. But, after a couple of months, Angie apparently got bored with being confined to a workbench; I guess he was addicted to the thrill of the hunt and got his jollies by stalking and attacking unwary visitors. He began his early retirement by missing an occasional Saturday morning, and then he stopped coming completely. I still saw him at woodcarving club meetings where he was always eager to show me and tell me, and anyone else in earshot, about his latest carving. Evidentially he still considered me a friend, but his docent days were definitely over.

Angie died a premature death about ten years after our "arrangement" had ended. I was living upstate at the time and didn't find out about it until I returned to Long Island six months later. When I asked one of our mutual friends about the fate of Angie's carvings, he sadly explained that his wife had held a garage sale and disposed of everything; she sold nearly a hundred carvings that he had made or collected, most of them of them going for $10 a piece. My friend had bought a half-dozen himself to use as models.

I causally asked, "Was one of them an old guy in oak with a tray of matches?"

"No," he replied, "I saw that one there, but it wasn't one of Angie's and it wasn't as good as his stuff."

Always Listen to the Little Man

Marie Wolff appeared at our workshop on a late fall morning in 1992, unknown and uninvited. She had "heard about the project from some guy whose name I can't remember . . . and came because it sounded like a fun thing to do." Marie, a small woman in her early thirties, was neatly and functionally dressed in jeans and a well-worn jacket. She wore no makeup, and her hair, while under control, was clearly not the most important thing in her life. In sum, she looked far more like a Greenwich Village artist of the sixties than a suburban matron of the nineties. Because she had heard that we were looking for volunteer painters, she brought with her a photographic portfolio of paintings that she had done. When my examination of her work showed her to be a competent and versatile artist, I gave her an extensive tour of our workshop, and we talked about different ways she might participate.

Her eyes lit up when I showed her the folklore panel of Captain Kidd that I had just completed. She remembered hearing of him in school, knew the tale of his buried treasure on Gardiner's Island, and was obviously strongly attracted to the three-foot-by-four-foot relief carving.

She could barely contain her enthusiasm: "Could I paint that one? I love those two guys digging the hole. They'd be fun to do." It was almost a plea, childlike in its intensity—and difficult to resist.

I had spent three months with that carving solving problems of perspective that involved a ship anchored in the distance, a beached rowboat in the middle ground, and Kidd and his fellow pirates in the foreground—and all this in less than two inches of thickness. The carving was crisp, the faces were revealing, and the clothing draped perfectly. It was, at that point, easily the best relief work I had done. I was quite taken with the success of the piece and not yet willing to let it out of my sight.

"Could I do Captain Kidd?" Marie was insistent. "I could take it home and have it finished before Christmas. If you don't like it, you can just put another coat of prime on it and have someone else repaint it. Could I?" All that was missing was a little bouncing up and down, a plaintive tug on my sleeve, and a few repetitions of "Huh? Huh?"

How could I say no to such a determined, talented ,and seemingly sincere woman? If I denied her request because I was not quite ready to trust her, it would be a denial of what I claimed as a basic belief—the inherent decency of most of my fellow human beings. On the other hand, I was no Panglossian fool; I knew there were bad people in this world of ours—predators who did nasty things to well-meaning people. So, as I have often done in my life, I turned to my *little man* for the answer. In Edwin O'Connor's novel *The Last Hurrah*, Boston political boss Skeffington relied on "the little man who lives in his stomach" to help him judge people. When the little man kicked him, Skeffington withheld his trust and watched warily.

My little man told me that Marie Wolff was an OK kid. So it came to be, on that early fall morning, that I, albeit a bit reluctantly, picked up my treasured relief carving and carried it outside, where I lovingly and gently placed it in the trunk of Marie's slightly dilapidated twelve-year-old car. I watched her happily drive off, taking my carving to God knows where. (In the excitement of the moment, I had gotten her phone number but neglected to get a street address.) My last memory of that old gray car was of a dented rear fender fading in the

distance and a barely suppressible concern that I might never see it or my carving again

During the months that followed, Marie, to her credit, did call me a couple of times to tell me that work was progressing nicely and to ask questions about use of color to highlight different areas. And then, one day in mid-December, that old gray car reappeared, unannounced as before, in our workshop's driveway, and a beaming Marie Wolff bounced out. She walked quickly to the rear of the car, and, like an impresario pulling aside the theater curtain to introduce her latest star, she opened the trunk to present Captain Kidd—in full and glorious color.

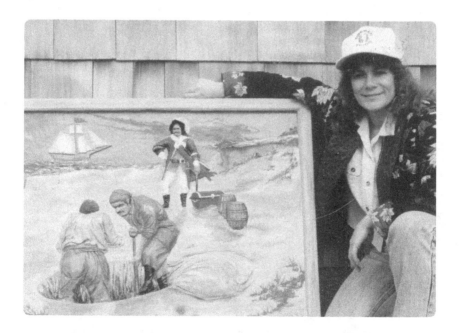

It was a superb piece of work! As good as I thought my carving was, her painting skill had made it even better than it was.

I love my little man—and that lady, Marie Wolff, she ain't half bad either.

Barter

I learned about the rewards of bartering from an ingenious dentist in Albany.

Paul, a longtime friend who recently retired from a thriving dental practice, swapped early and often, and there was frequently a connection between the stuff he swapped: a root canal for a year's worth of lawn care, a complete set of dentures for an elegant set of luggage, a couple of acrylic fillings for six full tanks of gasoline for his old station wagon (incidentally, he kept this nine-year-old vehicle running smoothly by providing routine dental maintenance to his mechanic's family).

But Paul, as obsessed barterers frequently do, finally had his day of reckoning. A well-established Albany madam, having heard of his swapping reputation, made him a tantalizing offer. She wanted him to provide regular dental checkups for herself and her girls in exchange for a complimentary account at her "house."

"How often?" Paul sheepishly asked. "As often as you like," she replied, "but, for our dental work, I'd pay you cash if we want any unusual stuff."

"And here," Paul grinned widely as he told me about the proposition, "she smiled and said, 'Of course, I would expect the same courtesy from you.'"

Paul, well-established family man that he was, said he quickly turned down this once-in-a-lifetime offer. I still see Paul three or four times a year. Every time we meet, I look deeply into his eyes and ask myself the same intriguing question: Did he really say no?

The Headless Horse
of the Hamptons

The ancient, acephalous wooden creature had been recently rescued from the depths of the Southampton town dump and had been brought into the relative safety of a Southampton cellar. That's where I first encountered the bleak body of a carousel horse that had been hand-carved by Marcus C. Illions, the "king of carvers," around the beginning of the twentieth century.

And, as those of you who have gone to the dictionary now know, this carousel horse—it had no head.

So here's the deal. A woman from Southampton who regularly visited the local dump searching for discarded antiques had found the horse and wanted to restore it. She phoned me, described the situation, and asked if I made house calls. Intrigued by her dump-diving activities and by her description of the horse, I agreed to visit and quote a price.

When I arrived at her modest (for the Hamptons) home, she took me to the spacious cellar that contained a seemingly endless but neatly organized array of antiques in various stages of disrepair.

"This started out as a hobby but it's become sort of a business," she explained. "Between visits to the dump—you'd be amazed at the things these rich people throw away—and restoring the stuff, I work pretty nearly full-time. Now this horse here . . ." With that she led me to the horse, which was in surprisingly good shape—if you ignored its highly advanced case of acephality. And if you looked beyond the

peeling paint, the elaborate details were still intact on the nicely carved trappings. "I found it last week on this pile of these things."

"These things" were a dozen sections of carved rounding boards inset with small, etched oval- and diamond-shaped mirrors. While a couple of them were badly damaged and rotted and some of them had missing pieces of trim, most of them appeared to be salvageable. But she didn't seem to want them.

So, we decided to trade—I would carve an Illions head and show her how to restore the horse's body. She, in turn, would give me all of the rounding boards.

It was another of those grand bargains. What else need be said? Well, on second thought, like the upcoming tale of my trade with Michael the mason, there was something else.

About a year later, she phoned again: "I've just returned from the dump and I had to call and tell you what I found—a horse's head! I think it's the missing one. It is very similar to the one you carved for me, and it's in pretty good shape. It was mounted on a nice oval board like they use for deer heads. I guess someone took it off my horse, fixed it up, and hung it on the wall. Then they threw the horse away. It's like killing an elephant just to get the tusks. And now, it seems they got tired of the head and they just dropped it into the dump. It must be nice to be so rich that you don't care whether you keep your heads or throw them away."

Her remarks immediately brought to mind the uneasy life of Rudyard Kipling who evidentially had suffered through a surprisingly similar problem, one that led him to pen these immortal words of advice: "If you can keep your head when all about you are losing theirs and blaming it on you . . ."

EPILOGUE

A few years later, while I was restoring those discarded rounding boards, I had a flight of fancy. What if Joseph Weber, the North Tonawanda

woodcarver whose tools I bought from his daughter, had carved these decorative carousel pieces—after all, it was exactly the kind of work he routinely did—and I was now, a century later, restoring his intricate work with the very tools he had used to create it.

Bashert?

"Hi Gerry ... and How Are You Feeling Today?"

I wanted a fieldstone fireplace; he wanted a cigar store Indian. He was a mason; I was a woodcarver ...

What else need be said? We both knew it was a match made in craftsman's heaven when we shook hands on the deal way back in 1979.

Michael, the mason, painstakingly selected the stones from a stone wall on the edge of the meadow adjacent to my nineteenth-century farmhouse. He laid them on the fireplace wall with the precise eye of a bricklayer, the trained hand of an artisan, and the spiritual soul of an artist. Although the pieces were of many different sizes, shapes, textures, and colors, he skillfully assembled then into a symphony in stone.

To fulfill my end of the bargain, I glued up air-dried basswood planks that I had cut from a tree on the far edge of the same meadow that had provided the stones. The life-size Indian that I created was one of a series of five, all of which were carved from the same pattern. However, I had introduced subtle variations in each one, and Michael's was one of the best of the bunch. He keeps it in his living room and proudly shows it to all who visit.

When the fireplace was completed and the Indian delivered, Michael set a ten-foot-long, four-inch-thick oak beam into the fireplace wall. To commemorate our trade, I carved a favorite verse from

Deuteronomy onto the face of the unusual mantelpiece: "Bless thee in all the work of thy hand which thou doest."

It was a grand bargain. What else need be said?

Well, on second thought, there is something else. Somewhere along the line Michael, who is about twenty years younger than I am, told a mutual friend that he had heard the work of an artist is worth more after he dies. Now, Michael doesn't know that our friend passed this information on to me. So whenever I see Michael, which happens only once every couple of years, he always gives me an appraising look while solicitously asking about my family and about my well-being. I have to suppress a grin because I know exactly whose well-being he has in mind.

This deathwatch has been going on for nearly thirty-five years. I suspect he might even

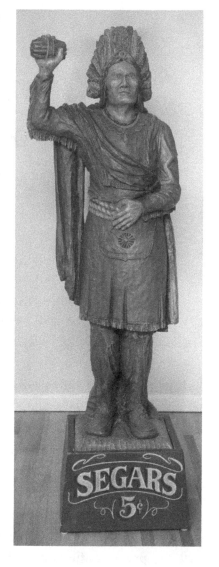

regularly read the Capital District obituaries with much the same thoughts of an investor checking out the Dow Jones Average. And I, being the thoroughly decent chap that I am, must admit that I do feel a bit guilty at my annual physical when Doc Pender cheerfully tells me that I should be good for at least another year.

"Sometimes We Get Lunch"

When Jimmy Carter declared, "Old age begins when regrets replace hope,"
he was already deeply involved in his extremely active postpresidential
life. His "old age" was still a long way away, despite the relentless ticking
of his biological clock. During the twenty-three years that we ran the
Empire State Carousel project, this same vital dynamic also motivated
the many volunteers who came to help us build our unique merry-go-
round. They were vigorous folks who, having paid their dues to the world
of work, still wanted to be players in the great game of life.

Here, in their own words, are the stories that three of these young-
sters told for our archival records.

An Old High School Friend

I went to high school with Gerry's wife, Arlene. You don't wanna
know how long ago that was. But my wife and I, we always kept in
touch with her and Gerry.

I'm an electrician, and I worked for the state doing maintenance
work at one of the mental hospitals. When I retired, I looked around for
something worthwhile to do. I was doing some work with the Knights
of Columbus, but that wasn't enough to keep me busy. So I asked Gerry
if he had any electrical work on the carousel. He had just gotten the
band organ and wanted to put lights on it, so I started coming in on

Saturdays to wire the organ. They had a great bunch a people working there, and we all got on great.

You should see the job I did on those band-organ lights. It was a very sophisticated piece of work. It had all sorts of switches and some of the lights even flashed on and off in time to the music. I could see that the guys were all impressed. I was sorry when I finished, because I didn't want to leave. So I offered to stay on and maybe do some of the tours—I never went to college, but I am a good talker and I enjoy being with people.

That's how I'm here. I may be retired, but now I've got a steady job at the carousel. I've been coming every Saturday for almost five years and never had a bad day. In fact, I've gotten pretty good at the tours. I've worked out a routine and a spiel that people seem to really like. The part I like the most is at the end when I walk them to the door and stand right next to the donation box and thank them for coming. It works every time. Nobody on my tours ever leaves without dropping a buck or two into the box.

One time, a TV crew came to film us when we were setting up a fundraising auction. All of us were working hard and rushing around so we could open on time. The reporter stopped me and asked why everybody was working so hard for no pay. I told him the honest truth: "We like what we do, we like each other and—sometimes we get lunch." He thought that was so good that he put it on his TV program. But it's no lie—it's really true—I like being here; it makes me feel good—and, you know, sometimes we really do get lunch.

The Woman in the Blue Blazer

I spent my working years as a nurse but, when I retired, I was able to spend a lot of time on my life-long hobby—decorative painting.

I loved the carousel project from the start and felt extremely lucky to be associated with it. I had volunteered to paint one of the folklore panels, and I was so proud of it that I brought my whole family to the

grand opening. It looked beautiful on the finished carousel. And Gerry was very nice to me. He even introduced me to the audience and told everyone he thought my panel was one of the best paintings on the whole carousel.

All in all, it was a very important day in my life.

But it wasn't always so nice and easy. I had some real problems with Gerry and his guys. They ran the project like a club—an old boys club. They should have put up a sign, "Carousel Boys Club—no girls allowed." To be fair, I must admit they had women around, but always in a subordinate role. Anybody could see that the guys were in charge and that they wouldn't do anything they didn't want to do. It was one of those "my way or the highway" operations as far as women were concerned.

That's why I made him sign a contract—a legal contract that my sister and I drew up. The purpose of the contract was to make sure that Gerry didn't control my painting like he did with almost everything else. It guaranteed me a lot of freedom with my work—like choosing my own colors and adding things that I thought were important. It also released me from any liability if he didn't like my painting or if I damaged the carving.

To show him how important I thought the contract was, the day I brought it in I got all dressed up in my best wool skirt and my blue blazer and I carried all my papers in one of those leather attaché cases. I even brought my sister with me to be my witness.

You should have seen his face. The president of that old boys club had no clue I was bringing a contract for him to sign. He thought I had just come to pick up the carving. But, once he got over his shock, all he did was ask for a few minutes to read it. I was a little afraid he might get mad—that's another reason I brought my sister, in case he said something nasty. But, when he finished, he sort of smiled and said that he would gladly sign it as long as I did too and asked if I would give him a copy. I gave him his copy, and he gave me his carving to paint.

That contract really did its job. He knew he couldn't mess with me after I made him sign it. I did that painting on my own terms in my own time. I knew my rights. And, sure as god made little green apples, did I ever teach that good old boy a thing or two about dealing with women.

An Old Dog Who Learned Some New Tricks

I've been carving since I became a Boy Scout—that's about seventy years. But it was almost all small stuff—birds, Christmas tree ornaments, and little animals—though I did do a miniature of a pair of fighting moose once that won first prize in a carving contest. In fact, that's how I got involved with Gerry.

He was one of the judges, and I guess he must have voted for my moose because he took me aside and asked me if I would like to carve a full-size animal for the carousel. I was reluctant, not because I didn't want to do it but because I was afraid that my work wouldn't be good enough. And besides, I had never done anything that big before. When I told him that, he said not to worry. He thought I could do it and promised to help me. He jokingly said, "I think you're one old dog who I can teach some new tricks to."

So I agreed to do it and learn some of those "great" new tricks of his. We picked the goat because we had some excellent pictures of one that had been carved about fifty years earlier by Daniel Muller, who was one of the best. Gerry, who is sometimes a bit of a wise guy, as you probably guessed with that "old dog" stuff, liked to tell people that our new goat was going to carved by our old goat. I'd like to tell him, "Old goat, my ass." But I won't because, otherwise, he's OK.

Anyhow, we set to work and he was as good as his word. I did most of the carving, but he helped me over the tough spots and even did small sections of the goat body and head to show me the way he thought it should be done. It all went well until I got to the legs. That's when the trouble started.

I had just about finished the body and it looked real nice. I had covered that entire goat body with detailed carvings of hair that the other guys said was very good. So when I got to the first leg, why I just followed the same style and carved it the same way. That leg was a lot of work—aside from shaping it and carving the hoof, it took me about two full days just to do the hair. I was so pleased with it that I took it to the workshop to show Gerry. When he saw the leg he got this funny look on his face—that look that he gets when something isn't the way he likes it.

"It's too squarish" he said.

"Too squarish?" I said.

"Yeah, too squarish," he said.

I had no idea in hell what he meant. And then he explained. "The hair is nicely carved but the leg needs to be rounder—it looks too much like a 2 × 4 with hair. Let me show you." And with that, he picks up his chisel and starts whacking off big hunks of the carved hair and reshaping the leg. He kept at it for about five minutes, and when he was done, I have to admit, it looked a lot more like a real leg—but without any hair. Two days work gone to hell.

I went home and went back to work on all four of those legs. It took a couple of weeks to make them less "squarish." But, to tell the truth, when they were finished, they did look damn good. You can see them for yourself if you ever go up to the carousel. So, in the end, I guess this old goat did learn a few new tricks—and finally satisfied that old bastard.

[My note: This old bastard was at least twenty years younger than that "the old goat."]

They Came to the Carousel

We had many unusual visitors to our workshop/museum during the twenty-three years we spent building the Empire State Carousel. I'd like you to meet a few of them.

A Private Space in a Public Place

The nine adults from a residential facility who came for a guided tour on a winter morning appeared to share only one common characteristic—they exhibited a childlike acquiescence to the familiar experience of being shepherded by their two well-intentioned guardians. My years of teaching had made me extremely sensitive to the nature of an audience, so I strove mightily to reach all the disparate members of this special group of four men and five women. I constantly scanned their expressive faces to see if they were receiving me and pulled out all the tricks of the teaching trade to engage them. I managed to get eight out of the nine; the ninth man, in his mid-sixties and relatively well dressed, appeared to be classically catatonic and reacted to nothing I did or said or showed. He just stared at some invisible point in space that only he could see. Yet he easily and agreeably moved along with the energetic group as I guided them through the small exhibit area.

When I turned on the loud band organ, a surprising thing happened—his trance-like expression softened into something that almost

resembled a smile, and his body rocked in time with the beat of the bass drum. When I turned off the band organ, it was as if he were directly connected to the switch; he abruptly stopped moving and reverted to his earlier pose.

I stood by the door as they departed the building in their accustomed single file, and I bid them goodbye. When the catatonic man reached me, he did something no one else in the group had done: he stopped and self-assuredly put out his hand to shake mine. As I took it, he said, loudly and distinctly: "Thank you sir, I enjoyed the visit, particularly the music. It was most invigorating." Then he let go of my hand, and, like that earlier moment with the band organ, he switched off, shuffled out, and returned to his own private world.

A Good Cry

Another band-organ experience produced an unforgettable moment of unimaginable emotional response.

One Saturday afternoon about a half dozen adults stood by the band organ and listened to my brief lecture on the workings of its traditional mechanism and the historical sources for its decorative carvings. Then, after warning the audience about the high volume of the music, I walked to the back of the organ and turned it on. I waited there for a minute or so to make sure it was running properly and returned to the audience in the front. One of them, a woman in her early seventies, had taken off her glasses and was gently wiping her eyes with her handkerchief.

Alarmed, I asked if she was all right. Was the loudness of the band organ hurting her ears? Did she want me to shut it down?

"No, definitely not. It's so lovely. It just made me remember the day my father took me for my first merry-go-round ride." At that point, she choked up a bit and, oblivious to the others around her, continued

to cry. Once more, I offered to turn it off, but she was emphatic in her denial: "No, no, let it go on a little while longer. It's such a nice memory."

The Tom and Gerry Show

Our small workshop was so crowded that the two Brownie troops had to sit on the grimy wooden floor, but they didn't seem to mind as they noisily scrunched around, making room for each other near my workbench and alongside the big carousel beaver. They quieted down when I shook my big mallet at them in a threatening way, but the chatter resumed when they saw me smile and realized that I was a genuine softie. However, as I began talking and demonstrating, they did become somewhat more attentive. But I knew I did not have their complete attention.

About five minutes into my presentation, I turned on the large overhead TV to show them excerpts from a recent TV program where NBC's Tom Brokaw interviewed me. The entire atmosphere changed quickly and dramatically. Except for the sounds from the television speaker, the room became absolutely silent; the Brownies were motionless and spellbound. That silence was broken when one of the girls pointed to me on the TV and shouted out: "Look, it's him!" And when the carousel beaver appeared on the screen, another Brownie exclaimed, "And there's Bucky."

Tom Brokaw, or more accurately the television set, had validated us. By being virtually presented, the physically present Bucky Beaver and Gerry Holzman had become undeniably real and therefore now deserving of full attention.

The Brownies were a marvelous audience.

A Dream Deferred

A man in his mid-eighties took me aside and wistfully confided in me:

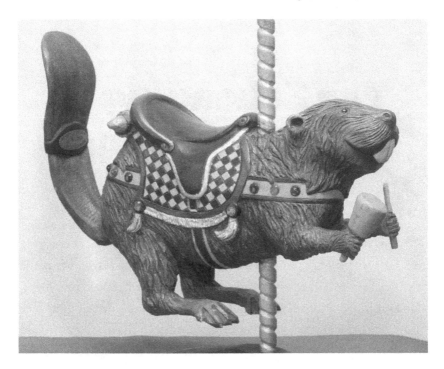

"I always wanted to own a carousel. I'd put it in a field and let people ride it for free, so I could just stand there and watch them having a good time. And sometimes, at night, when no one else was there, I'd put on all the lights, turn up the music real loud and stand out there, all alone, and watch it turn round and round and round."

Having made this confession, he then walked over to his wife, who hadn't heard our conversation and, very defiantly, repeated word-for-word, everything he had just said to me.

The Beheading of John Philip Sousa

It happened in Bellefontaine, Ohio, in the year 1992. There were three witnesses, two of whom helped to hold him down, while the third man (Orson, take note) approvingly looked on. Sousa was silent, with an expressionless—you might even say wooden—look on his face throughout the entire operation. Since I was in charge, I had to do the actual beheading. And, somewhat immodestly, I might say I did it rather well. In fact, throughout the ensuing years this work has been much admired by widely diverse audiences.

Hold on now! Don't call 911. I'm not a depraved serial killer who must be brought to justice; I was just an ordinary woodcarver doing his job. And in this Ohio gig, my job was to cut off Sousa's head—and arms—to properly prepare him to do *his* job, which was conducting a large military band organ.

A wee bit puzzled? How the hell does an armless guy without a head get music out of a military band organ? I guess some background is required before I carry the story any further.

The Stinson Band Organ Company of Ohio was creating a custom-built band organ for our Empire State Carousel project. The owner and designer, Don Stinson, had reached the final stage of construction for this magnificent air-driven instrument and, adhering to traditional practices, was ready to animate the hand-carved band leader, the aforementioned Sousa chap, so that his arms and head would move in accord with the music.

Jim Beatty, my carving associate, had claimed dibs on carving the four-foot-high, full-round Sousa figure because they both came from Port Washington. He was understandably reluctant to cut apart his superb sculpture, so the gruesome task of dismemberment fell to me. And that's the reason I was in Bellefontaine on a lovely spring morning holding a large backsaw in my hand and looking down on a passive wooden body spread out across two sturdy sawhorses.

I did the arms first; they were easy. But the beheading was a tricky process because it had to be cut at a very precise angle so that the inserted brass connectors would not be visible above the band-uniform collar. Had he squirmed even the slightest bit, the job would have been botched. But Sousa was immobile. My two assistants held him tight while I pushed the saw. And voilà, the dirty deed was done! John Philip Sousa had been successfully beheaded—and disarmed for good measure.

The rest was routine. I did a bit of carving to provide a recess for the neck; Stinson's men installed the brass fittings, attached the air hoses, positioned the head, and reset the arms. Then Don came over and thoroughly checked out our work. Apparently satisfied, he turned to me and, with an enormous smile, asked, "Are you ready?" When I nodded affirmatively, he walked to the back of the organ and flipped a switch. There was a slight whirring sound, Sousa cocked his head, lifted his baton, the blue lights flashed on, and the mighty, the magnificent, military band organ of the Empire State burst into a rousing rendition of "The Stars and Stripes Forever."

I'm not ashamed to admit that I cried (as did hard-nosed Don Stinson)—and I swear I saw a tear in Sousa's eye too, while his firmly attached arms moved up-and-down in time to the music. The March king was back in business, and, as his newly reunited head moved from side to side, he appeared to be truly loving his work.

Epilogue

During the three days I spent in Ohio, Don Stinson's foreman was extremely helpful and went out of his way to make my short stay as productive and pleasant as possible. Consequently, after getting Don's approval, I gave the him a $50 tip.

A couple of months after I returned home, I called Don to make final arrangements for the organ's delivery. He good-naturedly chided me about the tip. "You remember that fifty bucks you gave Bob? Well, he didn't show up for work the day after you left. He got ahold of a couple of his buddies, they bought a case of beer and spent the next day fishing and drinking beer. He was in such rough shape when he came back to work that I almost fired him."

Upstate Is Another Country

During my years as a teacher in suburban Long Island, I quickly came to realize that the overwhelming majority of my high school students had little knowledge of and even less interest in the entire area of New York that lies north of Westchester County, that huge, amorphous thing flatlanders conveniently call *upstate* or sometimes, even more ignorantly and arrogantly, simply—*the country*.

Upstate, which comprises well over three-quarters of New York's land mass and is home to approximately one-third of its population, is a highly complex and extremely diverse place. In truth, it may well be less of a place and more of a notion. However, despite the enormous economic and social difference between urbanized, sophisticated Saratoga Springs on the one hand and rural Amenia (where I grew up) on the other, the sensitive romantics among us can look beneath the surface and still find evidence of a common denominator that fits both of these upstate communities. This commonality is neither as apparent nor as potent today as it was some fifty years ago when Carl Carmer, one of our most incisive social historians, felt secure in describing upstate as "another country." Although not quite another country any longer—because of the obvious inroads of modern technology—upstate, to so many of us, still offers an alternate notion of how life is lived.

I am not perceptive enough to define that notion nor analytical enough to isolate its components. But, perhaps an incident that

occurred during a weekend that Jim Beatty and I spent in the upstate town of Waterloo will give the notion some life.

Jim and I arrived in town on a Friday afternoon in early October, a truly glorious time in Western New York. Since we were to be to be featured in a promotional parade for the Empire State Carousel project on Saturday, we brought with us the trailer-mounted band organ and a generous sampling of the carved and painted pieces from the carousel. Because of their value, we wanted a secure place to store them overnight. When we presented the problem to Bill Cooper, our regional representative, he arranged for us to lock them safely in a large enclosed storage bay that was an integral part of the Main Street police station. Early the next morning, as we got ready to set up our carousel display in the village park, we discovered that the police station was locked tight; a sign on the door stated that no one would be on duty until ten o'clock, an hour that was much too late for us.

What to do? We noticed an open diner a few doors down the street. Jim and I walked in and, obviously very troubled, told the owner of our predicament. He laughed, told us to relax and offered us some coffee. He then explained our problem to the half dozen early morning customers who had been watching us agitated strangers with courteous curiosity. When he finished his explanation, he turned to us. "Not to worry. George, over there, has a key to the police station, and he'll let you in."

Without a moment of hesitation, George, who we were to discover owned the antique store adjoining the police station, came over, shook our hands, and cheerfully said, " Bill told me all about you guys and the carousel project. It sounds great. Glad I can help. Let's go."

George walked us down the block, took out his key case, selected a key, and opened the door of the deserted police station

That's upstate.

Jack Barrette is from somewhere outside of Plattsburgh, which is nearly as far upstate as you can get. Jack was highly offended when he visited our Empire State Carousel display at the New York State Art Teacher's Convention in the fall of 1987 and learned that the loon was not on the list of carousel animals.

His luxuriant handlebar mustache quivered and his eyes flashed behind his steel rimmed spectacles as he lit into Jim and me. "If you don't put a loon on the carousel, I'll start a petition drive throughout the Adirondacks and force the issue. You guys just don't understand. The loon *is* the Adirondacks; I'm not going to let you get away with ignoring it and all of us up in the North Country!"

Just over a year later, Daphne Duck, Teddy Roosevelt, and Arlene Holzman accompanied me on a long wintry drive from Islip to Plattsburgh. We were there to participate in a ceremony at the Champlain Centre North Mall organized by the same Jack Barrette, now a calm, cheery man whose mustache no longer quivered and whose eyes gave off a merry twinkle. At the ceremony, he and other members of the Champlain Valley Woodcarvers presented us with Louie the Loon, a full-size carousel animal that they had spent the past year carving and painting. It was a well-attended affair that was suitably recorded by the local press and TV, both of whom took note of an emotionally moving subtext. Because one of the original carvers had died before the carving was completed, his carving colleagues put a brass plaque on the loon and dedicated it to Joe Shivokevich's memory. To oblige the TV cameras, Joe's young grandson jumped aboard the loon and took the symbolic first ride.

And, thanks to our former adversary, Louie the Loon wasn't all that the Champlain Valley had to offer the Empire State Carousel. When Jack came to understand that Jim and I shared his respect for the traditions of the North Country, he took upon himself the task of involving other craftspeople in the project. He coaxed the Champlain Valley Quilters into making a regional quilt and helped the Champlain Valley Woodcarvers design a frame for our center mast display. He

even got one of the local bird carvers to carve a nuthatch for our song-bird collection and later arranged for some community name boards to be carved for our upper canopy.

When the carousel had its grand opening in 2003, Jack made the trip all the way down to Long Island to bear witness—and maybe, true to his North Country instincts, to make sure that we flatlanders had given Louie his proper place on the platform.

Moral: Upstaters don't take kindly to being ignored, but once you get to know them, they're really not half bad.

$$)))))) (((((($$

And then there was the Calico Geese incident and the surprising connections that surrounded it. Bea Rexford from Hurleyville, way out in the wilds of Sullivan County, heard about our idea to put regional quilt banners on the carousel from Ruth Culver, my brother Steve's next-door neighbor in Kingston. Ruth, a quilting teacher at Ulster County Community College, had encouraged me to include the quilts and helped me set up the specifications for the project. She had written a note to Bea, an old quilting buddy, which ended with these hopeful words: "My take on this Empire State Carousel thing is that it is a go."

That's how Bea came to call me with her enthusiastic offer to get the quilting project up and running by sewing the first quilt. When I explained that we were looking for participation by guilds or societies, not individuals, and suggested that she contact one of them, her disappointment was obvious; there were simply no quilting clubs in the area. Our conversation ended with a few pleasantries, and I assumed the matter was closed.

But I hadn't reckoned with the determination and ingenuity of Bea Rexford. A few weeks later she called me to say that *they* were ready to make the first quilt. And who were they? In order to meet our requirements, Bea had created her very own quilting guild, which

consisted of herself and three other Sullivan County women. Bea was its first president.

About six months later, the quilt from the Calico Geese Quilters arrived. The front featured a white-tailed deer standing on a rocky ledge looking down at a meandering stream; in the distance, it showed the Catskill Mountains encircled by puffy white clouds; around the scene's oval frame were colorful fabric pieces arranged in those attractive geometric shapes so common to our quilting tradition. The reverse had only a simple outline map of Sullivan County, prominently, and I suspect, proudly, displaying the names of the four communities where the four quilters lived.

It was an auspicious beginning. By the time the carousel opened in 2003, the quilting project had expanded to the point where we had acquired thirty-six regional quilts, with no end in sight. And what became of the Calico Geese? Two years later, Bea sent me a letter containing an unexpected request:

> Thank you for the latest newsletter. I'm real pleased with the progress but sorry to hear that the funding is so difficult. If I were to win the lottery, you'd be real high on my list . . . Can you send our banner back? We would like to display it in a place of honor at our next quilt show. We will return it as soon as the show is over. Because of its making, the Calico Geese Quilters were formed, and we're now over a hundred strong. Thank you, and I wish I could do more.

So then, what is this notion we call upstate? I really don't know but whatever it is—I sure do like it. And maybe Carl Carmer was right—it just could be another country, a country that offers us another way to spend our brief moment on earth.

The Wayward Press

Most of you have seen those supermarket tabloids that tempt us with all sorts of bizarre and beguiling stories as we wait our turn at the checkout counter. Well, a few years ago, I was contacted by one of them.

The reporter was interested in doing a feature piece on my carousel work; he wanted to visit my studio with a photographer to conduct an interview. Knowing what I did about the nature of these papers, I was courteous but wary and said I would have to give it some thought. I suggested that he call back in a day or so.

I then drove down to the local supermarket and picked up a copy of his paper, which coincidentally contained a story by him. It was just as I feared—sensationalism ran rampant. I'm far from being a prude; in fact, as many of my friends will readily attest, I have a tendency to be a bit crude at times. But their stuff was over the top even for me. And, to make it worse for this old English teacher, it was poorly written and filled with grammatical flaws.

When he called back the next day, I politely explained that ours was an educational project with a strong family orientation and, as such, it didn't seem to be an appropriate subject for his newspaper. He was infuriated by my rejection—I can still clearly remember his threatening words.

"I thought I was doing you a favor by giving you some free publicity. I don't need you to do the story—I'll do it without you and if you don't like what I write about you and your cockamamie project, remember, you made the decision, not me."

And with those declarations of journalistic ethics and fact-checking integrity resonating in my ears, he hung up.

His threat had an immediate effect on his paper's circulation—it increased by one. For the next month, I faithfully, and apprehensively, bought my weekly copy at the supermarket. Since I have been gifted with a vivid imagination, one so wacky that it could have easily guaranteed me employment as a tabloid reporter, I anxiously watched for headlines along the lines of " Space Alien Carves Carousel—Earthling Claims Credit" or, horror of horrors, "Long Island Man Caught Fooling Around with Wooden Sheep." I was lucky; he evidently lost interest in my nefarious activities and returned to his routine beat at the United Nations.

Equally high on the list of journalists with impure motives is the beguiling tale of Denny the Deer Mouse and the Cheese Museum.

One summer morning, I received a phone call from a reporter who worked for an upstate news service. He had gotten hold of a partial list of member items—those special grants (often self-serving and occasionally ethically questionable, but very helpful to legitimate projects) obtained by state legislators for nonprofit organizations within their home districts.

While looking through the list, the coincidence of two apparently unrelated grants had caught his eye. One was $25,000 for the Museum of Cheese in Syracuse; the other was $7,500 for a wooden mouse in Islip. He wanted to know two things: Was it true that the State was going to give me $7,500 just for making a wooden mouse? Was there any connection between the two grants? In short, was it possible that my mouse was going to end up doing his mouse thing in the Museum of Cheese?

Because of the tenor of his questions and the tone in his voice, I immediately smelled a rat. Consequently, I deftly maneuvered to avoid the trap before it was sprung.

"I understand your concern, but, before I answer your questions, I want you to give me a couple of minutes to explain what the mouse is all about." The reporter reluctantly agreed to listen. Accordingly, for the next four or five minutes, I presented what I felt was a concise summary of the carousel project and the reasons why I, and many others, strongly felt it was a very important educational development. When I finished, there was a moment of silence and then: "OK, I got it. It sounds like a real complicated project—now, you promised to answer my questions. Are they actually paying you $7,500 just to carve one wooden mouse for that carousel?"

I responded by patiently describing the trappings on Denny the Deer Mouse. He would have an I ♥ NY button on his cap, wear a large detailed map of New York State on his flank, and be beating a drum inscribed with the State's Latin motto, "Excelsior" (Ever upward). As such, I pointed out that he would be a useful and highly attractive educational aid.

These explanations were a waste of time. He knew what he wanted to know and he knew it without me telling him. I took one last shot: "Do me one small favor. I'm going to send you a package of background material on the carousel project. Before you write your story, look it over." He agreed to wait until my package arrived before doing the article.

He didn't. Two days later, I received a phone call from a buddy in the Syracuse area informing me that a story about member items had just been published and that Denny the Deer Mouse and the Museum of Cheese were hot news. He sent me a copy.

7,500 Taxpayer Dollars for One Wooden Mouse— $25,000 for His Cheese

> Gerry Holzman, a Long Island woodcarver, has received a State grant of $7,500 to carve a four-foot-long wooden mouse who sports a floppy cap between his outsized ears. And, in a related grant, the Museum of Cheese in Syracuse has been awarded $25,000 to improve its cheese displays. These are only two of the many absurd examples of how our hard-earned taxpayer dollars are being wasted by New York State legislators as they try to curry favor with their constituents.

Guilty on two counts: I was going to use "hard-earned taxpayer dollars," and I was a Long Islander. The article went on to list other debatable grants and to attack the entire concept of the member-item pork barrel. Although nothing came of the story—member items continued, in fact expanded, and the carousel wasn't even mentioned by name—the betrayal of trust by the reporter still rankles.

It was a cheesy thing for him to do.

And finally, there was the Murrow heresy.

The profaners were a three-person reporting team from a local television station assigned to do a general-interest story on the carousel while it was in residence at the Ecology Center. The reporter, a tall, thin fellow in his late twenties, was quite taken with Sam Bear and decided to do the "teaser" shot with his hand in Sam's open mouth. His accompanying commentary was truly inspired: "I can't bear to leave this carousel."

Courtesy of Richard Walker

After witnessing this rousing display of journalistic creativity, I thought it would be helpful if I took them on a quick introductory tour of the carousel before they continued. I was hoping to provide them with enough background so they could move their coverage to a slightly higher level. That's why I began with the Edward R. Murrow / John Peter Zenger portrait panel. It depicts Murrow in the foreground and Zenger in the background with the two men linked by a scroll entitled "First Amendment." Next to this three-foot-high panel is a quotation board bearing a remark that Murrow made during the depths of the McCarthy era: "We must not confuse dissent with disloyalty and . . . we must remember that we are descended from men who were not afraid to disagree."

The others two team members, a female sound technician and a male cameraman, were also in their mid-to-late twenties. I

good-humoredly told them that since I was once a teacher and since they were now journalists, it was only fair that I ask them some questions about Murrow, Zenger, and the First Amendment. And I did. And I wish I hadn't—their answers were frightening. Not one of them had ever heard of either man. While I could understand and even accept their ignorance of Zenger, to my mind, a journalist who is unaware of Edward R. Murrow is equivalent to a priest who is unaware of Jesus Christ.

Perhaps the worst aspect of this impromptu class was their personal reaction to the revelation of their ignorance. Two of them—the reporter and the cameraman—seemed unfazed and disinterested. The reporter even made some lame jest about old timers and the modern world. To her credit, the sound technician appeared somewhat uncomfortable, particularly when I made some comments about the importance of the legacy that Murrow has left to modern-day journalists.

I went through the motions of continuing the tour, but, because their reaction had taken the heart out of me, I cut it short and let them go about their business, unimpeded and uninstructed. I guess my old ninth-grade guru, Gerard Pelletier, was right when he reminded me that "we're not all little Mr. Holzmans"

The piece, which aired on Long Island regional television that weekend, made no mention of Zenger or Murrow or of the carousel's educational foundation. It closed with the reporter thrusting his hand into Sam Bear's mouth while cheerfully saying, "I can't bear to leave this carousel."

When I opened the carousel building the next morning, I walked over to the Edward R. Murrow portrait to apologize. And I swear, that's when I saw a tear in his eye.

Honesty Is a
Sometimes Thing

A female relative of mine worked for Sal Chimenti, a genial, middle-aged, burly man who managed an upscale Long Island restaurant. When Sal decided he needed a new sign, my relative suggested that he commission me to design and carve one for him. Before she set up our meeting, my cousin explained that Sal was "connected" and that the restaurant was a Mafia-controlled business. But, she hastened to assure me, the restaurant was entirely on the up-and-up. And then, when she sensed my concern, she felt impelled to admit that, while certain questionable things did occasionally go on in the restaurant, she had learned to ignore them and cautioned that I do the same.

"Don't worry," Betty said, "Sal is a gentleman and a gentle man."

Our initial meeting went well. Sal was just as Betty had described him, and we quickly agreed on a design and a price. During the two months that the job required, I regularly kept him in the loop with in-progress photos, and we established a very comfortable working relationship.

One afternoon, as I was at the restaurant taking some final measurements, he invited me to sit down with a couple of his regular customers, guys who looked like they could have easily worked as extras on *The Sopranos*.

"This is Betty's cousin; he's an artist who's making a big carved sign for me. We're goin' to mount it on the roof and spotlight it so people will be able to see it from two blocks away."

Sal made this announcement with an air of considerable proprietary pride. It was only a few minutes later, while we were sipping our espresso and munching on anisette biscotti, that I realized what had happened; I had become Sal's Michelangelo and he was my Lorenzo De Medici.

Sal was delighted with the finished sign and expressed a genuine interest in seeing more of my carving work. When he looked at the sampling of six-inch figures I brought in, his smile conveyed his appreciation and approval. Then my newfound patron made me an offer that I couldn't refuse.

"Leave three of your best pieces here. We'll put them on this shelf by the register stand where everyone can see them—and I'll sell them for you. I don't want no commission. You did such a nice job on my sign that I want to give you a chance to pick up a few more bucks."

I quickly picked out three carvings, assigned a price to each, and carefully arranged them on the shelf. They fit in well with the restaurant's overall decor, and I was quite pleased to see my work so prominently displayed.

As I gathered up my things and turned to go, Sal shouted at me. "Hey Gerry, you're not going to leave them like that?"

"Like what?"

"Like loose on the shelf, you gavone. Don't you know that people steal stuff? We gotta make sure your carvings don't walk. Wait here."

With that, he disappeared for a couple of minutes and returned with a drill, a screwdriver, and some long screws. He pencil marked the location of each figure, put them off to the side, drilled three holes in the shelf, reset the figures, and drove the screws through the bottom of the shelf and into the base of each figure.

"There—that'll take care of the crooks." And with a fatherly grin, he opened his brawny arms, gave me a hug, and whispered in my ear, "Gerry, you're gonna have to learn that not everybody in this world is honest like you and me."

Window Chopping

Having written freely about the misdeeds of others, it's about time (the statute of limitations hopefully having run out) for me to confess to a crime on the high seas. It involved the Cunard Cruise Line during my artist-in-residence years. The crime was not premeditated, nor was it intentional; it was more like a hit-and-run on an unoccupied car in a parking lot. But it was a crime nevertheless, and by committing it, I certainly cost the Cunard people some considerable annoyance and some several hundred dollars.

My carving bench on the ship was an improvised piece of furniture—two planks that I clamped onto the side of a rear-deck window frame. For a jerry-built platform, it worked quite well. The large three-foot-by-six-foot window provided excellent light, and its wide frame offered sturdy support for my constant mallet pounding.

On the day in question, I was vigorously roughing out a three-foot-high ship's figurehead. Because it was afternoon teatime, my audience, which typically numbered about fifteen people, was nonexistent. When I chopped an unusually large chunk off the basswood shoulder, I felt the bench shudder and heard the window frame on which it rested snap. The entire window assembly shook for the briefest of moments, then broke loose of its enclosure and began a downward descent into the calm blue waters of the South Pacific.

I watched in horror as it tumbled end over end in what seemed like a slow-motion eternity. The window finally hit the ocean with a visible but inaudible splash and was gone forever. I quickly looked around the deck to see if anyone else was watching.

There were a few sunbathers and a couple of ancient shuffleboarders, but no one seemed to have noticed the "hit." Now, my survival instincts told me, it was time for the "run."

I leisurely unclamped my makeshift bench from the newly empty window frame and disassembled it. When one of the deck stewards walked by, I coolly made some remark about teatime and began slowly packing up my tools. The dirty deed having been done, I hid out in the lounge, successfully camouflaged by a teacup and a large, crumbly scone with clotted cream.

The next day, I set up my carving bench by clamping it to the underside of the stair assembly. This new arrangement proved to be even sturdier than the window bench and, as an unanticipated bonus, offered more sitting space for the audience. Perhaps sometimes crime does pay.

As I began my carving work, I casually looked over at the scene of yesterday's malfeasance. Blimey! The ever-efficient Brits had replaced the bloody window! I breathed a sigh of relief. There was clearly some sort of design flaw in the QE2's superstructure, and this falling window sort of thing was a routine occurrence.

They sure as hell don't make ships like they used to.

Me and Dick Nixon

Now, I'd like to tell you about the time I got involved with President Nixon. Not directly involved, mind you. That would have been a bit much for a mere woodcarver, even though Tricky Dick and I certainly did have one thing in common—we were both confirmed chiselers. And, while my adventure didn't come close to being Watergate-level stuff, it did involve the water—well, sort of.

Let me explain.

During his years as president, Nixon had two very close friends, Bebe Rebozo and Bob Abplanalp. While I didn't know Bebe Rebozo, Jim Beatty and I did get to spend an unforgettable afternoon with Bob Abplanalp in 1976. It was just around the time that the turmoil surrounding Nixon's resignation was subsiding.

Bob Abplanalp had made his considerable fortune by perfecting and promoting the aerosol spray can. Those spray cans of his occupy a vivid part of my memory of our first meeting. When we entered his office, the aerosol king was seated behind a very large glass-topped desk. The entire left corner of the desk was covered with an attractive display of commercial spray cans—about two dozen of them in a variety of sizes, shapes, and colors.

But even more vivid in my mental picture of this meeting were the photos of him with President Nixon that were on the wall of his spacious office—him and President Nixon fishing on the ocean, posing with friends, sitting in the Oval Office, or simply chatting together. Apparently, despite the disgrace of the resignation, Bob Abplanalp remained a loyal friend.

We were there in his Yonkers office because Abplanalp had recently salvaged a Spanish galleon, the *San Juan Evangelista*, which had sunk off the coast of Florida in 1714. He had come up with the idea of refurbishing pieces of its 350-year-old oak planks into souvenirs that he could sell in his Walker's Cay–resort gift shop. During a serendipitous conversation with a fishing-boat captain that he and Jim both happened to know, our woodcarving activities somehow came up, and Abplanalp was intrigued. He asked the captain to arrange a meeting so he could pick our brains and, possibly, give us some work making some souvenirs.

On his desk that afternoon, right next to all those aerosol cans, were two pieces of well-weathered grayish oak from the galleon. They were each about a foot long, two inches thick, and approximately six inches wide. Allowing for the fact that they had been submerged in salt water for over 350 years, they seemed to be in remarkably good condition. When I picked up a piece and fingered it, I was surprised at how much integrity it still had and how solid it still felt.

The three of us brainstormed for about half an hour and settled on some practical possibilities for the gift shop: jewelry boxes, book ends, and chess sets. While the first two would require minimal carving, a proper chess set—I had suggested one with a maritime theme—would require considerable detail work. But we all had some concerns about how the ancient water-soaked wood would respond to the stress of carving.

Of course, there was only one way to find out. So I offered to take a piece of wood home and put it to the test by carving a couple of chess pieces. It all began easily enough. I put that old oak plank on my band-saw table, drew an outline of a queen and a king, and started cutting. Smooth sailing for a brief moment and then—then the misty essence of the *San Juan Evangelista* emerged.

It certainly wasn't a genie coming out of a bottle, but something strange—very strange—was coming out of that wood. I could barely see it, but, boy oh boy, could I smell it! Although it faintly resembled

the alluring aroma of the seashore, it had another unfamiliar and unpleasant ingredient—a mysterious odor that overrode the scent of ocean and seemed to contain equal parts of swamp, musty attic, and yesterday. So pungent and so potent it was, an alarmed Arlene came running into the shop to see what was going on. (My shop was in the rear of our attached garage.)

But an open window and a whirring exhaust fan soon made short work of the irritating smell, and I set to work on the chess piece. After a few hours of satisfying, odor-free carving, I produced a very respectable and pleasant-looking queen for the chess set and went off to dinner, quite pleased with my efforts.

The next morning, when I returned to the shop to admire my work, I was in for a bit of a shock. The relatively smooth chess piece that I had created was now quite coarse looking; the summer-wood and spring-wood layers had slightly separated, and, in so doing, had distorted the queen's face. It was as if someone, or something, had tampered with the carving during the night. And, even more disturbing, traces of that strange smell had re-emerged.

When I called to tell Jim what had happened, he suggested that the wood's distortion might simply have resulted from being reshaped too severely and being dried too rapidly. But, sensing my discomfort with the whole idea of carving salt-water-infused wood, he agreed that we best jump ship and not link our fate to a project that might become another Watergate.

However, if we had been honest with the aerosol king, we would have told him we were simply disinclined to antagonize the ghosts who were, sure as hell, still walking the planks of that 350-year-old ship.

A Not-So-Wicked Witch

When she first came into our woodcarving shop, I didn't realize she was a witch—not one of those mean-spirited, constantly complaining, wicked old lady kind of witches—no, none of that nasty stuff. Laura was just one of your normal, decent, ordinary, everyday witches.

I'd guess Laura was just north of thirty years old and aging well. Tastefully dressed in crisp khaki shorts and a snug-fitting light-blue blouse, she was about five feet, four inches tall, a wee bit chunky (but that's how I like my women), and had a very pleasant face that was jauntily set off by her bouncing chestnut-colored ponytail.

She strode up to the counter, smiling in an engaging sort of way, and took a deck of large cards out of her shoulder bag.

"Your advertisement said that you could carve almost anything. I've got a bit of a problem and hope you can help me" She spread an array of tarot cards on the shop counter and picked out one that showed an elaborately costumed medieval figure holding a scepter.

"I need to have one of these carved." Seeing my confused look, she clarified her request. "No, not the whole figure, just the scepter."

I looked at the card more closely and was somewhat taken aback when I realized that the figure was holding a double-ended phallus.

We had opened our woodcarving shop about a month earlier. While we stocked all sorts of things associated with carving—tools, books,

kits, sharpening stones—our business plan was heavily based on the idea that the shop would generate lucrative carving commissions.

Four very long weeks had passed, and this request for a double-ended phallus was our first inquiry. However, as needy as we were, the little man who lives in my stomach gave me a cautionary kick. I stalled by asking some questions.

"What size did you have in mind?"

"About two feet long. And it must be made of willow."

"Why willow? Wouldn't pine or basswood do? Willow is more difficult to find."

"No, it must be of willow. Of all the woods, it is the most fertile." And then with a challenging look, she asked, "Can you carve it, and, if you can, how much would it be?"

It was Saturday; the second month's rent was due on Wednesday.

"Well, I need to know a bit more. How much detail should it have? What sort of finish do you have in mind? How thick would it be?"

To help with that last question, I looked around for a large dowel. There were none. And then inspiration struck. I reached for the shop broom. "About this thickness?"

She cocked her head in an inquisitive way, but quickly satisfying herself that I was not mocking her (at this point, I did not have the slightest inkling that she was a witch), she said that the scepter would have to be nearly twice as thick as the broomstick.

After agreeing on what I thought was a reasonable price of two hundred dollars and a month's working time, we filled out the commission form, and she gave me a one-hundred-dollar deposit. That's how I learned her name was Laura and that she lived just a few miles from our shop.

The reaction of my partners to our first commission was mixed. The bizarre nature of the carving disturbed one of them but the other one was childishly gleeful and couldn't resist making obscene jokes about it.

Two weeks after Laura entered my life, I read a feature article in *Newsday*, our regional newspaper, about a renewed national interest in witchcraft. The article reported that the Long Island area where our shop was located was home to at least three covens of witches, but, the writer quickly noted, none of them engaged in malevolent practices. They were "good witches not wicked witches." And further, in keeping with the contemporary demands of political correctness, their adherents were both male and female. While there was no mention of double-ended phalluses, this well-weathered woodcarver began to realize that he might have wandered into wayward territory.

When a very attractively attired Laura arrived to pick up the finished scepter, her satisfaction with my work was obvious. As we chatted about the tarot cards, the difficulty of finding a suitable piece of willow, and other benign topics, I waited for an appropriate pause and posed the burning question: "I couldn't help but wonder after reading the article in *Newsday*—are you a witch?"

Her smile was not unlike that of Glinda, the good witch of the South. "Yes," she readily admitted, "I belong to Wicca. But there is none of that double, double, toil and trouble stuff; we are good witches. No curses, evil potions, or flying around on brooms during Halloween. We pretty much follow the teaching of the druids from medieval England and worship nature."

And here her smile became a wee bit, dare I say it—bewitching. "If you'd like to learn more about us, our coven meets regularly not far from here, and we always welcome kind people who are curious about our practices." She graciously handed me a simple business card inscribed with just a first name and a phone number. (This was long before the days of the internet.) And, with that, she picked up the carved double-ended phallus and walked out of my life, her chestnut-colored ponytail bobbing beguilingly.

That was more than thirty years ago. Since then, I have carved many unusual things. I have met many captivating people. I have traveled widely in this fascinating world of ours, and I have been involved

in many extraordinary adventures. Yet for all that, every once in a while, I find myself musing about life's unpredictability and wishing that I had kept Laura's business card.

Solvitur Ambulando

It is often said that Latin is a dead language. Well, for me it has always been a pretty vital part of my life, as this essay elaborately explains.

In 1946, during my freshman year of high school, I took Latin from Mrs. McKean. Rosie was a very short, skinny strawberry-blond widow who habitually wore a simple black dress decorated only by an unreliable hearing aid. Since we students never could be sure if she was on the air or off, sometimes we got caught saying bad things. Rosie usually carried a twelve-inch ruler in her left hand and a thick piece of yellow chalk in her right. The chalk was for teaching and the ruler was for preaching and, too often for my tender twelve-year-old hands, it was also for hitting.

I was there, as were the other seven students, not by choice but by New York State edict. In those bygone days, if you wanted to graduate with a Regents diploma, you had to take two years of a foreign language. And nothing could be more foreign in my tiny rural village of Amenia than Latin.

Somehow, I suffered through the basic *unus, duo, tres* and the *amo, amas, amats* of the autumn months and grudgingly learned how to create simple sentences like *agricula arat* and *carthago delenda est* during the dreary winter days. But when spring came around, I did too and found myself eager to cross the Rubicon with Julius Caesar as

he defiantly proclaimed "Alea jacta est." By Jove, I really got to like the Roman stuff and had even begun to notice the Latin roots of English words on my own.

Just before Christmas, Mrs. McKean, by bribing us with her home-made cookies, taught us to sing "Adeste Fideles"—in Latin, of course. However, my parents weren't impressed when their little Geraldus proudly demonstrated his newly acquired linguistic ability by singing about the *regem angelorum* at dinner—but only after first finishing his matzo ball soup.

To her further credit, Rosie also told us barbarians how lucky we were to be living, not in ordinary villages like neighboring Millerton or Dover Plains but in *amenia*, a Latin word meaning pleasing to the eye. And she bluntly pointed out that our state motto, "Excelsior," should be an inspiration to the laggards among us (I swear she was looked directly at me) because it meant New Yorkers were destined to go "ever upward."

So, you see, I was pretty well Latined up when I got to Albany and encountered Minerva, the Roman goddess of wisdom, whose larger-than-life statue royally reigned over the main lobby of the state college. In fact, I might even go as far as to say that the milestones of my life have been inscribed in Latin. While in college, I bought my first car, a 1939 Mercury, the Ford brand named for the Roman messenger of the gods. After finishing college, as a responsible citizen of the United States of America—a country that was formed around the idea of *E pluribus unum* (one from many)—I served in the army signal corps, whose Latin motto was "Certo cito" (Swift and sure). Discharged in January (named for the two-faced god Janus), I got married in December (the tenth month) to a woman who had been a high school salutatorian at graduation.

My professional life was no different. As one of the founders of a teachers union, I named and edited our official publication, *Vox Veritas* (the voice of truth). And one of my closest colleagues in the union was a delightfully rotund and sometimes-pompous chap who regularly took

umbrage at remarks made by nonunion teachers. During these years, I discovered that many of our great institutions have Latin mottos—Yale, "Lux et veritas" (Light and truth); the Olympic Games, "Citius, altius, fortius" *(Faster,* higher, stronger); and even the Maine State Police, "Semper aequus" (Always just). After I switched careers to become a carver, these experiences made me insist that our grand carousel could not be officially launched unless it had a proper Latin blessing. So one of our board members, a retired Latin teacher, came up with our very appropriate motto: "Sic mundus festive circumeat," which translates loosely—very loosely—to "May the world go merrily around."

Now, please excuse me while I put the Latin aside for a momentary, but necessary, digression. It seems that my personal merry-go-round of life always brings me back to the same starting point—my childhood home. Not only was my Amenia pleasing to the eye, it was pleasant on the feet. And, because I grew up there before the era of the helicopter parents and the horror of Sandy Hook, I could and did walk everywhere without worrying about kidnappers or cutthroats. If I include my routine two-mile round trip to school, walking three or four miles a day was not unusual—nor did I resent it. I carried this custom of walking into my college years and have happily continued it throughout my adult life. I walk for purpose, for physical well-being, and for pleasure. I have even succeeded in passing this compulsion on to some of my children and grandchildren. In fact, sometimes when I'm unusually tired and my legs ache, I have brashly involved God in the process by offering Him a deal: if He would pick them up, I would put them down.

The reader might justifiably ask, "So Mr. Digresser, what does all this walking stuff have to do with woodcarving?" Well, now we have reached the real nitty-gritty of the essay—continuity. I have tried to encourage continuity by establishing a family tradition, a tradition using Latin as the glue that binds walking to woodcarving.

Arlene and I have six grandchildren. For their high school graduations, I have carved each of them a decorative walking stick inscribed

with their initials and the Latin words "Solivutur Ambulando." In a separate envelope, I included some much-appreciated cash and a copy of a poem I wrote.

SOLVITUR AMBULANDO

A walk,
Every day—
About two miles
In roughly half an hour.
Always seeking shade in summer,
While welcoming warmth in winter.
Each morning
Something fresh to see,
And, the overwhelming necessity
To foretell the day's essential mystery.
This, of course, demands a sudden end
To all that empty and irrelevant talking.
Solid thought and solitude, my frantic friend—
Forsooth—*the problem is solved while walking!*

The grandchildren have reacted in surprising ways. Liam, the oldest and consequently the first recipient, showed his appreciation by loudly saying, to his mother's horror, "It's the best fucken present I ever got." A couple of months later, to my horror, he had the words "Solid thought and solitude, my frantic friend," tattooed on his right forearm.

Granddaughter Julie, because she is the only girl and the youngest of the bunch, was always concerned about getting her due respect. I like to think it was that attitude, and not worry about my premature death, which led her to suggest in the spring of her junior year that it might be a good idea if I started working on her stick during the upcoming summer. I followed her advice and, mercifully, was still alive to hand it to her on graduation day.

So, that's it. Many times I found the problem *was* actually solved while walking—or, at the very least, it was momentarily forgotten or, even more likely, was put into perspective and became less of a problem. God picked them up, I put them down, and life went on.

Although I never taught anybody to sing "Adeste Fidelis," I think Rosie McKean might be pretty well pleased with the way things turned out.

Excelsior!

The Persistence of Nat Gutman

I first encountered Nat Gutman in 1984 at New York's International Center for Photography during an exhibition of Roman Vishniac's poignant photo collection *A Vanished World*. Vishniac's photographs of Jewish communities of Eastern Europe, made on the eve of World War II, constitute the last pictorial record of a unique world that vanished soon afterward. While there were over fifty pictures in the show, the larger-than-life portrait of Gutman somehow seemed different from the others; it was as if he were actually present and calling out to me from the black-and-white photographic paper; his compelling eyes drew me toward him and challenged me to respond.

A little research revealed his familiar but nonetheless heartbreaking story. After working as a bank cashier for many years, Nat Gutman was dismissed when Poland's powerful far-right party forced most economic, cultural, and political institutions to boycott Jews. Intent upon survival, he was reduced to working as a porter (that's when Vishniac photographed him) in order to support his wife and son. After the German occupation, even that scanty thread of life was withdrawn, and he and his family were sent to an extermination camp, where they were killed.

But here was Nat Gutman alive in Manhattan, still a survivor yet forty years dead. He was here for me to see because of Roman Vishniac's photographic ability. I wondered, could I, another kind of artist, use my carving skills to create a different dimension of survival for him?

The creation of a woodcarving, like so many art forms, is often an impulsive and a near-mystical process. My English mentor, Gino Masero, put its unpredictability into a very British context: "If you're traveling to York from London, there's nothing wrong with taking a side trip to Cambridge or even stopping off in the Cotswolds for a few days. Eventually, you'll get to York, and the trip will have been all the better for the unplanned things that happen."

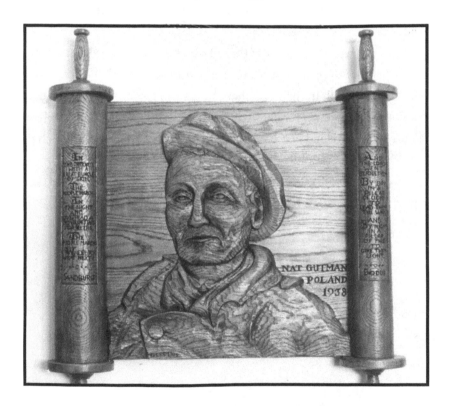

I have carved Nat Gutman in white oak because it is a tough. durable wood with a strong grain, an appropriate medium to convey the expression of pride, defiance, and determination that Vishniac caught in the face of this innocent target of anti-Semitism. I have placed him on a Torah scroll, because its contents offer many dramatic examples of those very same qualities and are the likely source of his strength.

My "side trip to Cambridge" took me to an old favorite poem, Carl Sandburg's *The People, Yes*, which contained this highly appropriate affirmation of the resilience of life: "In the darkness with a great bundle of grief, the people march. / In the night, and overhead a shovel of stars for keeps, the people march. / Where to? What next?"

While spending "a few days in the Cotswolds," I found a surprisingly similar biblical verse from Exodus. "By day, the Lord went ahead of them in a pillar of cloud to guide them on their way and by night, in a pillar of fire to give them light."

I have carved the words of these two versions of mankind's timeless and endless journey within recessed frames on the rolled portions of the Torah scroll. In the hope that one day all this will come together in some unknown way for some other member of Sandburg's Family of Man, I have provided Nat Gutman with another opportunity to challenge future generations.

"Communicating, that's what us carvers are about," said my friend Gino.

A Thread that Binds

During my quest to find some meaning in my wanderings through nearly a half-century of woodcarving adventures, I may have found one of the many interdependent threads of the fabric that so imperfectly envelops our civil society today. And its discovery, I brashly suggest, may be the Rosetta Stone that will help us understand how to preserve what we've got—that is, if we really want to.

Given what seems to be the immutable nature of mankind, I am convinced there will never be a utopia nor will there be anything remotely resembling it. But I am reasonably confident that there can be an imperfect middle ground between what is and what will never be—a place where, in the words of the poet Longfellow, "The night shall be filled with music, and the cares that infest the day / shall fold their tents, like the Arabs, and as silently steal away."

Consider, if you will, carving, quilting, singing, cooking, painting, potting, drawing, dancing—the list of these self-expressive activities is nearly endless. And the escape they so often provide from "the cares that infest the day" can become the entry point to an alternative way of living—a way of living where people can communicate in a manner that transcends language, ethnicity, race, and culture.

During my wanderings to such diverse places as a Haitian mountain workshop, a Himalayan village street corner, an English backyard carving studio, a remote Canadian carving village, and an American carousel-museum classroom, I have easily, and gratifyingly, communicated with "mes frères en bois." Aside from facilitating communication with my brothers in wood, the commonality of our interest has had a

completely unanticipated side effect: it has led to peripheral encounters that have expanded and enriched my entire being.

To show you what I mean, let's revisit a fifty-year chain of experiences—encounters most of which I have earlier described—and I'll try to explain how these accidental connections have altered my life.

Remember that dignified Indian woodcarver who, way back in 1968, tolerantly told this brash American tourist that "I am an artist, sahib; I do not bargain"? His declaration marks the first link in this chain. Although it was made some years before I remotely considered myself an artist, he indelibly imprinted himself on my subconscious, and I've had to deal with the fallout ever since.

The second link was forged when my neighbor, Jack Kahler, a seventy-ish woodworking hobbyist who was an avowed right-winger, more or less adopted me and tried to steer me away from my progressive proclivities into his more practical world of woodworking. It was during the time when I was experimenting with woodcarving, and Jack helped me along by cutting out blanks and by gluing-up larger pieces. One morning as I got in the car to begin my daily commute, I found a magazine tucked under my windshield wiper. Jack had placed a copy of *Chip Chats* there in hopes of broadening my horizons.

Boy, oh boy, did he ever do that. Buried between carving patterns, photos of members' work, and carving tips, this journal of the National Woodcarvers Association had found room for a very brief article about Gino Masero. And, Bob's your uncle, that magazine became link number three.

The following summer, because of a cash surplus generated by Arlene's windfall of a one-year teaching job, we took the children to England for six weeks. While there, I arranged to meet Gino for a one-hour morning visit at his home in Sussex. Because we took to each other immediately, that one-hour visit expanded into lunch, a carving lesson, and a tour of the Sussex countryside. That was day one. Day two took the form of a new career for me, access to the esoteric world

of United Kingdom woodcarvers, and a cherished life-long friendship with Gino.

Number four: I wrote a book about all of it—*Us Carvers*. His grandson Ricci found out about the book fourteen years after Gino died and arranged for his siblings and Gino's great-grandchildren to meet with me, my daughter, and two of my grandchildren in London. Because the book presented his grandfather in an entirely new and highly favorable light, Ricci has thoughts about one day becoming a professional woodcarver. That's number five.

Link number six was created during one of my trips on the QE2 as a woodcarver-in-residence for Cunard when we met a couple from Wales. Graham was a university professor who dabbled in photography. He attended all of my demonstrations and shot a great many videos and stills of this old wanderer in action. Shirley was a midwife and social worker who specialized in being a thoroughly decent person. It was one of those encounters where all four of us felt we had known each other in another time and our meeting aboard ship was not a new friendship; it was simply a continuation of an old relationship, one which has endured to this very day. They have visited with us many times in America, and we have done the same in the UK, even straying into France with them for three weeks.

Graham, who had lived in France for a while and was relatively fluent in French, made arrangements for a one-week house rental. Charles, the homeowner, lived in an adjacent house and just happened to be an amateur woodworker who had a small workshop on the grounds. When he discovered that I was a woodcarver, he offered me free run of the shop and even gave me permission to cut a branch off one of his trees so I could carve a walking stick. Using a jack knife that I had brought from home and a couple of the tools in his shop, I was able to rough out a fairly respectable stick.

The night before we left, Charles invited all four of us to visit him and his wife. We spent a pleasant evening talking about woodworking, painting (his wife did portraits in acrylic, and Graham was quite good

with pastels), and the differences between France, England, and the US. After finishing two bottles of the local red wine, we decided that things were pretty much the same no matter where you lived. If you're still keeping track, this is link number seven in the chain of connections.

When we returned to America, one of the first things I did was finish the walking stick and put it among a stack of a half-dozen or so that I kept on hand for customers. About a month later, we attended a week-long series of events in Cooperstown that was being conducted to commemorate our donation of the Empire State Carousel to the Farmers' Museum. At the conclusion of the last event, where I presented a slide show especially designed for the year-round residents, Arlene and I went to dinner at the local hotel. While eating dessert—an unusually moist and tasty piece of chocolate cake—I had a full-blown heart attack.

It was a good news–bad news event. The bad news was that a major artery was completely blocked and I needed a triple bypass and a pacemaker; the good news was that the local hospital had been given a major grant a few years earlier to set up a state-of-the-art cardiac unit that would be a prototype for rural hospitals throughout the country. Because of the efforts of this highly capable medical group, I am still alive fifteen years later. (At least I was when I wrote this book.)

As a token of our appreciation, Arlene suggested that I give walking sticks to the two cardiologists and the cardiac surgeon who treated me. I did—and one of three gifts was the walking stick from France. That stick went to one of the cardiologists who, I later discovered, was an avid collector of the work of Käthe Kollwitz, a print maker who specialized in woodcuts. A couple of years earlier, I had used one of her prints as a reference for a deep-relief woodcarving. Number eight.

About five years later, I received an email from the historian of St. Mary's, a small Catholic church in the Hampstead section of London. While updating the church's history, he discovered that Gino had done a significant amount of carving for it—all fourteen Stations of the Cross and a nearly life-size crèche scene. The historian learned that

I had written a book about Gino and wanted to conduct a telephone interview. By an extraordinary—almost eerie—coincidence, we had arranged to meet our Welsh friends that very week in North London just a few miles from St. Mary's.

So it came to be that the four of us met with the St. Mary's historian, an affable man who marveled at the serendipitous nature of our visit. He gave us a tour of the church, opened the dusty storeroom so we could photograph the Nativity scene, and helped us photograph the Stations of the Cross

I had noticed that the anatomy of the first Station (Jesus being condemned to death) was surprisingly crude and stiff; it was not typical of the quality of Gino's work. But equally surprising was the fact that the sculpting of the fourth Station (Jesus encounters Mary) was quite refined. It was as if they had been done by two different carvers. When I pointed out this discrepancy to the historian, he smiled and told me a fascinating story.

"Gino had a great deal of trouble with the first couple of carvings. It was very early in his career, and he hadn't had any experience carving the human form. But, to his great credit, he was so dissatisfied with his efforts that he took an anatomical drawing course to sharpen his perception. That course, coupled with his instinctive flair for facial expression and composition, led to the steadily increasing sophistication of the subsequent carvings."

With that, the historian walked us over to the twelfth Station, which depicts Jesus dying on the cross. "This is my favorite; to my eye, aside from being the most recognizable, it shows Gino at his very best. It was at this point that he offered to re-carve the first two Stations but the canon wisely refused saying, 'Let everyone see for once an artist in the making.'"

And here's the most current link. (Notice I avoided the term "final link" because I have no idea how long this chain of unanticipated connections will be—and therein lies the beauty of it.) A couple of years ago while vacationing in Charleston, I attended an informal carving

demonstration by a highly talented itinerant South Carolina carver named Mary May. During a long and lively conversation, I casually mentioned my involvement with Gino. Mary was completely taken aback; she walked over to the table where she had some of her tools on display, picked one up, and showed it to me. The handle had been wood-burned with a carver's name—Gino Masero.

"I was over in the UK last month teaching a carving course and stopped off at a London carving supply store to pick up a few tools. This was one of them."

The house we were renting was just two blocks away from her demonstration site. I took a quick walk over there and brought back a copy of *Us Carvers*. I inscribed it to her with some words about happy coincidences. We continued to chat for a moment or two, but both of us were a bit distracted and caught up in our private musings. I left, and that was the end of that.

A month or so later, Mary sent me a check ordering three more copies of the book, saying she was going to give them to some of her carving buddies. And that was the end of that . . .

"Where to? What next?"

A Blessing from the Butcher

Walt "Woodchip" Wilson worked for a supermarket chain as a specialty butcher for nearly forty years. He and I met when we both became founding members of the Long Island Woodcarvers Association. We soon discovered that we had a mutual interest in carving life-size shop figures and spent a good bit of time working together on a variety of projects. When it came time to retire and leave the island, Walt expressed some concern about his long-planned move to the South.

"I don't know anybody there, but I don't want to be cold anymore and it's too expensive up here so I guess we'll have to make it work out. My church [I suspect that Walt was an Evangelical Christian] has a branch there, and that should help some. And maybe I can find a couple of Southern woodcarvers who don't mind an old guy with a Brooklyn accent."

I heard nothing from Walt until he returned to Long Island for a brief visit a couple of years later. It was then that he told me of how his Long Island past had changed his North Carolina present.

"It wasn't easy at first. It was a real small town. The church people were OK, but they were a little stand-offish, like they were saying, 'We've got enough friends already.' Then I saw a notice in the paper about the monthly meeting of a woodcarving club in a small city nearby. So I got my courage up and went. I took a couple of my carvings with me, some

pictures of the big figures you and I used to do, and I even brought some tools along."

"There were about twenty guys at the meeting, and they were different from the church people. I found out later that most of them had come from someplace else like me. A couple of the guys picked up my tools and were real surprised at how sharp they were. When they asked me what kind of machine I used, I told them I was a butcher, and I sure as hell didn't need any goddamn machine. Jeez, I spent half my life sharpening knives—by hand."

"They called some other guys over to look at the tools, and suddenly I was like a celebrity. The president of the club took me aside and asked me if I would join up and maybe teach a class on tool sharpening. So I did, and it worked out good."

Here, Walt's sad, saggy eyes filled with tears. "It worked out real good."

"Gerry, these guys took me in like we knew each other all our lives. One of them was a dentist, one guy taught in the local college, and the guy who is my best buddy now is a big-shot lawyer in the city. Think about it, a goddamn butcher hanging out with guys like that. Christ, I barely got out of high school."

As he spoke, tears began flowing freely down Woodchip Wilson's long, jowly face and spilled over into the deep furrows. "Gerry, we've been given a blessing, you and me. When God made us into woodcarvers, He blessed us. He truly did. And we can never forget that."

Amen, Woodchip, amen!

Epilogue

And finally, for those of us who sometimes forget how large this world of ours is and how small a part of it we are, here is a clear-cut statement about the reality of life as offered by a no-nonsense fourth-grade teacher when she introduced me to her class:

This is Mr. Holzman. He is going to talk to you today about his merry-go-round. If you have crunchies, don't eat them during the talk. Remember that, class. Mr. Holzman is a very important man—no crunchies today.

Index